ASSYRIAN
PALACE SCULPTURES

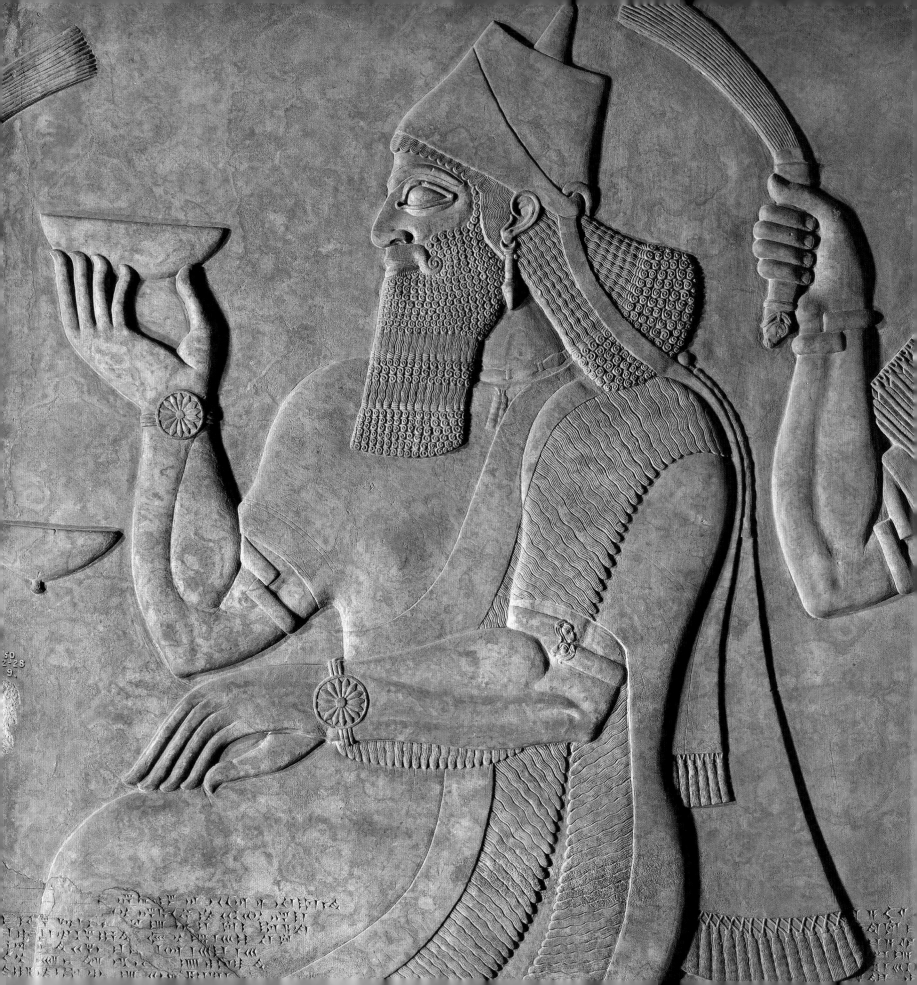

ASSYRIAN
PALACE SCULPTURES

PAUL COLLINS WITH PHOTOGRAPHS BY LISA BAYLIS AND SANDRA MARSHALL

THE J. PAUL GETTY MUSEUM LOS ANGELES

ACKNOWLEDGMENTS

I would like to thank John Curtis for inviting me
to write this book, Lisa Baylis and Sandra Marshall
for their superb photography, and Carolyn Jones of
British Museum Press for expertly guiding the book
to completion. I am especially indebted to Ian Jenkins
who read an early draft of the manuscript; it bene-
fited enormously from his unrivalled knowledge
of the acquisition, arrangement, and interpretation
of the sculpture collections of the British Museum.

This edition is issued on the occasion of the exhibi-
tion *Assyria: Palace Art of Ancient Iraq*, on view at
the J. Paul Getty Museum at the Getty Villa, Malibu,
from October 2, 2019, to September 5, 2022.

The works in the exhibition represent an exceptional
loan from the British Museum in London.

**Published in 2020 by the J. Paul Getty
Museum, Los Angeles**
Getty Publications
1200 Getty Center Drive, Suite 500
Los Angeles, California 90049-1682
www.getty.edu/publications

Distributed in the United States and Canada by
the University of Chicago Press

Printed in China

ISBN 978-1-60606-648-5
Library of Congress Control Number: 2019943387

First published in 2008 by British Museum Press
A division of The British Museum Company Ltd
British Museum, Great Russell Street, London,
WC1B 3DG

King Ashurnasirpal II wears the distinctive Assyrian
crown. His luxuriant beard and hair symbolize his
virility and power. *frontispiece*
The protective Sacred Tree consists of streams and
palmettes, symbolizing in perfect symmetry the
fertile world established by the gods. *right*
Assyrian scribes methodically record captured furni-
ture, vessels, and weapons. *page 6*

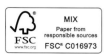

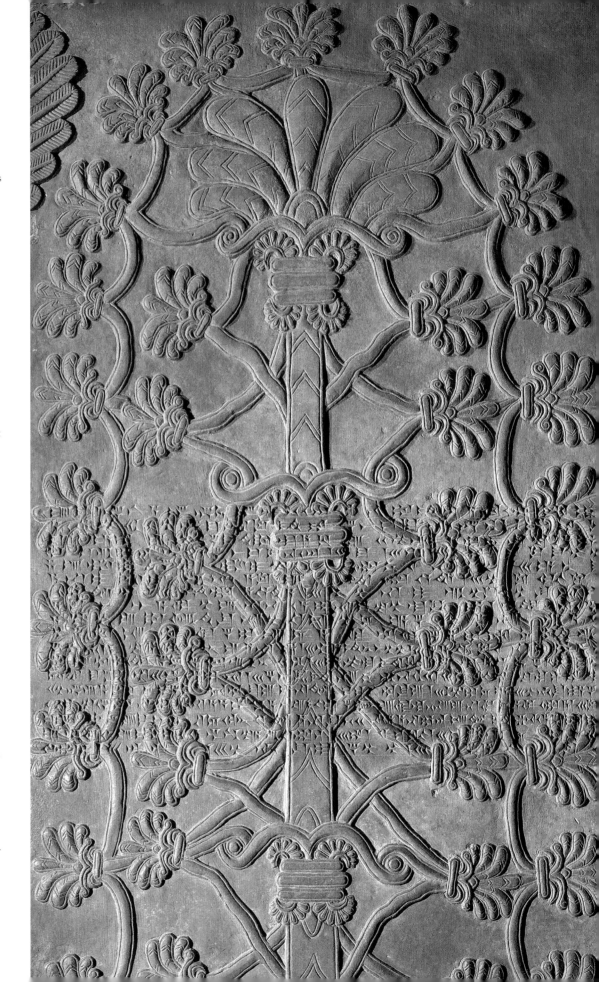

CONTENTS

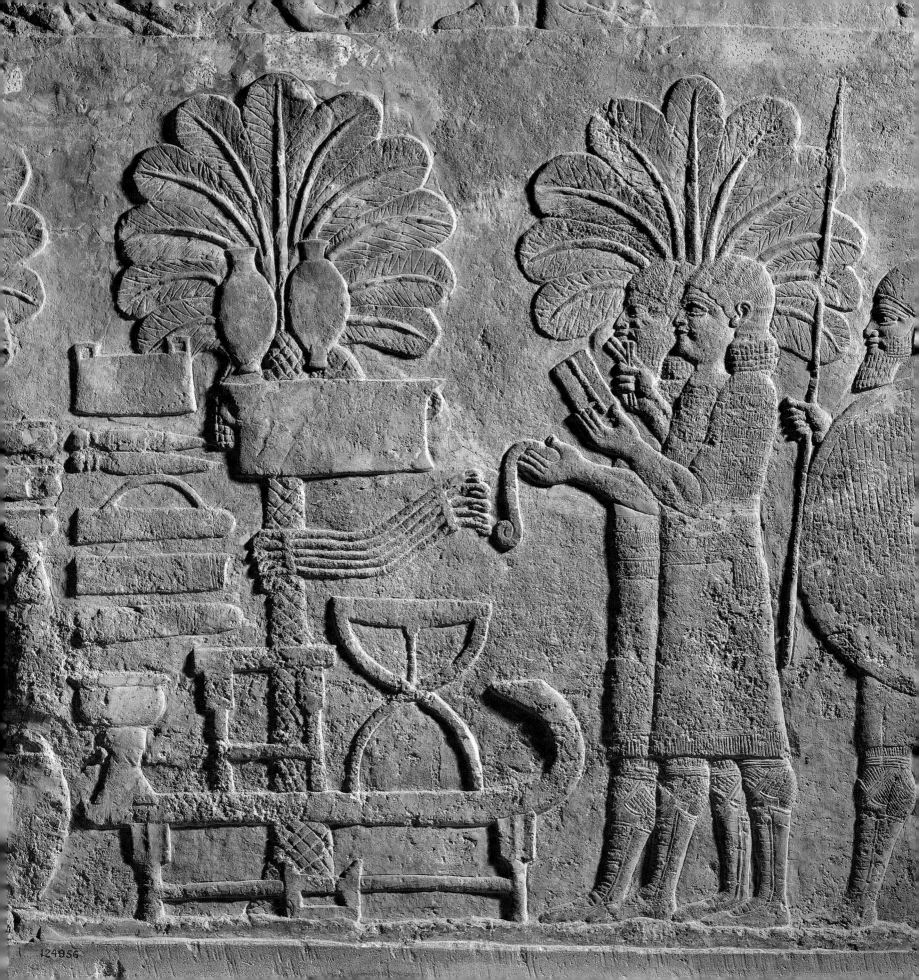

FOREWORD

BETWEEN THE NINTH AND SEVENTH CENTURIES BC, THE ASSYRIANS CREATED THE GREATEST empire the ancient world had yet known, stretching from Egypt, the Levant, and southern Anatolia (Turkey) through Mesopotamia to western Persia (Iran). To glorify their achievements and their patron god, Ashur, the Assyrian rulers built a series of new capitals during this period within the Assyrian heartland in modern-day northern Iraq: Kalhu (modern Nimrud), Dur-Sharrukin (modern Khorsabad), and Nineveh. The centerpieces of these imperial complexes were the royal palaces, whose walls were elaborately decorated with relief sculptures celebrating the kings' conquests and prowess as hunters as well as ritual and protective mythological scenes. At once spectacular and frightening, these reliefs were clearly intended to intimidate all who came into the kings' presence.

Both for their rich and varied subject matter, and for their narrative and artistic sophistication, the Assyrian reliefs count among the greatest achievements of ancient art. The historical scenes, which are accompanied by commentaries in Assyrian cuneiform, are graphic (and often gruesome) records of conquest and deportation—making the pathos with which the dying lions in royal hunts are portrayed all the more striking. It may come as a surprise to learn that many of the reliefs were at least partly painted, though only traces of pigment now remain. The effect would certainly have been more vibrant than the monochrome stone conveys today.

Several of the works in this book are among those the British Museum generously placed on long-term loan at the Getty Villa in 2019. They include one of the most famous masterpieces of Assyrian art: the banquet scene showing Ashurbanipal and his queen relaxing in a garden, the severed head of the Elamite king hanging from a nearby tree.

The historical, artistic, and cultural importance of the reliefs has, tragically, increased since the barbaric destruction of some Assyrian palaces by Daesh/ISIS in recent years. The preservation of what remains, and the recognition of its significance for the history of humankind, is a greater imperative than ever.

Timothy Potts
Director, The J. Paul Getty Museum
June 2019

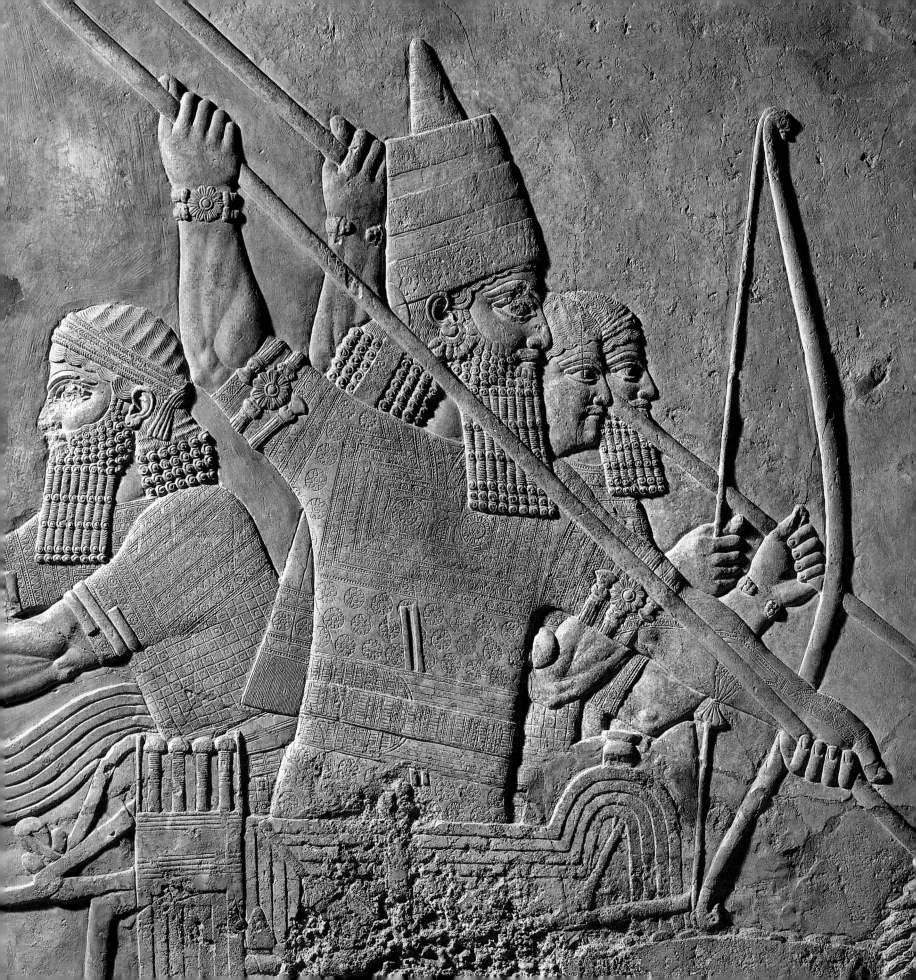

ASSYRIAN PALACE SCULPTURES

NEARLY THREE THOUSAND YEARS AFTER THEIR CREATION, THE ASSYRIAN SCULPTURES RETAIN THEIR power to astonish. They demand attention, and can even intimidate a viewer by their scale, authority, carefully observed treatment of animals and exquisite details of ornamentation, or the drama of a narrative that compels the eye to move from one image to the next. The emotional impact of the reliefs and the excellence of their design and carving easily qualifies them as great works of art. Even though their surfaces have been dulled by the passage of time, we can marvel at the artists' skill in creating a clear and vivid message: the Assyrian king, supported by the gods whose high priest he was, brings abundance to his land and defeats dangerous forces that disturb the divine order of the world.

It is perhaps the representations of the king as huntsman and warrior that are most disturbing for a modern audience; the pain of the hunted animals and the cruelty inflicted on those overwhelmed in battle has suggested to some that they are the product of a blood-thirsty people. Before reaching such a conclusion, however, we should pause to consider whether these scenes are any more barbaric in content than those portrayed in the countless representations that glorify wars and warriors decorating palaces, churches and government buildings around the world, as well as in more recent cinematic depictions. The reliefs certainly can serve to remind us of the brutality, cruelty and atrocities of war, and the pain inflicted on animals and humans across the globe, both in ancient and modern times. Indeed, what helps to make Assyrian imagery so compelling is that it presents a very believable world; conflict is not masked by treating it as set in mythological time and place as in the imagery of classical Greece. The violence of the Assyrians was considered a means to an end – it resulted in order. It is a concept that still resonates in the contemporary world, often with catastrophic consequences.

ASHURBANIPAL effortlessly thrusts a spear towards a wild lion. The king's strength, indicated by the delicately modelled muscles of his arm, is granted by the gods.

These magnificent sculptures were carved on huge panels of gypsum and limestone between about 875 and 620 BC. During this period the kingdom of Assyria, located in the fertile valley of the River Tigris in what is now northern Iraq, came to dominate a geographical area that stretched from the eastern Mediterranean to the Persian Gulf. As an expression of their piety and power, a number of Assyrian kings undertook vast building programmes at a series of royal centres. Although constructed of mud brick, palaces were made majestic by lining the walls of principal rooms with carved stone slabs which formed part of much wider schemes of decoration that included glazed bricks, wall paintings, textiles and furniture. The imagery embellishing the palaces was rooted in the artistic traditions of Syria and Mesopotamia (ancient Iraq) but had developed from the late second millennium BC as a distinctive Assyrian visual language intended to glorify the king. The earliest scenes are summaries or symbols of royal achievements. By the seventh century BC, however, compositions, sometimes consisting of multiple narratives, might occupy entire rooms. This artistic tradition was brought to a violent end with the destruction of the Assyrian empire in 612 BC, when the palaces were abandoned and the sculptures were buried under decayed mud brick and debris for over two thousand years.

RECOVERY OF THE ASSYRIAN SCULPTURES

The story of the recovery of the Assyrian sculptures begins in the early nineteenth century when most of the Middle East belonged to the Turkish Ottoman Empire. At this time most educated people in Europe were schooled in the Bible and classical authors, and they recognized that many of the sites in Iraq represented the remains of some of the oldest civilizations in the world, including Assyria. Indeed, European merchants, diplomats, and adventurers who had earlier journeyed through the region had returned with tales of the ancient ruins. However, opportunities for direct European exploration of these sites only became possible as a result of the widening interests of the British and French empires following Napoleon's expedition to Egypt and Palestine. Some of the earliest archaeological research was carried out by Claudius James Rich, British Resident in Baghdad from 1808 to 1820. The antiquities he gathered before his untimely death formed the basis for the Mesopotamian collections in the British Museum. It was, however, a Frenchman, Paul-Émile Botta who undertook the first major excavations in 1842. He started digging at Nineveh, but a lack of major discoveries led him to move to the site of Khorsabad where he started to uncover the palace of Sargon II (721–705 BC) and its superlative sculptured monuments.

These French discoveries had a profound impact on Austen Henry Layard, an Englishman who had trained as an attorney, but who had spent several years from 1839 exploring the Middle East including visiting some of its ancient sites and expressing a desire to see them excavated. By 1845, at the age of twenty-eight, he was attached to the staff of Sir Stratford Canning, the British ambassador at the Ottoman court in Constantinople. Writing in the

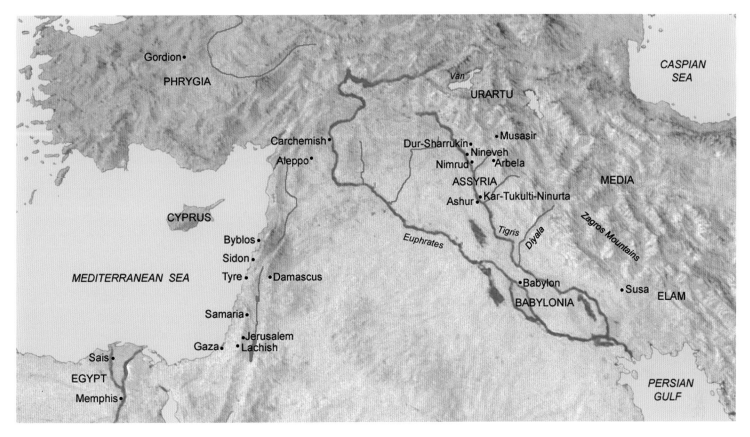

Malta Times, which had been founded by Canning to foster British interests in the eastern Mediterranean, Layard revealed his passion for the newly discovered Assyrian sculptures. With the support of the British Resident in Baghdad, Henry Creswicke Rawlinson, whose own interests lay in the cuneiform writing system of ancient Iraq, Layard persuaded Canning to provide funds for two months of excavations at the site of Nimrud. Sir Stratford needed little encouragement. He had already acquired some fragments of Assyrian sculptures from Botta's excavations at Khorsabad and these had been forwarded to London as curiosities for Lord Lansdowne who owned a famous collection of classical sculptures.

In November 1845 Layard began to excavate and, almost immediately, his workmen found inscribed stone panels. Within weeks, sculpted slabs were being uncovered in the ruins of the so-called Southwest Palace of Esarhaddon (680–669 BC). Rawlinson was unexcited by the carved scenes, writing, 'I regard inscriptions as of greater value than sculptures'. Canning too doubted the works' aesthetic worth but nonetheless valued the finds because they allowed England to rival and even surpass the achievements of France. In this spirit of competitiveness, by 1846 arrangements were made for the British Government to take over responsibility for funding the excavations and Layard became the agent of the British Museum. The excavations now began to uncover outstanding reliefs in the Northwest Palace of Ashurnasirpal II (883–859 BC). Agreements were made with the Ottoman government, which

MAP OF ASSYRIA and neighbouring regions.

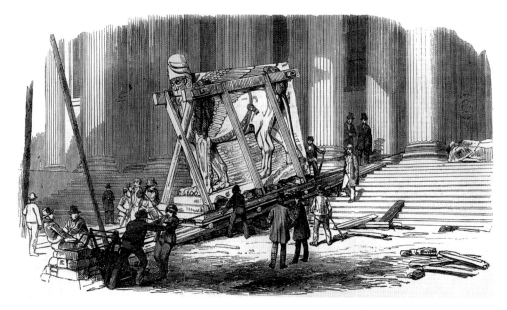

had little interest in antiquities at this time, to have the sculptures shipped to England. With the help of his assistant Hormuzd Rassam, Layard set to work copying inscriptions, drawing the reliefs, making casts, and having the slabs crated for transport or reburying any that could not be moved.

Layard closed the excavations at Nimrud in May 1847 and briefly turned his attention to Nineveh, where he located the greatest of the Assyrian palaces belonging to Sennacherib (704–681 BC). However, by now his funds were exhausted and Layard returned to England; the first reliefs arrived in London in June. They had been transported on carts to the Tigris, loaded onto barges which carried them to Basra, where they were transferred to a steamship and taken to Bombay. From India, they were sailed around Africa to Chatham before being transported to the British Museum. This great achievement was acknowledged in popular publications such as the *Penny Magazine*. Intended to serve the education of the British working classes, these periodicals eagerly endorsed Layard's positive descriptions of the reliefs. The rhetoric had great appeal and people could appreciate the finds from Layard's descriptions without recourse to a classical education:

> they are immensely superior to the stiff and ill-proportioned figures of the monuments of the Pharaohs. They discover a knowledge of the anatomy of the human frame, a remarkable perception of character, and wonderful spirit in the outlines and general execution.

RECEPTION OF THE ASSYRIAN SCULPTURES

The rapid discovery of so many reliefs took the British Museum by surprise. The Museum's Greek-revival building, designed by architect Robert Smirke, was reaching completion but no one had foreseen the need of space for the Assyrian sculptures. Many of the Museum's Trustees, staff and their advisors were less than enthusiastic about the aesthetic merit of the reliefs as

they considered Greek art to be superior to all other. Nevertheless, viewed as historical documents for illuminating the world of the Bible, the Assyrian sculptures immediately went on show in temporary accommodation. Reliefs carved with narrative scenes from the throne room of the Northwest Palace as well as two slabs depicting protective spirits and a further fragment were placed in a room devoted to miscellaneous antiquities (the first room on the left on entering the front door) together with a range of sculptures including British antiquities.

The excitement generated by the discovery of the sculptures created a demand for public access to the Assyrian monuments that continued to arrive. In 1849, the Museum responded by opening the so-called 'Nimroud Room'. This was a basement space which one contemporary museum officer described as a 'dark vault where they [the sculptures] cannot be seen at all'. Entered by a temporary wooden staircase, in this small space visitors were unable to stand in front of the reliefs which were cordoned off.

Perhaps more than any other factor that caused the public to flock to view the Assyrian sculptures at the British Museum was the publication in 1849 of Layard's best-selling *Nineveh and its Remains* which ultimately went through six different editions. Although the book gives only a limited account of the Assyrian excavations, it contains a story which combines adventure, romance, discovery, the exotic, and the ability of one man to overcome adversity.

T. CRANE AND E. HOUGHTON, *London Town*, London 1883, pp. 26-7.

Above all, people's imaginations were captured by the ingenious ways in which Layard was able to ship home the massive sculptures, particularly the huge winged bulls and lions, the first of which arrived at the Museum in 1850. This was seized upon with enthusiasm by the popular press, especially the *Illustrated London News*. Indeed, the massive animals came to serve as visual emblems not only of Assyria but also the achievements of a heroic Victorian adventurer.

The arrival of yet more sculptures, coupled with the public enthusiasm for Assyria, compelled the British Museum to provide them with more appropriate, permanent accommodation. A new installation of the reliefs was created between 1852 and 1854. Two long, narrow rooms were designed from space squeezed in between the Egyptian and Greek sculpture galleries. Even though the then Keeper of Antiquities described these rooms as 'only an expedient and not a very good one', the sculptures remain today where they were first installed 150 years ago. In 1857–8 additional space was created with the construction of the 'Assyrian Basement Room' west of the Nimrud Gallery; a mezzanine floor was installed here in the 1960s to create the current arrangement of Assyrian galleries.

APPRECIATION OF THE ASSYRIAN SCULPTURES

This juxtaposition of Assyrian and other ancient civilizations in the British Museum neatly reflected the understanding among many nineteenth-century connoisseurs of antiquity that Assyrian art represented a link in a developmental sequence which led from the achievements of Egyptian art to the idealised humanism of ancient Greece and the ultimate triumph of the Parthenon sculptures. Previously, universal histories of the ancient world had relied on Persian art as the link between Egypt and early Greece but now Assyrian art came to replace it. The Assyrian sculptures were generally perceived as an art of power, grandeur and violence in contrast to Egyptian calm and Greek beauty. Critics, such as John Ruskin, found the scale and simplicity of the design, particularly of the colossal winged animals, appealing. These opinions were popularly endorsed in reactions to the so-called 'Nineveh Court' at the Sydenham Crystal Palace exhibition which opened in June 1854. Here, in one of a series of spaces dedicated to the art and architecture of various historical periods, Assyria was presented using casts of the sculptures set within a structure designed to convey an 'idea' of Assyrian architecture that included several winged bulls, their bright colours based on the few fragments of paint found on the ancient reliefs, wall paintings and glazed bricks.

Layard, who wrote the guide to the 'Nineveh Court' at Sydenham, was now a national celebrity and he resumed excavations in 1849. However, even after Layard left archaeology for good in 1851 to pursue a career as a diplomat, public interest in Assyria remained closely tied to his achievements through the books he continued to write about the subject and his adventures. Indeed, the public enthusiasm for Assyria prompted the so-called Assyrian-revival style in the decorative arts, including jewellery. Machine-made brooches, ear-rings and bracelets were manufactured largely from simple gold plaques with replicas of the reliefs

applied to them. The fashion for Assyrian-style objects also led W.T. Copeland & Sons Ltd to expand the range of their Parian Ware porcelain collectibles to include figurines of, among others, Sennacherib and Ashurbanipal. Though inspired by the reliefs they were modelled in the round in the fashion of contemporary portrait busts and marble sculptures. None the less, one commentator described them as 'faithful reproductions of Assyrian art'.

Among artists and critics, however, there was less interest in Assyrian art. Indeed, when reference was made to the sculptures, in particular the massive gate guardians, they were often evoked simply to emphasise the transience of empires such as in Dante Gabriel Rossetti's poem *The Burden of Nineveh*. Despite the fact that the discovery of the Assyrian reliefs coincided with the popularity in England and France of history painting, in which antique themes combine archaeological exactitude with scantily clad women, the sculptures rarely figure. Gustave Courbet merely capitalized on the acclaim of the Assyrian discoveries by making reference to his long pointed beard as the 'Assyrian beard' even though it bore no resemblance to those depicted in the reliefs.

Some muted attention from within the art community was, however, devoted to sculptures discovered in Assyia after Layard had left for London. Hormuzd Rassam continued to dig at Nineveh, as well as at many other sites throughout Iraq, and in 1853 he discovered the palace of Ashurbanipal (668–631 BC) including some of the famous reliefs depicting the Assyrian king hunting lions. A further series of hunting reliefs was discovered the following year by his successor, the English geologist and archaeologist William Kennet Loftus. On their arrival in London, the *Times* newspaper described the reliefs as 'the finest specimens of that art hitherto found'. Indeed, Delacroix remarked on the naturalism in the form of the

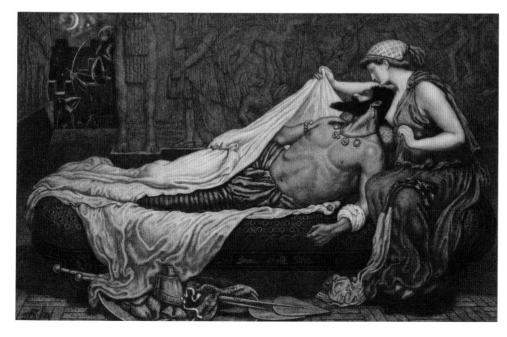

The Dream of Sardanapalus, etching by George Woolliscroft Rhead (1855–1920) after Ford Madox Brown (1821–1893). *British Museum (P&D 1916,0809.26).*

Diversion of an Assyrian King, photogravure of a painting by Frederick Arthur Bridgman (1847–1928). *Private collection.*

animals, while the notebooks of Edgar Degas and Gustave Moreau contain sketched details but these never found their way into finished paintings. Only a few contemporary painters, such as Briton Riviere and Frederick Bridgman, were inspired to produce finished works, transforming events depicted in the reliefs into realistic scenes which sometimes included references to specific Assyrian sculptures. However, more generally, when such Assyrian imagery did figure, it merely served as an authenticating element for Biblical and Oriental scenes; often pastiches that might also included Renaissance, classical and contemporary Arab elements designed to evoke an exotic and mysterious East. The inclusion of Assyrian details to persuade viewers of a scene's historical authenticity also figured in the cinema from W.D. Griffiths' *Intolerance* of 1916 to more recent 'historical' epics.

When the Assyrian sculptures were considered as art in their own right, there was a tendency to regard the separate panels as individual works. Indeed, the British Museum had wanted only one example of each kind of relief and so Layard and Rawlinson had distributed others to individuals and institutions around the world. Some sculptures were even cut down in the nineteenth century to produce, for example, 'portrait' heads. The reliefs thus became divorced from their intended role as integral elements of much larger schemes of decoration within the Assyrian palaces.

UNDERSTANDING THE ASSYRIAN SCULPTURES

The notion that realistic art was the highest form achievable began to be questioned in the new intellectual climates that emerged from the scientific and social revolutions of the

nineteenth century and ultimately the social devastations wrought by the First World War. The traditional aesthetic values of the eighteenth and nineteenth centuries have proven durable, however, and even today it is often taken for granted that a work of art is intended as a record of visual reality.

During the second half of the twentieth century, many art historians and archaeologists devoted their energies to reintegrating in print the scattered Assyrian reliefs in order to reconstruct something of the original schemes of decoration in the palaces. It has thus become possible to answer more fully questions about the meaning of the imagery and what tasks it was designed to fulfil. Attempts have begun to be made to understand how the techniques, subject matter, narrative composition, space, scale and significance of the sculptures operated within an Assyrian world view. It is now clear that levels of realism in images are culturally constructed and that there is no universal struggle by artists towards ever greater realism in their work as was previously considered to be the case. In Assyrian culture, image makers were interested in representing the essential abstract form of their subject; imitating the precise external form was not important. What was created met certain standards of correctness as understood by the Assyrian audience. When the fitness of the image for its intended task was combined with skill in production, the result produced a response in the viewer described in the Assyrian texts with such words as 'radiance', 'wonder' and 'joy'. These words were similarly used to describe the experience of the sacred. They reveal the close association between the representations and the divine world that was thought of as the source for the correct order of the universe. Thus, for example, a relief depicting the Assyrian king was intended as a portrait of kingship rather than that of a specific man who possessed distinctive physical features. As high priest of Ashur, every king was the divinely appointed custodian of Assyria and through his relationship with the gods he ensured victory and abundance.

Each Assyrian king proclaimed his success in achieving this perfect image of kingship by recording his name and accomplishments in cuneiform inscriptions. In addition, narrative scenes, represented in either paint, metalwork or carved stone, could be historically specific and revealed a particular ruler's success in imposing the just rule of the god Ashur. This divine world order was considered to be unchanging, with the result that continuity was respected and the qualities of aesthetic value and experience remained relatively fixed. Hence, although stylistic and technical innovations occurred in Assyria, the message of the reliefs remained largely consistent throughout the 250 years of their creation – the glorification of the king as the embodiment of perfect kingship achieved through the benevolence of the gods.

Some of the meaning of the carved imagery inevitably becomes easier to understand when it is possible to view sequences of the actual slabs in their original order. For this, the British Museum's collection of sculptures provides unparalleled opportunities. There is the added bonus that the encyclopaedic nature of the Museum makes it possible to investigate how Assyrian art both informed and was influenced by the art of other cultures. The unity of the

LESSER PODIUM FRIEZE of the Nereid Monument (390–380 BC) from Xanthos (modern Turkey), showing a city under attack, a motif inspired by Assyrian art. *British Museum (Sculpture 869).*

Middle East established by Assyrian military expansion and diplomatic relations resulted in vast movements of goods and peoples, leading as never before to cultural exchanges and technological and social revolutions. With the growth of the empire it became necessary to adjust the imagery of the reliefs so that, as Irene Winter has persuasively argued, the ideological messages they incorporated could also be understood by a non-Assyrian audience. Thus by the seventh century BC, specific Assyrian cultic imagery had become less evident while scenes of battle, celebration and lines of deportees were the dominant themes. In addition, the re-working of the imagery produced an almost unique development in the history of ancient art, an expansion in the detailed portrayal of historical narratives.[1] Despite these developments, the clarity of the central message of the reliefs was never lost, and its impact on the wider region, perhaps conveyed on portable objects as much as via the massive carvings, can even be recognized in the sculptures of Persia and Lycia long after the Assyrian palaces themselves had been abandoned.

THE ORIGINS OF ASSYRIAN PALACE SCULPTURES

To appreciate fully the meaning of the palace sculptures it is necessary to understand the transformation of Assyria from a small trading centre into a mighty empire. The name Assyria derives from the city of Ashur, home of a god with the same name. Situated on an escarpment overlooking the Tigris, the settlement had developed since at least the mid-third millennium BC as a cultic and tribal centre. The basis of the Assyrian economy was agriculture; wheat and barley were grown across the surrounding rolling plains while sheep and goats were pastured on the less fertile areas and rough hills. Irrigated orchards also contributed

to the agricultural production. The inhabitants of this rural world lived in small market towns and villages, their houses built from plastered sun-dried mud-brick and coarse stones.

It was the geographical position of Ashur that determined the growth of the state, at first commercially and then politically. To the north and east of Assyria lay heavily wooded mountain ranges which gave access to raw resources such as exotic stones and metals. To the southwest a progressively drier steppe reached towards the deserts of Arabia. Bounded by the mountains and desert, trade routes converged on Ashur which, by controlling a significant crossing of the Tigris, provided a passage for goods moving between southern Iraq and Iran and the West. The Assyrians, although sharing the language (Semitic Akkadian) and culture of Mesopotamia, drew upon a wide Middle Eastern heritage.

By 2000 BC trade was playing a major role in Ashur's relations with the wider world. The city's merchants had come to monopolise trading relations with states across the Anatolian plateau (modern Turkey) where small colonies of Assyrians exchanged textiles and tin for silver and gold. Although these mercantile families had considerable authority in Ashur, of central importance for the community was the Assyrian king, who held the significant role of high priest of the state god. An image of the god Ashur represents one of the earliest surviving Assyrian stone reliefs; it dates to the first half of the second millennium BC when groups speaking Amorite and Hurrian languages were expanding their authority across the plains of Syria and Iraq. The large limestone block, which was found in the god's temple at Ashur, is carved in relief with the figure of a bearded man shown frontally almost two-thirds life-size. His lower body and headdress are covered in a scale pattern, the traditional Mesopotamian method of depicting hills and mountains. Ashur is thus envisaged as embodying the very hill on which his city was built. Flanked by smaller figures representing rivers and streams, the god holds branches ending in fir cones, two of which are being eaten by goats, his sacred animal.

Around the year 1400 BC, Ashur lost its independence to the Hurrian kingdom of Mitanni centred in eastern Syria. The city now shared the types of painted pottery and faience cylinder seals, carved in a crowded busy style, found along the east – west trade routes. However, after half a century, Mitanni's power began to decline and the Assyrian king Ashur-uballit I (1363–1328 BC) took advantage of this to annex the important grain-growing regions to the north and east of the capital Ashur, which included the towns of Nineveh, Arbela and Arrapha (Kirkuk). The ideology of Assyrian kingship was transformed over the following years as Ashur-uballit and his successors led their forces west and north to acquire labourers, metals and horses, and to keep in check mobile pastoralist groups. With no natural boundaries to define the state, Assyria was increasingly driven to campaign as each conquest brought its borders to those of other potentially hostile states and peoples. This reality was translated into a religious doctrine with the Assyrian king swearing a coronation oath to extend the lands of the god Ashur. By the early thirteenth century Assyrian forces had pushed south against the border with Babylonia while, to the west, the remnants of

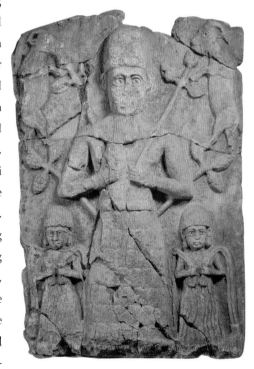

RELIEF OF THE GOD ASHUR from the site of Ashur. Height 136 cm. *Vorderasiatisches Museum, Berlin (VA Ass 1358).*

the heartland of Mitanni were absorbed.

As Assyrian power grew there emerged a new and original local artistic style. The densely packed imagery of the Mitannian cylinder seals gave way to well-balanced compositions finely cut in stones such as chalcedony. A winged griffin-demon, often grasping its prey by their hind legs, is a popular figure on these seals. There was also a revival of more traditional Mesopotamian themes such as the contest scene which was given an Assyrian flavour with a single hero or a mythological creature grasping an animal.

The Assyrian king was now interacting at a diplomatic level with the powerful Egyptian, Hittite and Babylonian rulers who all called each other 'brother' in their mutual correspondence. An international style of art had emerged, through which the owners of small luxurious objects could express their shared relationship across and between these great kingdoms. Such images included animals grazing among exotic, stylized vegetation. Assyria's entry into this exclusive family of 'brothers' came relatively late, with the result that its relationship with the international style was to some extent muted. Nevertheless, a favoured design for Assyrian cylinder seals, which reflects influence from the west, was an animal such as a goat, gazelle or deer, sedately pacing towards a tree.

During the fourteenth and thirteenth centuries BC the central tenets of Assyrian kingship began to be expressed in ever longer royal inscriptions on clay and stone objects. In an ancient Mesopotamian tradition, these texts were often incorporated into the foundations of temples and were designed to be read by the gods as well as future rulers who might discover them when restoring the building. As a declaration of their piety, Assyrian kings recorded their name, ancestry and achievements. Such texts announced their success in maintaining the order demanded by the gods and would often conclude with a command that, if the inscription were uncovered, the inscribed royal name should not be destroyed but be honoured. Over time the narrative sections of many of these inscriptions, detailing military campaigns and the collection of plunder and tribute, became longer and more complex. The developing importance of narrative within these expressions of kingship would eventually manifest itself in Assyrian visual art as it too was transformed to reflect the expansion of Assyrian power.

Not all Assyrian royal inscriptions were hidden from view. For example, a series of freestanding monuments (stelae) were erected at Ashur. Each ruler had his own stela inscribed with his name, and, perhaps every year, another was set up recording the name of a senior official. This had the practical value of creating a monumental calendar and king-list which could be consulted. Most of the surviving inscriptions on the stelae begin with the word *salam* which may be translated as 'symbol of' or 'image of'. Such monuments therefore stood for the named individual even though there was no visual imagery accompanying the inscription.[2] The same Assyrian word for 'image' is also used in their texts to describe a statue, metal engraving, relief, painting or drawing. Text and visual image thus

existed as parallel forms of representation. When the two were combined on monuments the text did not necessarily relate directly to the image but nonetheless acted to create a more complete statement of authority.

This is made apparent in one of the earliest surviving royal images from Ashur. Carved in relief on one side of a rectilinear stone pedestal is a representation of two bearded figures in profile, facing towards an altar that has the same form as the one that bears the scene. The pedestal is in fact a support for a divine symbol and is inscribed on its stepped base with a text of the Assyrian king Tukulti-Ninurta I (1244–1208 BC). The fringed robes and mace identify both men in the scene as the king, his right hand raised with pointed figure in a distinctive Assyrian gesture of prayer. We thus see Tukulti-Ninurta approaching and kneeling before the altar at the same time. A symbol on top of the altar may represent a clay tablet, and the tapering rod dividing it, a writing stylus. The accompanying inscription states that the unceasing prayers of the king, perhaps imagined as being written on the tablet, were repeated daily by Nusku, the god of light, in the presence of the gods Ashur and Enlil. The relief is thus a representation – literally a re-presentation – of the actual act of worship by the king. The scene is a continuous narrative, that is, the action takes place within the same space rather than in separate episodes as in a modern comic strip. Through this very sophisticated use of space, the artist emphasizes the unceasing nature of the king's worship as stated in the inscription – there is nothing visually to disrupt his movement.

Although the king's role as high priest remained paramount, it was the military successes of Tukulti-Ninurta I that considerably enhanced the image of Assyrian kingship. Assyrian authority was extended west into Hittite territory and, most spectacularly, south into Babylonia. The plundering of the great city of Babylon was celebrated not only in royal inscriptions but also in a lengthy poem that was copied in Assyria for centuries, underlining the scale of the achievement. The heightened historical consciousness apparent in the literary works is reflected in the contemporary visual arts. For example, the carved imagery on a fragment of a small black stone lid from the area of Tukulti-Ninurta's palace at Ashur was probably inspired by the Babylonian campaign. A sufficient amount of the lid survives to show that it was divided into two equal halves by a straight line in relief. The top half has a scene of battle in which a largely missing figure adopts a stance known from Babylonian sculptures and rock reliefs of the later third millennium BC in which a triumphant king presses his foot on a defeated enemy. On the lid, the warrior raises his sword ready to strike a naked man he grasps by the hair (the pointed blade is visible above the hole for the peg on which the lid would have pivoted). This action parallels scenes found on contemporary Assyrian cylinder seals where a hero in a tasselled skirt brandishes a weapon against an animal he grasps by the leg. Thus on the lid an Assyrian hero appropriates a Babylonian stance of royal triumph. With the exception of the hero, all the figures in the battle scene are naked, a standard Mesopotamian method of indicating that they are dead or about to

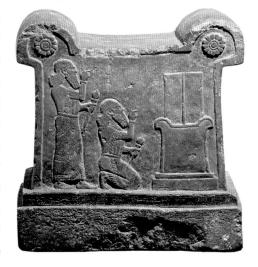

CULT PEDESTAL of Tukulti-Ninurta I (1244–1208 BC) from Ashur. Height 57.7 cm. *Vorderasiatisches Museum, Berlin (VA 8146, Ass 19869).*

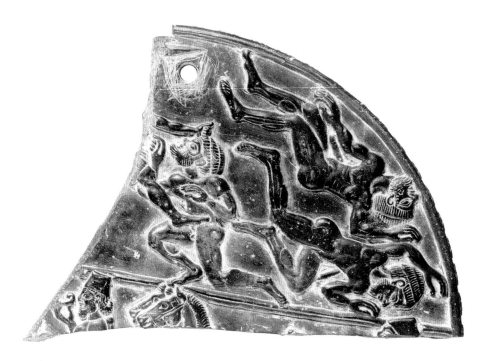

CARVED BLACK stone lid from Ashur.
Restored diameter approximately 12 cm.
Vorderasiatisches Museum, Berlin (VA 7989).

die. The men are shown almost frontally but all the heads are rendered in profile which conveys action and the involvement of the actors in a space of their own. Despite the care with which the figures have been carved, there is no indication of landscape to indicate place. This is an iconic image of a victorious king which stands outside space and time.

In the lower half of the lid, on the far right, the conical hat of a man crosses the central dividing line, suggesting a connection between the two scenes. He may have originally been shown standing in a chariot drawn by the two horses whose heads survive. Further left, a man facing left with a short beard and wearing a conical hat raises a bowl in his hand. In representations of later date, this is a ritual gesture made by the Assyrian king to celebrate his and, by association, the gods' achievements. Since the man with the bowl is shown directly beneath the warrior in the upper register, it is probable that these two figures are intended as representations of the king. Although both registers contain separate iconic images of kingship, that is conquest and celebration, there is a relationship established between them. The artist had used the circular form of the lid and the direction of the figures to create a continuous reading of the message. At the top, action moves to the right, while at the bottom peace is celebrated by a return to the left and a simple narrative is achieved.

The style of the carvings on the pedestal and lid was possibly inspired by wall paintings, the usual form of decoration within royal buildings; the two-dimensional approaches of the paintings were basically transferred to stone. Examples of such paintings have been found at the site of Kar-Tukulti Ninurta, a royal city established by Tukulti-Ninurta I across the river from Ashur. Here the walls were painted with stylized palm trees, sometimes flanked by animals such as goats, chains of palmettes and rosettes, and bird-headed griffin men. There was an interest in the clarity of the design where symmetry is an important element. Similar balanced compositions are found in cylinder seal designs of the same period.

Combative themes are developed with scenes of fights between animals, often protecting their young against lions or griffins in a triangular arrangement. The horse and the fallow deer are frequently represented as well as winged bulls and horses.

Images of conflict between animals and between humans perhaps reflect the militancy of the period. By the middle of the twelfth century BC the political and social structure of the eastern Mediterranean world had began to unravel with the collapse of the Hittite and Egyptian empires. In addition, climatic changes pushed populations of Syria into more nomadic lifestyles which disrupted communications. The result was that under Tiglath-pileser I (1114–1076 BC), Assyria struggled to maintain its authority in the west. Around 1100 BC, however, the king undertook a triumphal march through Syria to the Mediterranean and received gifts and tribute en route. It is possible that Tiglath-pileser was influenced by the decorative traditions he encountered, since he records that a new building he had constructed at Ashur was embellished with limestone and basalt slabs just as is known much earlier at Syrian sites such as Ebla. In addition, one of his palaces at Ashur had its lower courses covered in slabs of alabaster. There is no indication that these stone panels were carved. However, the king informs us in his royal inscriptions that at the gates of a second palace he had erected guardian figures of basalt, such as were regularly used in western Syria. By the time of his son Ashur-bel-kala (1073–1056 BC), additional gate guardians had been added so that the palace was eventually protected by two *nahiru*, an animal identified as coming from the Mediterranean, and six *burhish* (two of which were of limestone) from Iran or Anatolia; the sculpted animals were intended to reflect the extent of Assyria's influence from west to east. In addition there were four lions of basalt and two alabaster *lamassus* (probably human-headed winged bulls).

Although Tiglath-pileser undertook extensive building projects at Ashur, the city was increasingly occupying a marginal position as Assyria had expanded northwards. The result was that the ancient site of Nineveh became more important. Here the king had a palace decorated with glazed bricks, some of which represented palms, perhaps symbolizing divine abundance. Of particular significance, however, was the wall decoration utilized by Tiglath-pileser in a second palace at Nineveh. According to the written annals of his achievements he, 'portrayed therein the victory and might which the gods… had granted me'. These images have not survived but presumably represented scenes of battle, perhaps as narrative, in either sculpture, or glazed bricks, or paint. The inclusion of references to these depictions in the royal inscriptions indicates the significant role that visual imagery now played in Assyrian royal ideology. Indeed, there is good evidence for the production of Assyrian monumental stone carvings in an image of Tiglath-pileser sculpted in low relief on a cliff face in eastern Turkey at what was considered to be a source of the River Tigris. The king is represented in profile, standing with his hand raised in prayer.

Public images of the ruler were also presented on free-standing stone monuments such as stelae and obelisks. Ashur-bel-kala is depicted on the so-called Broken Obelisk from

PINK CHALCEDONY cylinder seal, about 1300–1200 BC, and modern impression (below). Height 4.1 cm. *British Museum (ME 129572).*

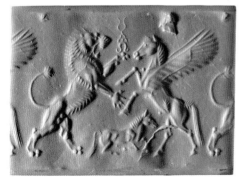

Nineveh, facing two pairs of tributaries or bound prisoners with the symbols of the gods above them. The king is shown considerably larger than the other figures, indicating his importance. His face is placed in line with the divine symbols, one of which, that of the sun god Shamash, hands the king a bow to indicate the source of his victory.

Of slightly later date, perhaps from the reign of Ashurnasirpal I (1049–1031 BC), is the so-called White Obelisk from Nineveh. The limestone pillar is carved in low relief with eight horizontal registers. The carvings show military campaigns, the bringing of tribute, victory banquets, religious and hunting scenes; they are therefore among the earliest representations of what would become the main themes of the Assyrian palace sculptures. The organization of the images is, however, unexpected. There is an expansion in the length of individual scenes within each register moving from a single image on each of the four sides at the top and bottom of the monument towards the two middle registers, where single scenes wrap around the entire pillar. In fact, the top and bottom halves of the monument are essentially mirror reflections of each other in both structure and subject matter. This has led Holly Pittman to make the inspired suggestion that the carvings on the obelisk are a reduced copy of imagery, perhaps wall paintings, which originally lined the long walls of a rectilinear throne room. In her reconstruction, the paintings decorated opposing walls: at one end of the room there were scenes of siege directly across from scenes of the hunt moving in the opposite direction. Further along the room there were opposing images on the walls of ceremony and celebration and, finally, longer scenes of tribute-bearers. Thus the sculptor of the White Obelisk copied the imagery from the length of one wall and, dividing the themes of the paintings into four registers, carved them from the top to the middle of the obelisk. Then, taking the images from the second wall but starting with the longer tribute scene, the registers were carved from the middle to the bottom of the obelisk.

An alternative reconstruction could have the hypothetical wall paintings arranged in two parallel registers along one wall of the throne room. The sculptor simply divided them between the upper and lower halves of the obelisk, carving the first images of the upper register at the top of the obelisk and the first images of the lower register at the bottom, winding each towards the middle. The source of the obelisk's imagery in this arrangement would thereby find a close parallel in the earliest surviving stone wall reliefs – those from the throne room of the ninth-century Northwest Palace at Nimrud discussed below – where both siege and hunts move in the same direction.

CREATING AND DISPLAYING THE RELIEFS

The design and construction of the enormous Assyrian royal palaces during the ninth to seventh centuries BC inevitably involved many specialists. The most important people responsible for the decorative scheme were likely to have been the scribal scholars who were experts in magic, religion and the ideology of kingship. Only they would have been able to

determine the correct form and location of the images so that the protective spirits and the cultic messages could be effective. Similarly, the scribes who composed and edited the royal inscriptions would have probably devised the narrative messages of the painted or carved images; the visual tradition was probably transmitted and preserved in the way that texts were transmitted and preserved within scribal schools. It comes as no surprise, therefore, that the Assyrian artists were heavily influenced by traditional forms of representation in stone-working, wall painting and metal and ivory engraving. It is likely that the king's approval was sought for at least the most important aspects of the design. This is reflected in contemporary documents, such as a seventh-century BC cuneiform letter from Nineveh in which a scholar-priest informs the king that he has sketched a royal image and sent it to him for his comments.

Statements of kingship as well as the content of narratives were carefully crafted and information selected to highlight the central message; in scenes of battles, for example, only enemy soldiers are killed or injured. The carved figures were formed from basic lines to achieve clarity. Humans are usually shown with a twisted perspective so that the body appears almost frontally but the heads are rendered in profile; no individual in the reliefs ever looks out at the viewer, they exist in a self-contained world in which the action unfolds. The power structure of the Assyrian world is clearly defined, with the most important individuals empowered by the clothing and equipment that marks their office. It is an almost entirely male world of war and sport in which women appear only as prisoners or to celebrate the king's achievements. The Assyrian king himself can always be easily recognized because he wears the royal crown, a conical headdress with a small cone on top and a diadem with long streamers at the back.

The agreed design would have determined to some extent the size of the stone slabs to be carved. The stone used for the sculptures, with a few limestone exceptions, is gypsum, the finest grained examples of which can be termed alabaster (in Iraq it is sometimes called Mosul Marble). Blocks were quarried from outcrops in the Assyrian countryside on both sides of the River Tigris. Some details of the quarrying of the stone can be learnt from a series of magnificent reliefs from the palace of King Sennacherib (704–681 BC) at Nineveh. The hard work was largely undertaken by prisoners of war. Metal picks were used to extract the stone and it was then cut into blocks with long iron saws. For larger sculptures, like the gateway figures, the shape was roughed out in the quarries to reduce weight. The slabs were then dragged using levers and rollers through the countryside to the city. If the quarries were on the other side of the river, the stone was loaded onto rafts and floated across; the heaviest pieces would have to wait for the spring floods. The slabs destined for panelling the walls averaged between two and three metres high and thirty centimetres thick. Individual slabs can weigh several tons, with the blocks for the largest gateway figures at Nineveh weighing as much as forty tons.

Often scribes would incise or paint royal titles in cuneiform on one side of a wall slab

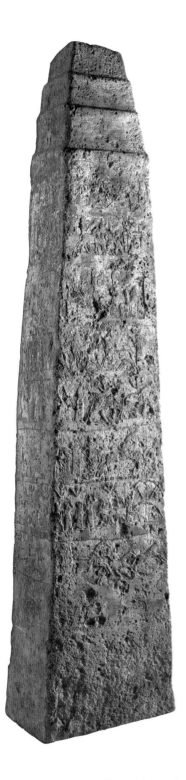

WHITE OBELISK from Nineveh. Height 284.5 cm. *British Museum (ME 118807).*

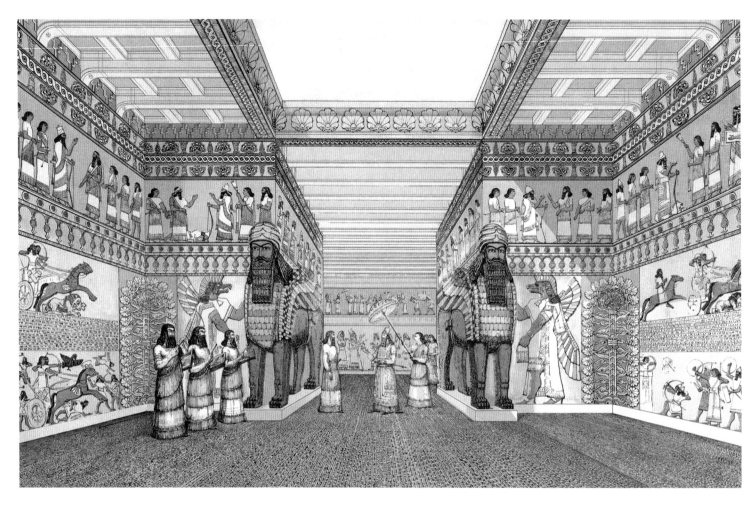

RECONSTRUCTION OF the interior of an Assyrian palace. A.H. Layard, *The Monuments of Nineveh*, London 1849, plate 2.

which was then chiselled by a stoneworker. This side of the panel was destined to be set against the mud brick wall of a room; the invisible inscription was intended for the gods and posterity. The design of the relief was then drawn onto the other side. The gypsum, a very soft stone, was incised easily with a metal point, in the same way that the scribes drew images with a sharpened stick on clay tablets. This may have been undertaken in workshops where the slabs were laid out in rows, which would have been especially useful where the designs crossed successive panels. Some of the heavy work of removing the background may have also been accomplished here although it is possible that the majority of work was done once the slabs had been set into place against the walls. Indeed, there is generally consistency of design within rooms and differences between them suggest the allocation of rooms to certain individual draftsmen and teams of sculptors.

The panels were arranged along the mud brick walls of the palaces, sunk a few centimetres into the ground onto a bed of bitumen which allowed fine adjustments to be made in positioning them alongside other slabs. They thus formed immensely expensive stone dados. Metal dowels and clamps held the panels together and they were probably bracketed to the

wall. The major carving was undertaken with metal points, used to chip away large areas of the surface, and metal chisels for smoothing. It would have been hard work and the tools would have needed constant sharpening. Points were again used for the fine incised details and it is possible that abrasives such as sand were used for the final finish.

The Assyrian sculptors cut the stone away around figures only enough to produce sufficient shadows to reveal their outlines. Clearly, a crucial factor in the visibility of the reliefs was the amount of light entering the different spaces in which they were displayed. In the courtyards, sunlight would have produced sharper shadows than in the interior rooms which were illuminated only by the light from open gateways, torches and braziers and perhaps clerestory windows. The fact that, when freshly cut, the alabaster ranges from white to grey in colour means that, even in the most dimly lit of rooms, it would have reflected some light. The white/grey surface also provided a canvas, just like the plastered wall above the reliefs, for the application of paint. Although little paint survives today, some figures may have been completely coloured or, possibly more generally, paint was used for special effect. Four principal colours were used: red, blue, black, and white (some traces of green, yellow and violet survive, but these may be decayed blues and reds). They represent the same palette as used in Assyrian wall-paintings; glazed bricks and fragments of paintings suggest the ground may have also been occasionally coloured though no traces of background paint have been preserved on the reliefs. Mineralization of paint or varnish may have contributed to the brownish surface colour of many of the reliefs today although this was largely the result of their exposure to the elements and contact with the mud brick of collapsing walls which buried them following the abandonment of the palaces.

In their heyday, however, the palaces would have been magnificent statements of the king's power and achievements colourfully emblazoned on the walls in stone, plaster and perhaps as textile hangings, as well as in metal overlay and ivory carving on objects and furniture. The clarity of the visual message was such that it was possible for any viewer to understand it without being able to read the inscriptions that accompanied the scenes; this was important in a largely non-literate society. However, the writing on the walls not only reinforced and enriched the messages of kingship displayed in the imagery, naming the man responsible for them, it also reflected the king's control of the scribal bureaucracy that helped order his realm. Ultimately, however, the message of both text and image, as stated unambiguously in the royal inscriptions, was intended for the gods, and to astonish kings, governors, and the people of Assyria.

1. A similar imperial situation in Egypt under Seti I (1294–1279 BC) and Ramesses II (1279–1213 BC) produced a short-lived experiment with historical narrative on royal monuments. Following the fall of Assyria, historical narrative would re-emerge during the Roman empire, for example, on Trajan's Column.

2. There is one seventh-century BC stele with a representation of a queen.

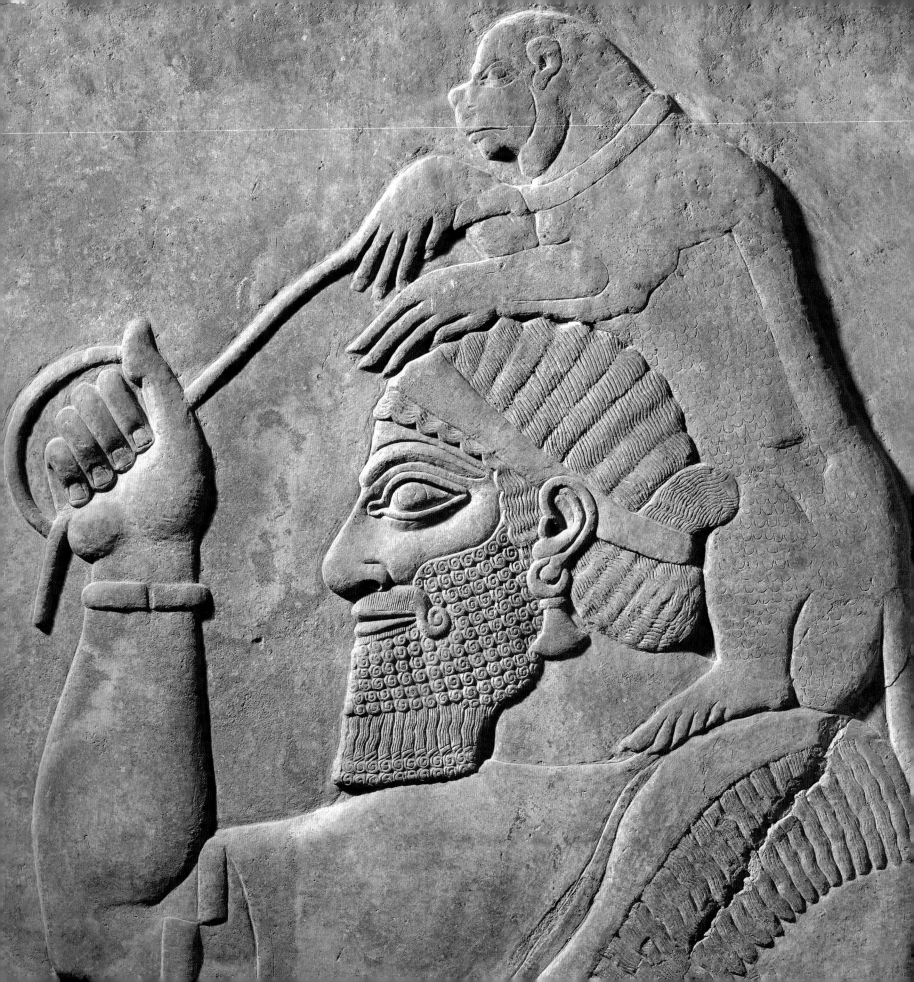

THE ART OF ASHURNASIRPAL II

THE FIRST ASSYRIAN KING TO USE RELIEF DECORATION EXTENSIVELY WAS ASHURNASIRPAL II (883–859 BC). When he ascended the throne of Assyria the kingdom was already established as the dominant power in northern Iraq and eastern Syria. The king probably resided at Nineveh, but in 879 BC he selected the site of Kalhu (modern Nimrud), an ancient settlement beside the river Tigris, to become his royal centre. Subject rulers, especially in the mountains to the north and east of Assyria, were required to supply him with workers and materials, and vast numbers of people were drafted in to undertake the building work. City walls were constructed enclosing an area of some 360 hectares and a canal was built to water orchards and gardens planted with exotic trees and plants gathered from distant regions and symbolizing the extent of the king's realm. The most impressive buildings were erected on the old settlement mound which was cleared for the construction of temples and Ashurnasirpal's principal residence, known today as the Northwest Palace. It was an enormous building, more than 200 metres long and 118 metres wide with state apartments, offices and private apartments organized around separate courtyards.

The reliefs on the façade of the throne room showed lines of tributaries, carrying exotic objects and animals, approaching an image of the king and converging on one of the gateways which gave access to the throne room itself. As with all of the wall sculptures from the Northwest Palace, the figures are carved in shallow relief and shown in profile against an undecorated background. The sculptures are linear in style although the contours of flesh and musculature are carefully observed, emphasizing the perfection and strength of the king and the gods. This two-dimensional approach was carried onto

MONKEYS WERE traditional royal gifts sent to the Assyrian king from western states. Traces of black paint were visible on the man's face at the time of excavation and may suggest that this is an Assyrian depiction of an Egyptian.

the huge *lamassu* gate-guardians. These creatures, sculpted nearly in the round with either the body of a lion (which is tethered by a rope around its torso) or that of a bull, have five legs because they were designed to be seen from two angles. From the front, the legs stand firm and unmoving. Viewed from the side, however, the creatures are shown walking on four legs, active to attack any evil forces.

Carved across the slabs and between the legs of the *lamassus* is a cuneiform text known today as the Standard Inscription because it is repeated on nearly every stone panel in the Northwest Palace. It names Ashurnasirpal II, including his titles and those of his royal ancestors, his role as the priest and ruler chosen by the gods, his successful military campaigns, and the building work in Nimrud. The inscription was often carved last, obliterating some of the finer incised details of the reliefs. Repetition of text and image was an important element of the decoration of all the rooms at Nimrud; it was as if a giant cylinder seal had been rolled across the walls, sealing the room to ensure its ritual purity and surrounding and enclosing the viewer with the central message that Ashurnasirpal II was the perfect king chosen and blessed by the gods.

In the huge throne room (some 45.5 metres long, 10.5 metres wide, and perhaps originally 6 to 8 metres high), the wall at the eastern end, behind the throne dais, was decorated with a large carved slab depicting religious imagery of spirits and the king flanking a god in a winged disc above a Sacred Tree, a protective symbol of divinely bestowed abundance. This balanced composition was intended to show the stability achieved through the proper exercise of kingship; it does not lead the eye elsewhere as in the narrative reliefs found on other walls in the throne room.

The stone panels that decorated the southern long wall of the throne room had two bands of carved images, each just over one metre high, separated by a somewhat narrower band carrying the Standard Inscription. Closest to the throne were iconic images of kingship. Each of three adjoining panels was treated as a separate canvas with an action scene in the top register: the king hunting bulls, the king hunting lions, and the king leading an attack on a walled city. In the lower register of each panel was a 'culminating' scene related to the one above, each a ritual celebration in which the king is shown in turn with dead bulls, dead lions, and a line of prisoners with booty placed above them as a visual parallel to the written lists of captured goods. Only the essential elements of the scenes are included with little concern about relative scales and perspective; background scenes are simply placed above foreground scenes and the size of figures is often dependent on their importance. Figures stand on the ground line with spatial depth indicated by overlapping. The king is shown the same size or only marginally larger and is distinguished by his dress.

Further along the wall, beyond more religious imagery paralleling that found behind

the throne, the reliefs were once again organized into two registers separated by the Standard Inscription. The length of the wall was divided into three compositions, each of which was carved across a number of panels with the top and bottom registers thematically related. They present a carefully designed, visually complex world, rich in details. In the upper register, Assyrian battle chariots, with the king accompanied by a god in a winged disk, overrun enemy troops, while in the lower register the Assyrian army crosses a river, probably the Euphrates, as part of a single (perhaps historically specific) campaign; the swirls of the water parallel the wheels of the chariots above. The action moves to the right, that is, to the West as in many of the king's actual military expeditions. In the next composition, however, the direction of movement is reversed, with the king's triumphal return towards a camp and celebrations outside the royal pavilion; in the lower register the victorious king receives captives. The final imagery in both registers depicts a city under siege. The arrangement of the scenes is thus in the form of a disrupted narrative where events don't occur in a linear sequence, such as is also known, for example, on some painted Greek vases or on the Bayeux Tapestry. The calm and order established by the king on behalf of the gods is placed at the centre of the scheme rather than at the end.

More than half the decoration of the entire Northwest Palace as known was religious and apotropaic. The eastern rooms of the palace appear to have been devoted to ritual use and the wall slabs of these rooms were covered with carvings of magical images. Winged humans wearing horned helmets indicating their divinity or with the heads of birds of prey are so-called *apkallu* protective spirits. Many hold buckets which were thought to contain holy water, used to sprinkle and purify the king and the Sacred Tree using symbolic fir cones. In such scenes the Assyrian king often plays an active part holding the weapons with which he maintains divine order or raising a ceremonial bowl. Very fine incised designs, depicting a largely mythological world, cover or edge the costume of the king, his courtiers and the protective spirits.

It is perhaps surprising that, despite the expense and effort involved in embellishing the Northwest Palace with the stone reliefs, Ashurnasirpal does not refer to them explicitly in his building inscriptions. He does say, however, that he decorated the palace 'in a splendid fashion' and that he 'depicted in greenish glaze on their walls my heroic praises, in that I had gone right across highlands, lands, (and) seas, (and) the conquest of all lands.' When the palace was inaugurated, the king invited some 69,574 people to a celebratory banquet where for ten days they were given food and drink, bathed, and anointed. It is possible that many of Ashurnasirpal's guests stood in wonder before the huge carvings and reflected not only on the king's obvious power and wealth but also on his benevolence, just like that of the gods.

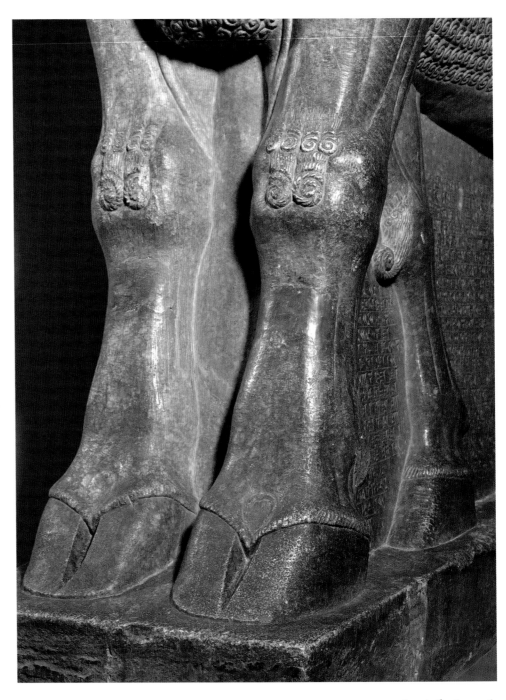

VIEWED FROM THE front, the legs of
a colossal bull-*lamassu* stand firm against
any threat. *above*

THE EYES OF A human-headed
winged bull appraise all those approaching
the palace gate he guards. *right*

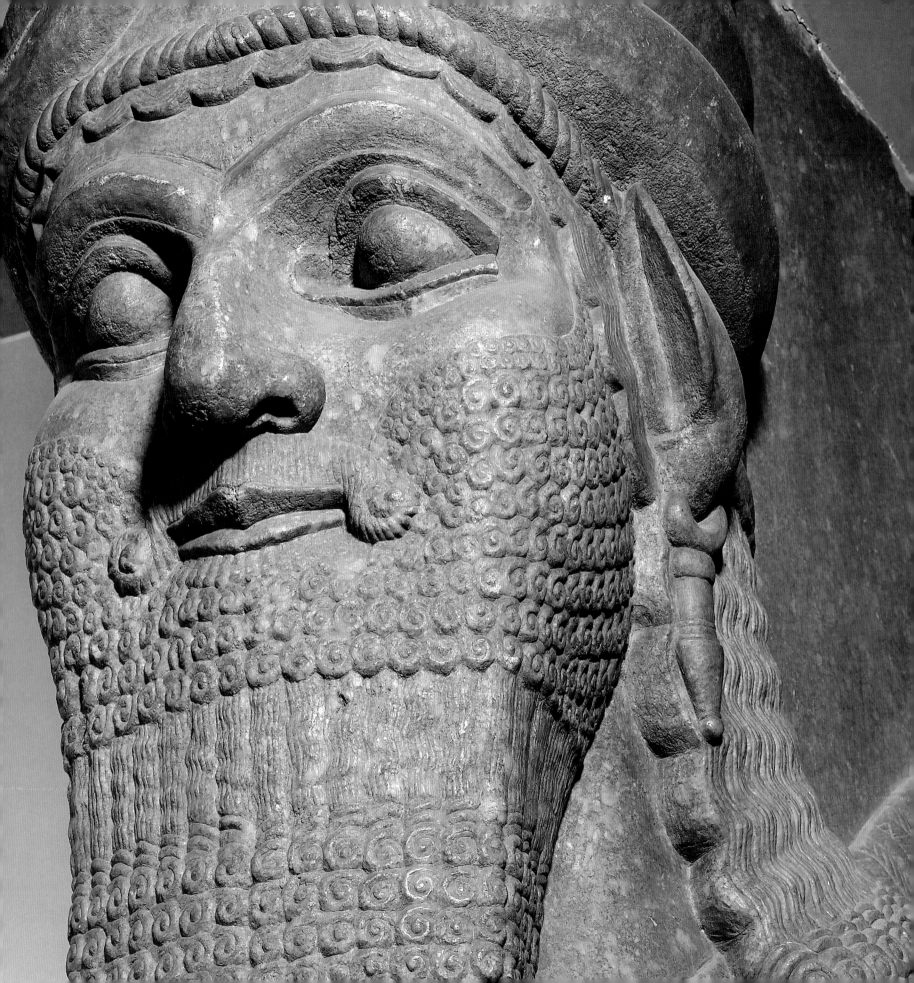

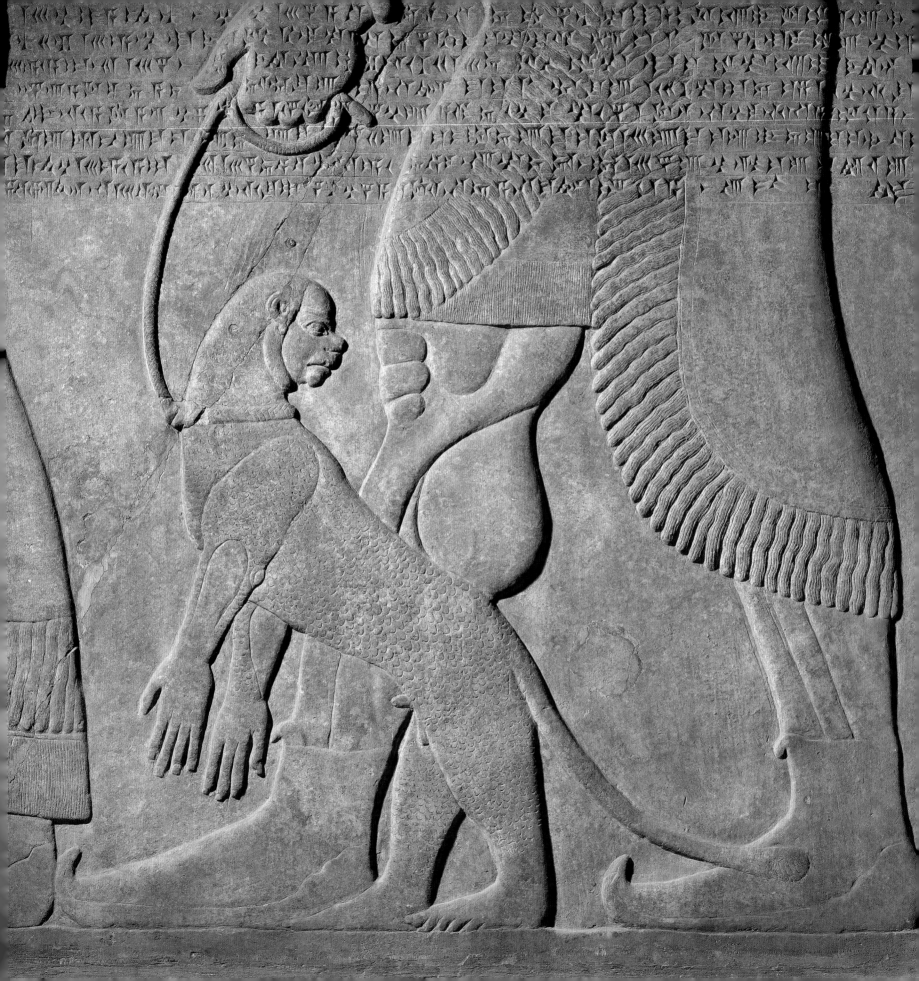

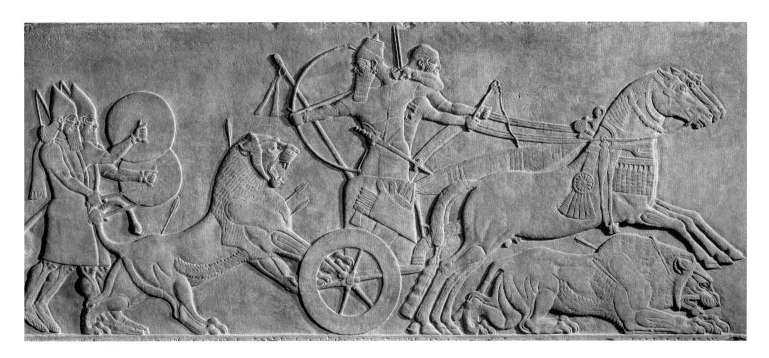

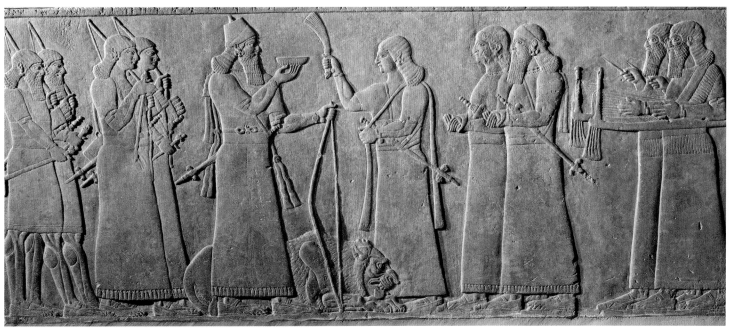

THE FAÇADE OF the throne room
was decorated with lines of tribute-bearers
wearing distinctive foreign clothing and
bringing exotic gifts. *left*
PLACED CLOSE TO the royal throne
were visual statements of power which
included the king hunting wild lions and
celebrating his divinely granted success.
The so-called Standard Inscription naming
Ashurnasirpal II once linked these
two images but it was cut away in the
nineteenth century. *top and above*
THE SCALE OF the king overwhelms
the enemy who are small and helpless
when faced by his weapons, which
include a siege tower with battering ram.
following pages

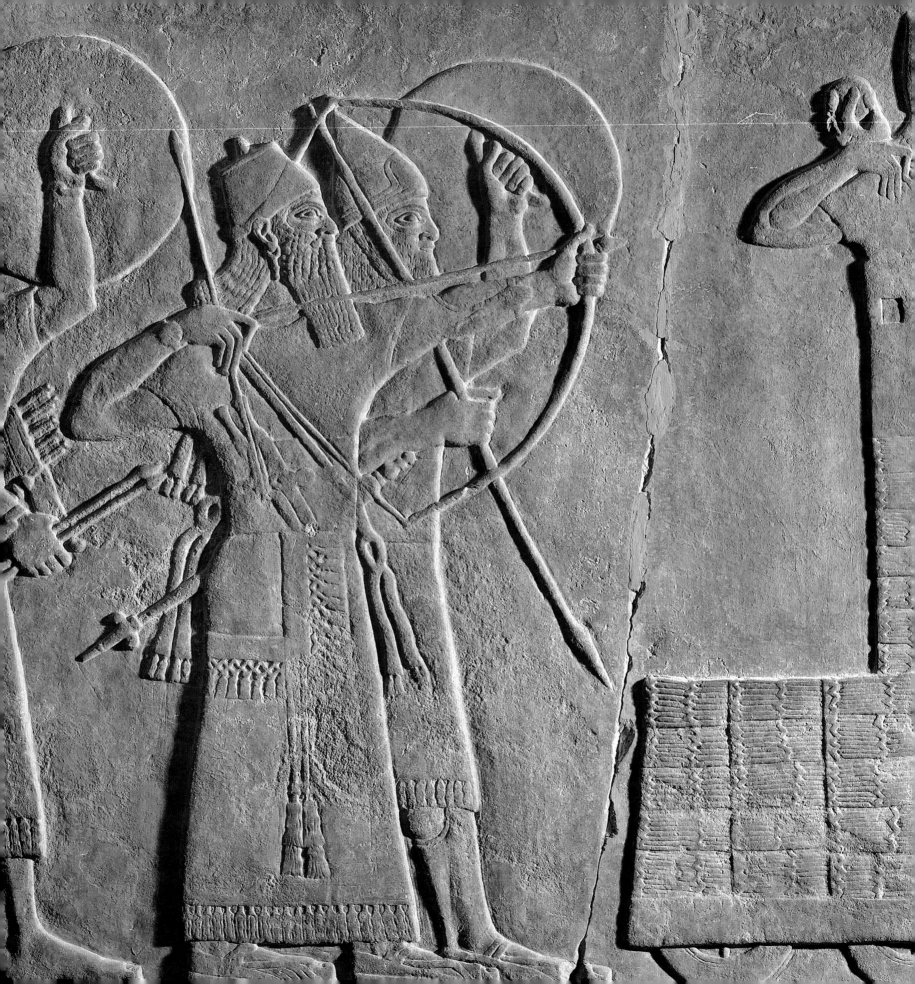

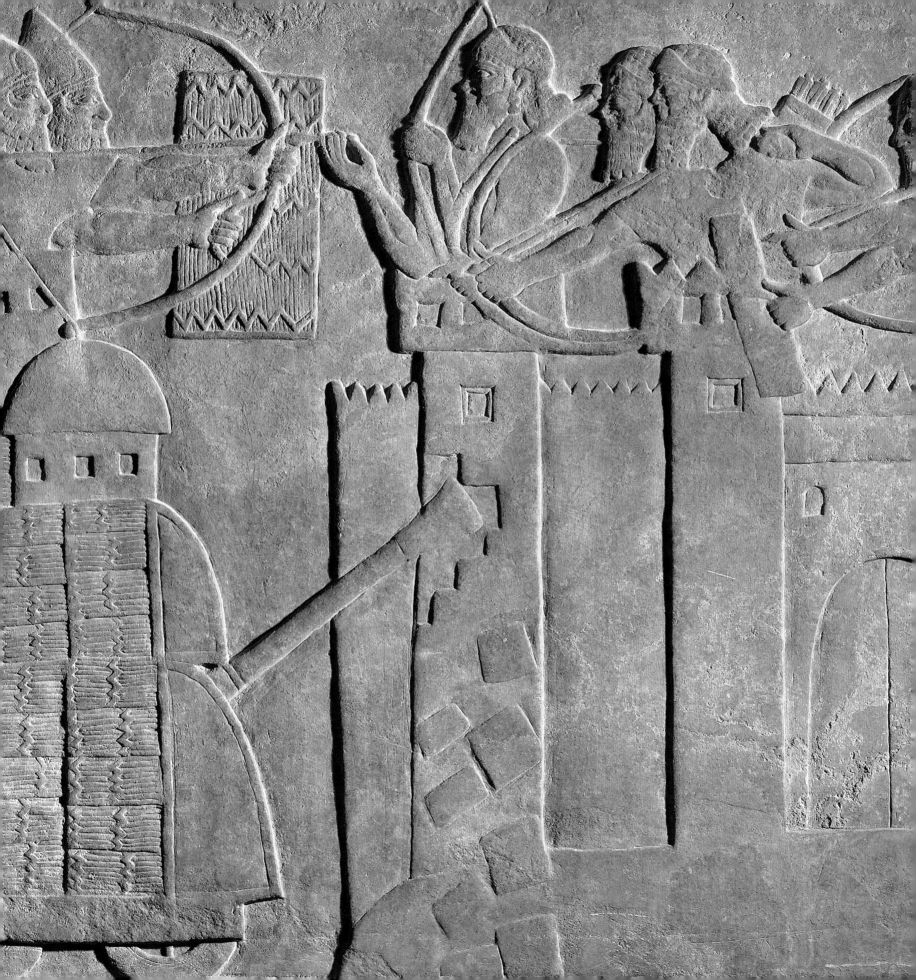

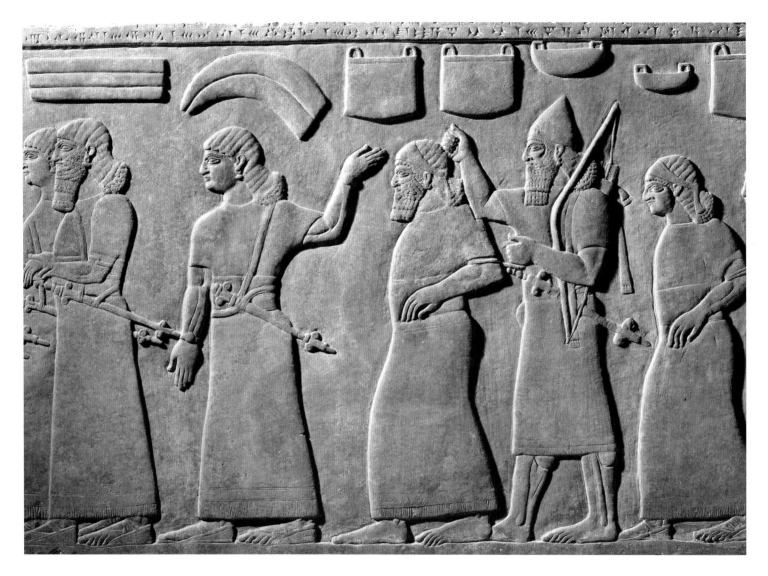

BOUND CAPTIVES are paraded in triumph. The booty from the successful campaign, which includes elephant tusks and metal vessels, is listed visually above the prisoners' heads. *above*

ASSYRIAN CHARIOTS thunder across a battlefield which is strewn with the bodies of enemies. The horses of the king's chariot are in the foreground, alongside a chariot supporting the divine standard of the storm god Adad. *right*

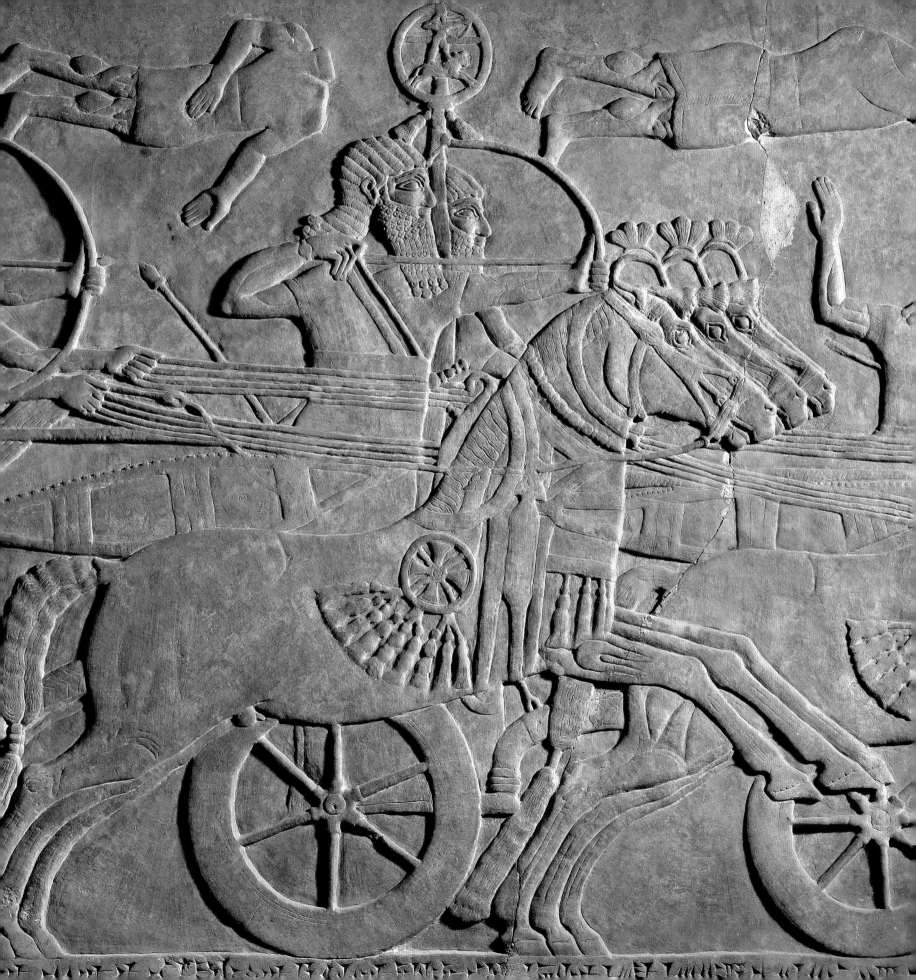

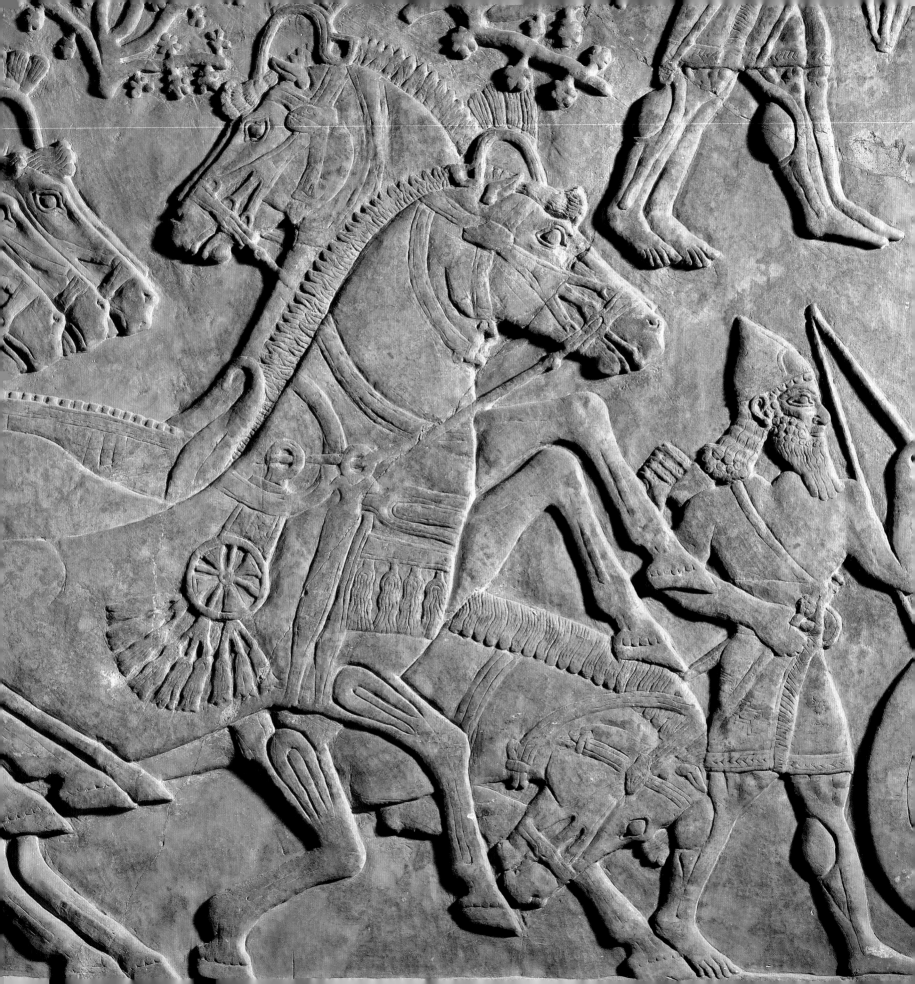

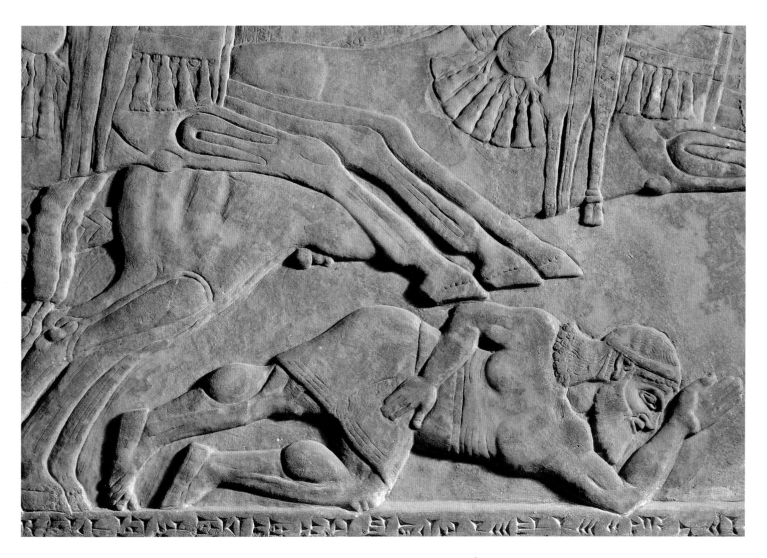

THE HORSES OF ENEMY chariots tumble in a choreography of confusion at the advance of the Assyrians. *left*

AN ENEMY SOLDIER falls beneath horses' hooves. He occupies a similar position to that of a dead lion in one of Ashurnasirpal's hunting reliefs. *above*

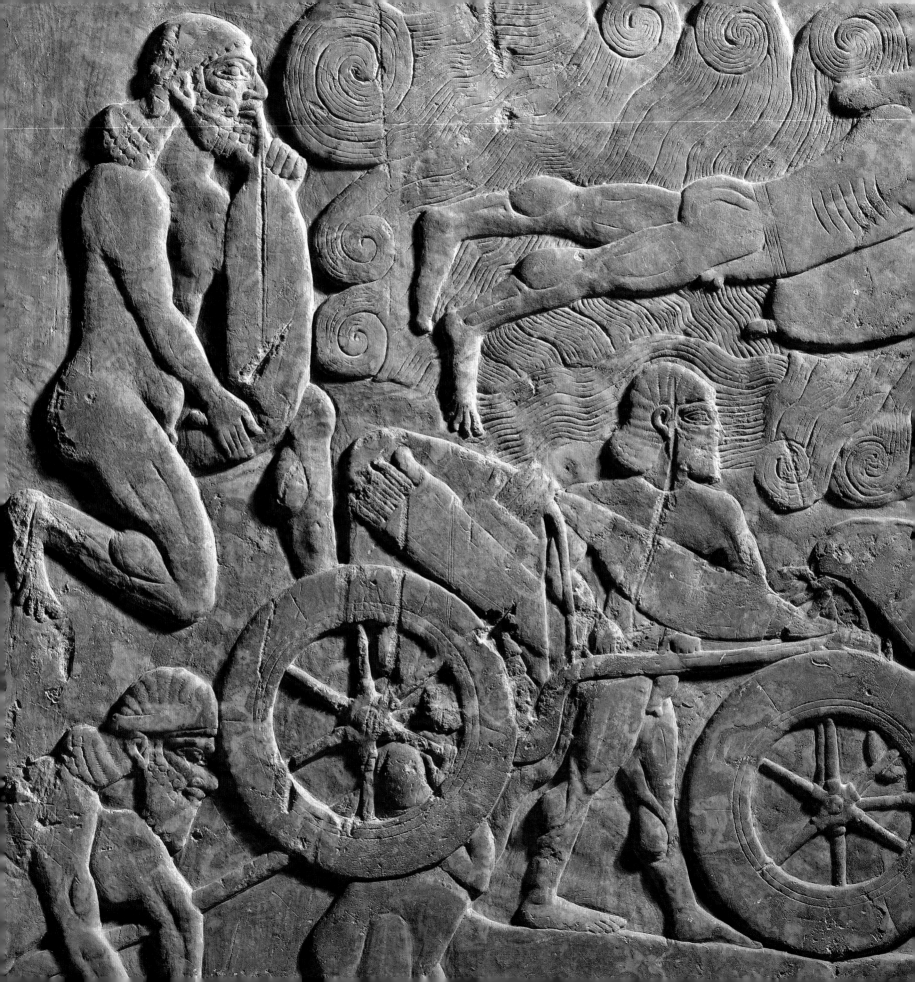

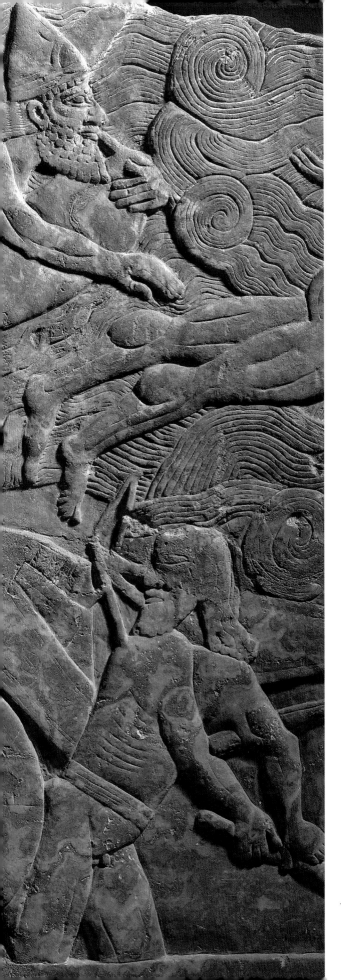

THE SWIRLING WATERS of a wide
river, probably the Euphrates, present no
obstacle for Assyrian infantry, who inflate
animal skins as buoyancy aids at the same
time as chariots are ferried in boats. *left*
SOLDIERS, HORSES AND fish swim
through the fast-flowing waters. They
are shown as if floating above the river,
so as not to obscure their true form.

following pages

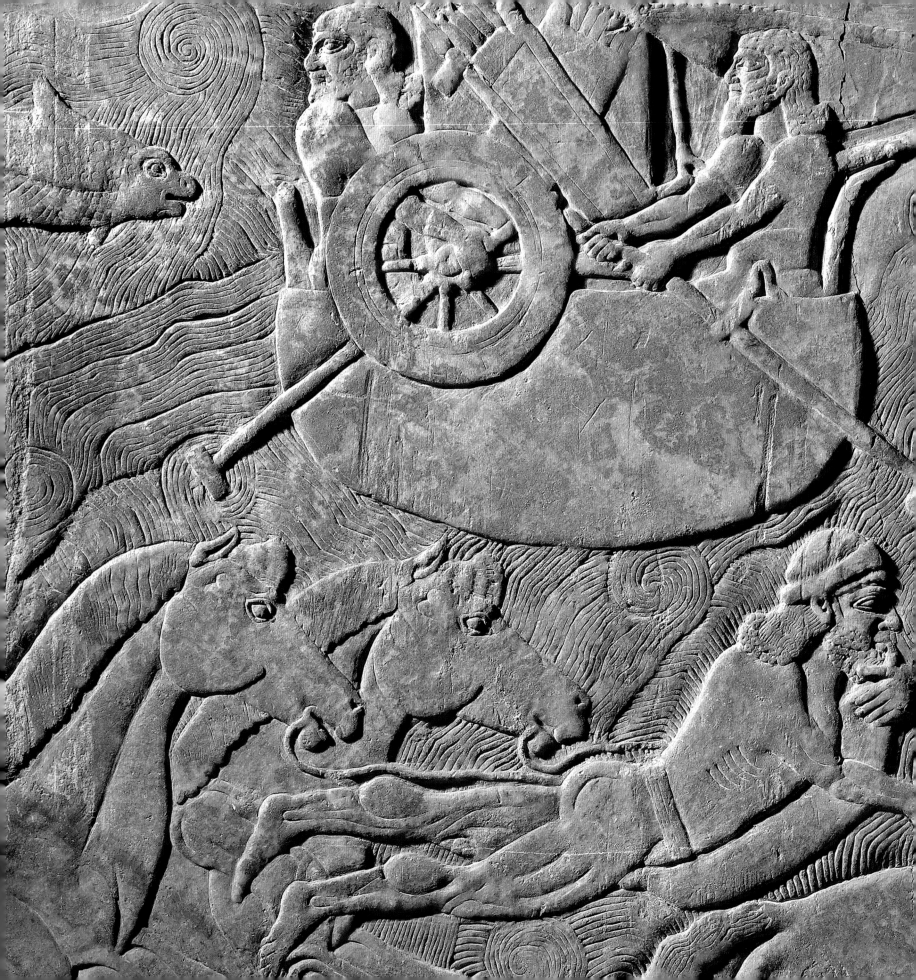

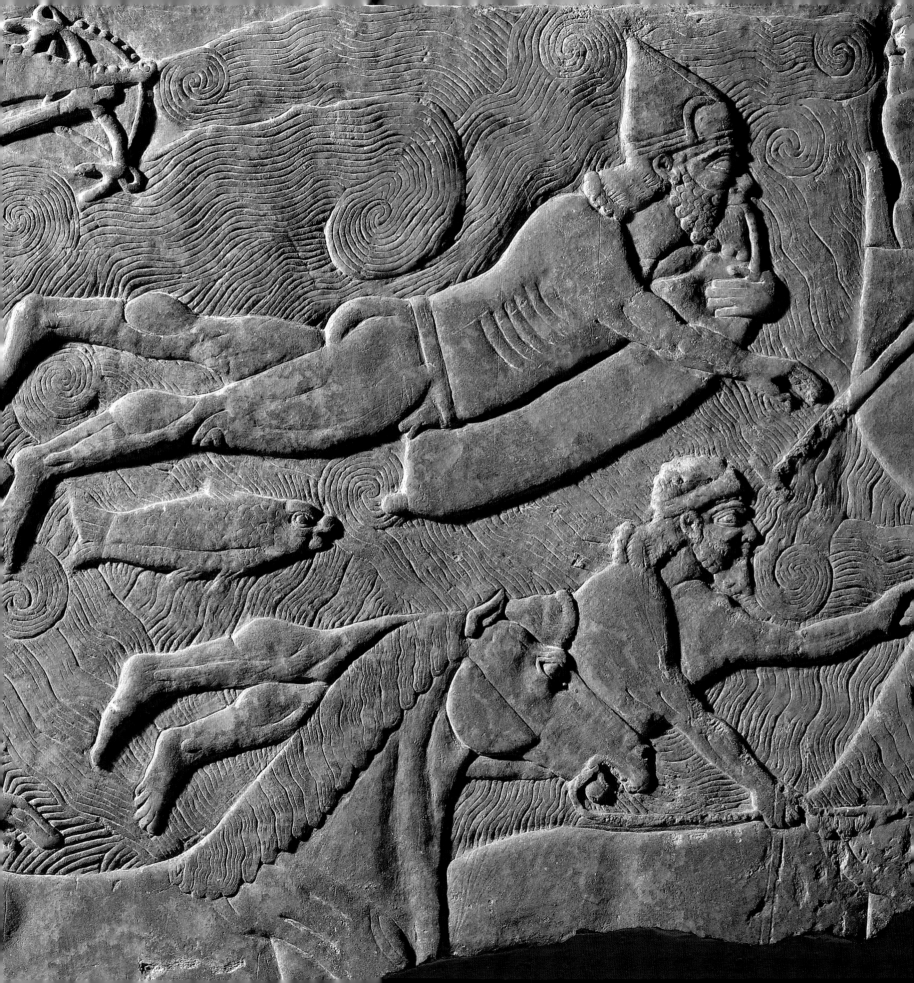

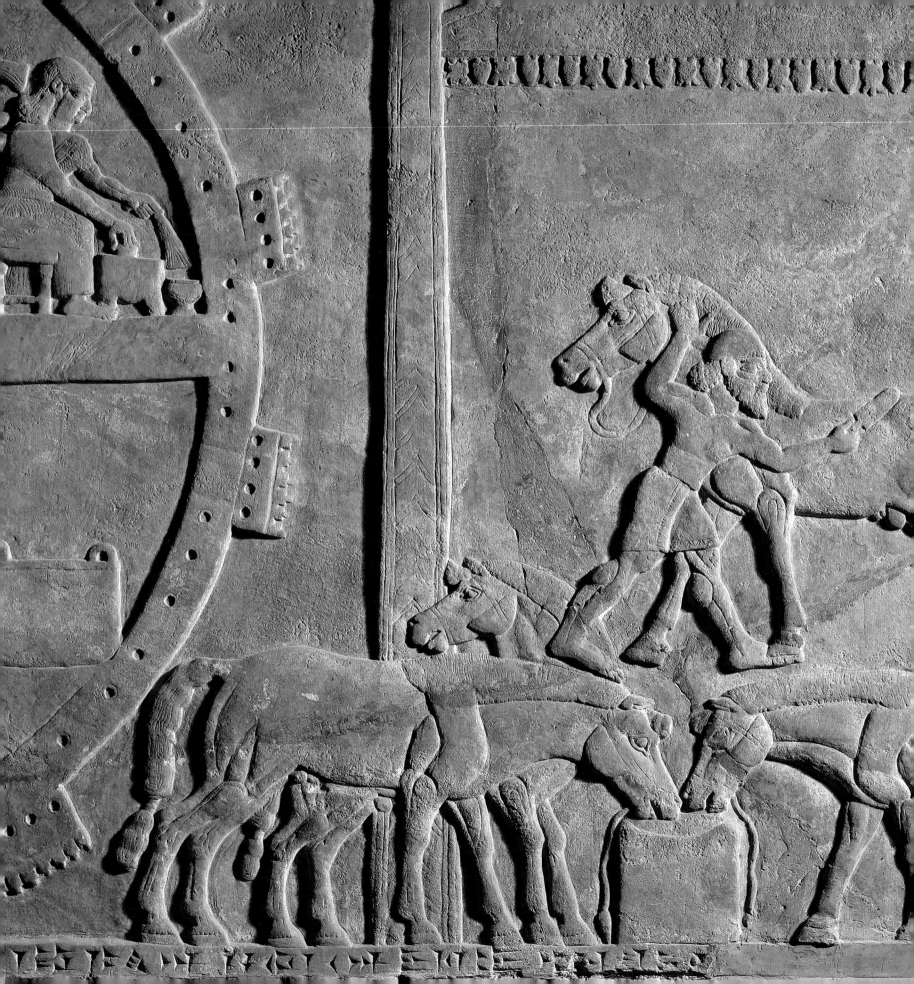

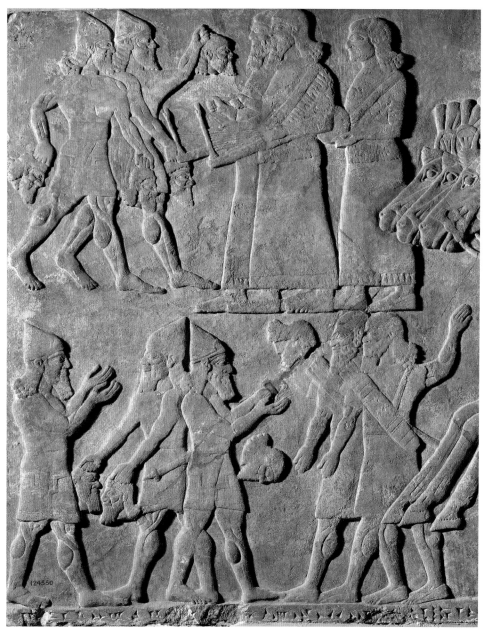

IN THE AFTERMATH of battle, calm
permeates an Assyrian camp where
horses are watered and groomed. *left*

MUSICIANS ENTERTAIN soldiers as
they play catch with the severed heads of
enemies. Such images were intended to
produce cheers of satisfaction at the demise
of the villains of the narrative. *above*

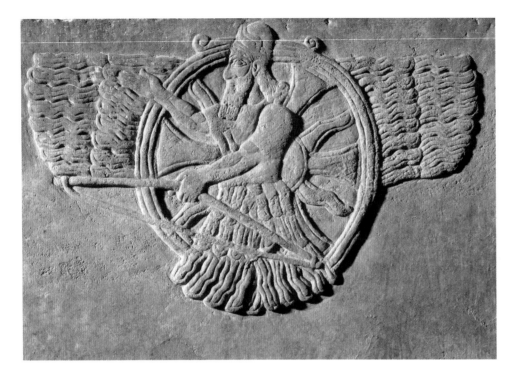

WITH THE ORDER of the universe restored, the god accompanying the Assyrian king lowers his bow. *above*

THE WOMEN OF rebel lands are not mistreated but acknowledge their submission by wailing and tearing their hair. *right*

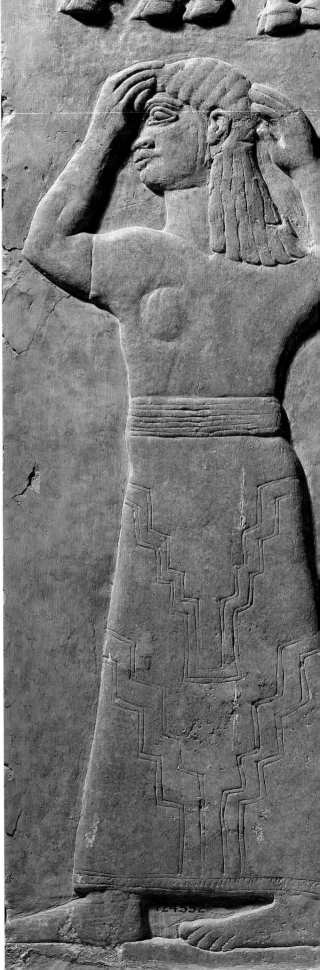

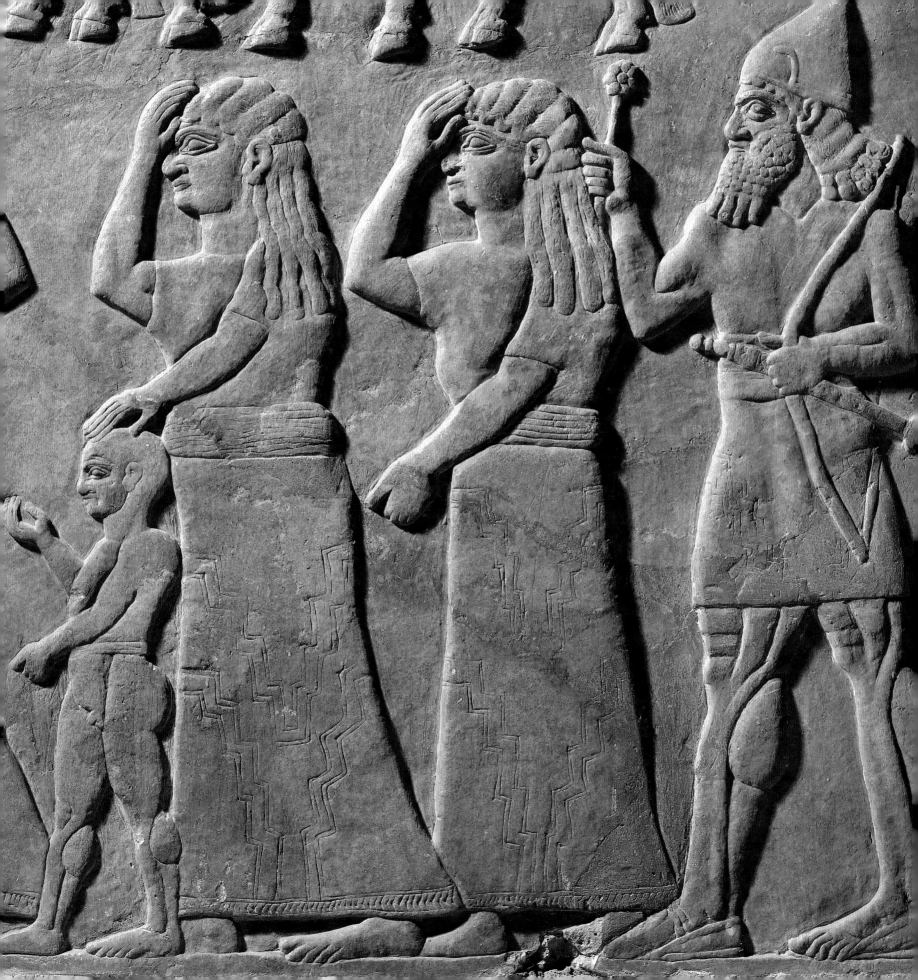

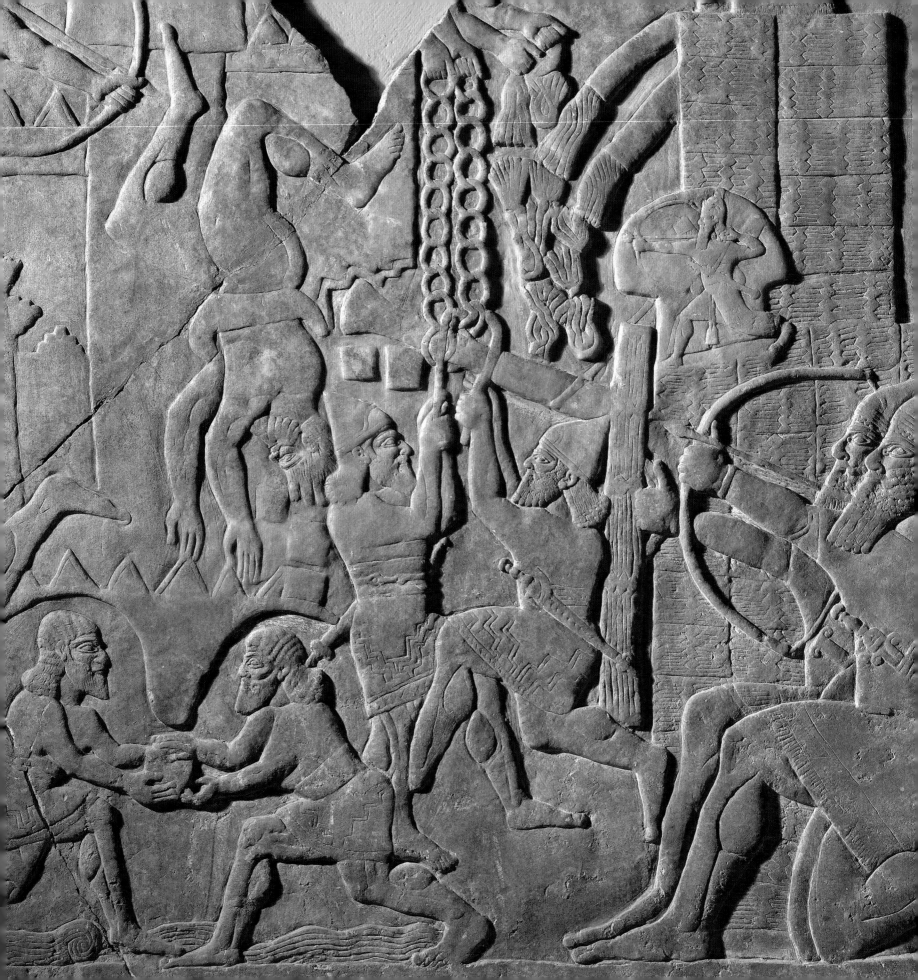

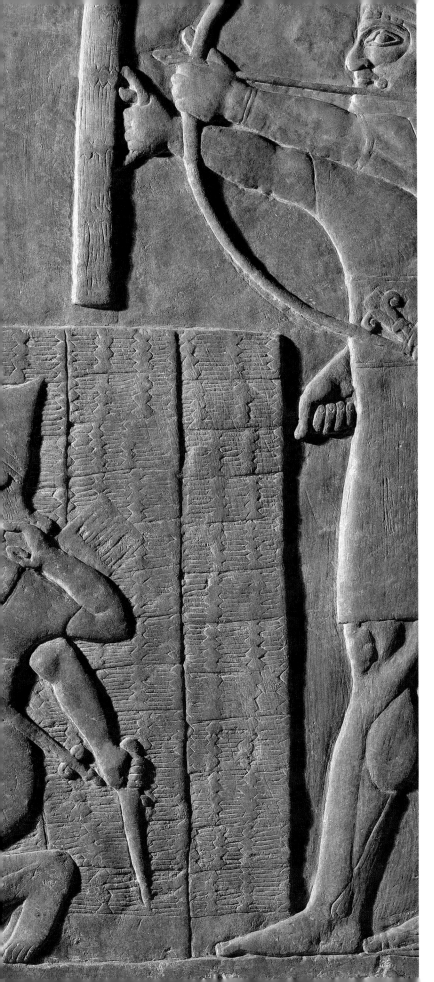

THE DETAILS OF an attack on a
fortress are tightly drawn to convey the
drama. Water pours from pipes on the
siege engine to extinguish fiery bundles
being dropped from the battlements;
chains attempt to dislodge the battering
ram; Assyrian soldiers undermine the
walls at the same time as an enemy,
shown exposed and therefore vulnerable,
falls from the battlements.

ORIGINAL PAINT survives on some of the sandals of the royal attendants. *above*

THE EMBODIMENT of perfect kingship, Ashurnasirpal II raises a ritual bowl to acknowledge the gods. A courtier uses a whisk to maintain the king's purity. *right*

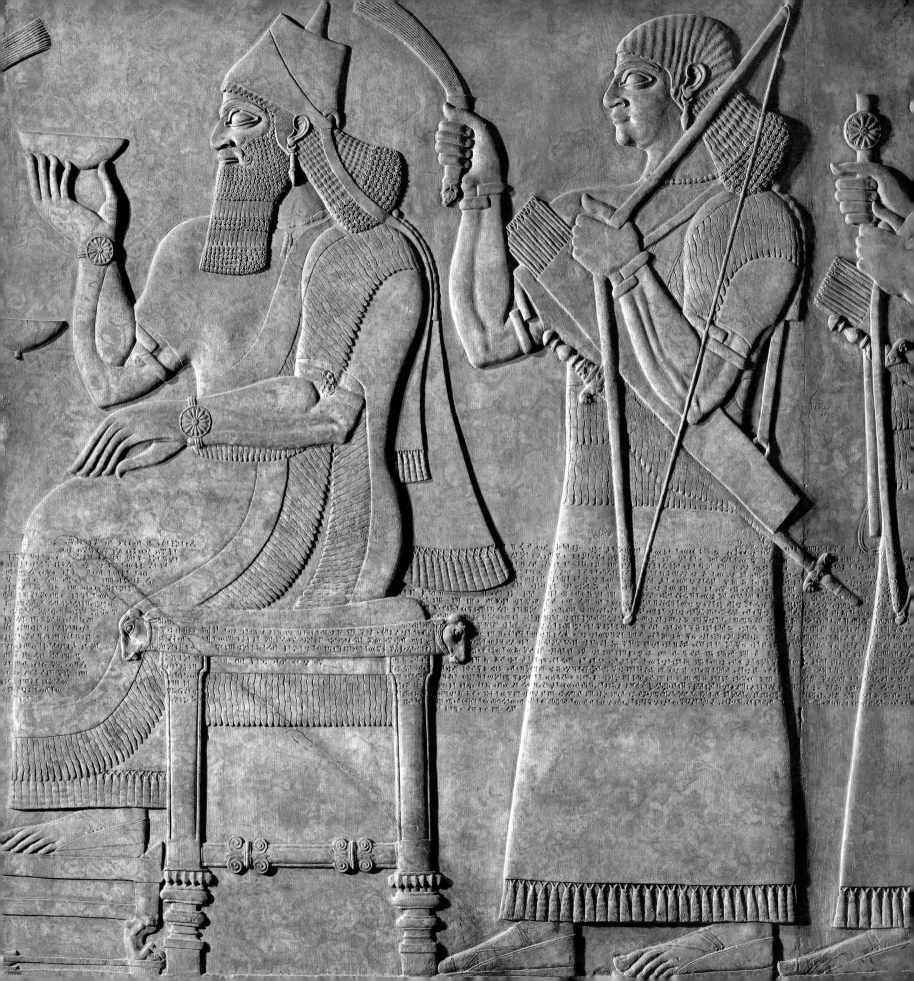

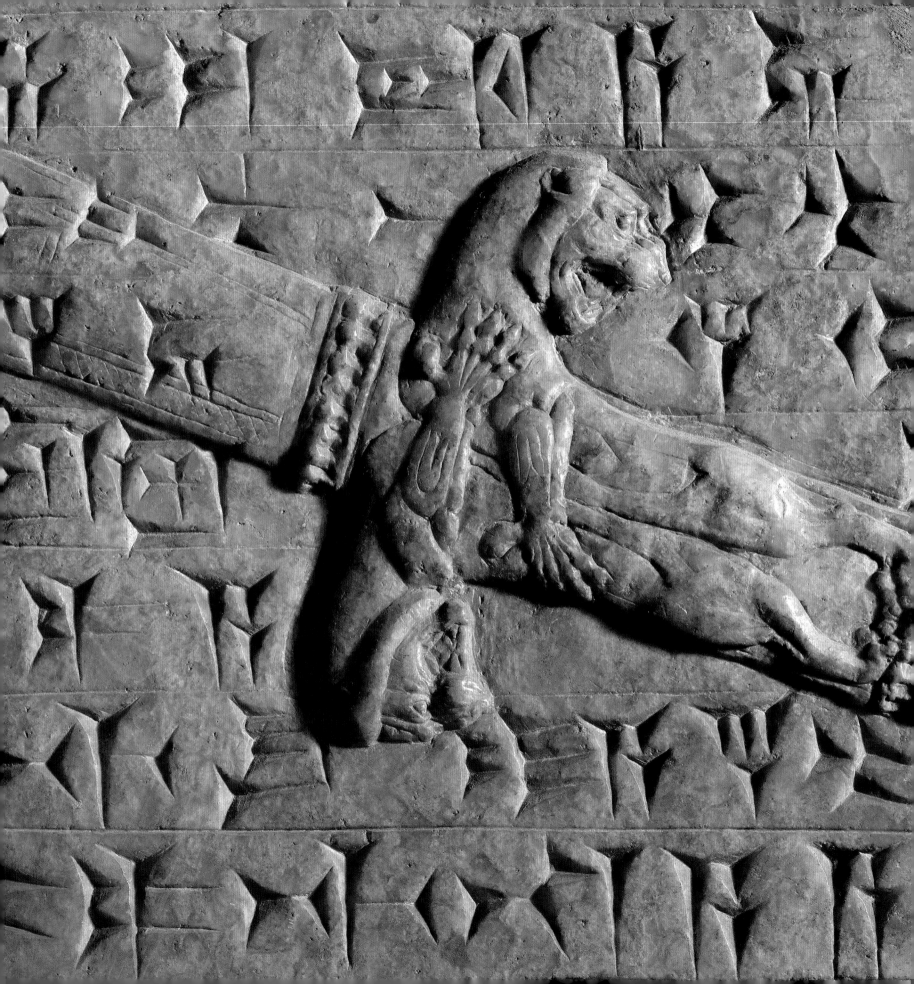

THE SCABBARD OF the king's
sword ends in a pair of royal lions
that wrap their front paws around
each other, infusing the weapon with
their strength.

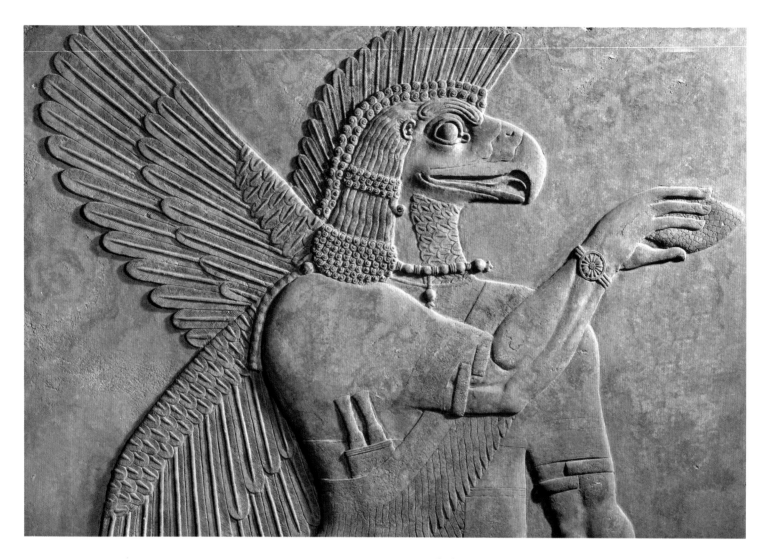

PROTECTIVE SPIRITS with the heads of birds lined the walls of ritually significant rooms at the heart of the Northwest Palace. *above*

AN INTERPLAY OF feathers, fringes and dagger-handles creates many levels of texture and light in this detail of a winged spirit. A delicate line of embroidery depicts animals and spirits adoring Sacred Trees of abundance. *right*

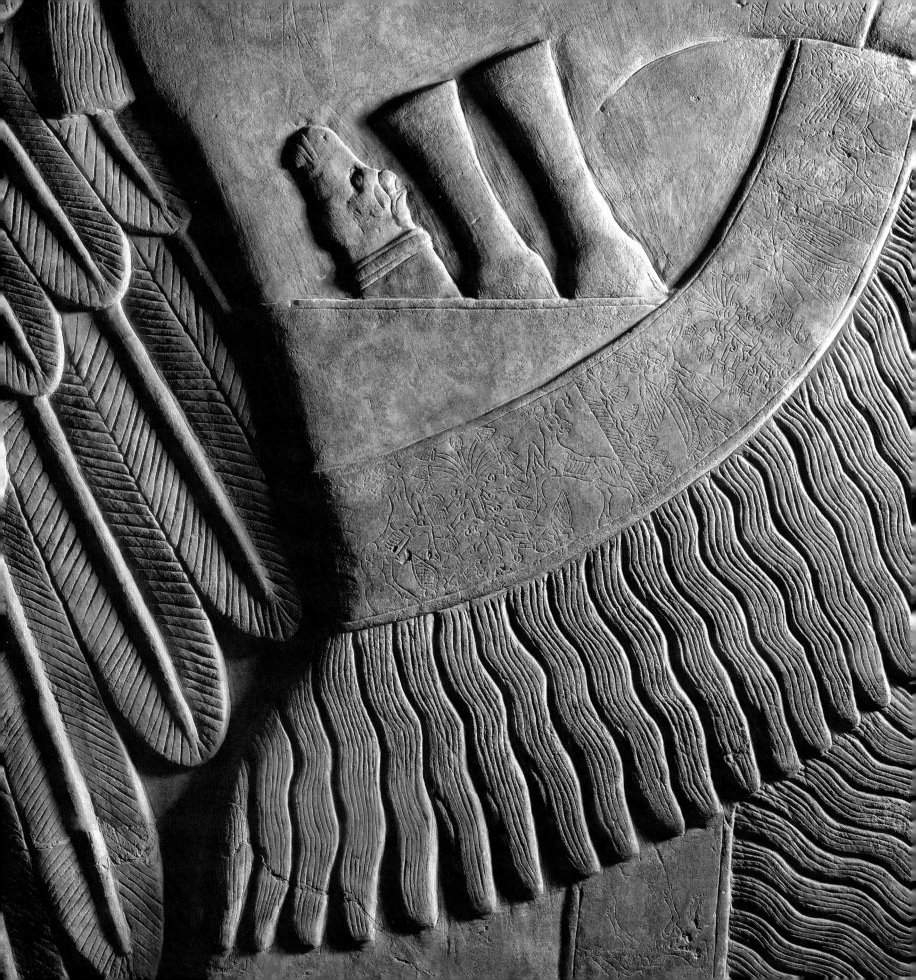

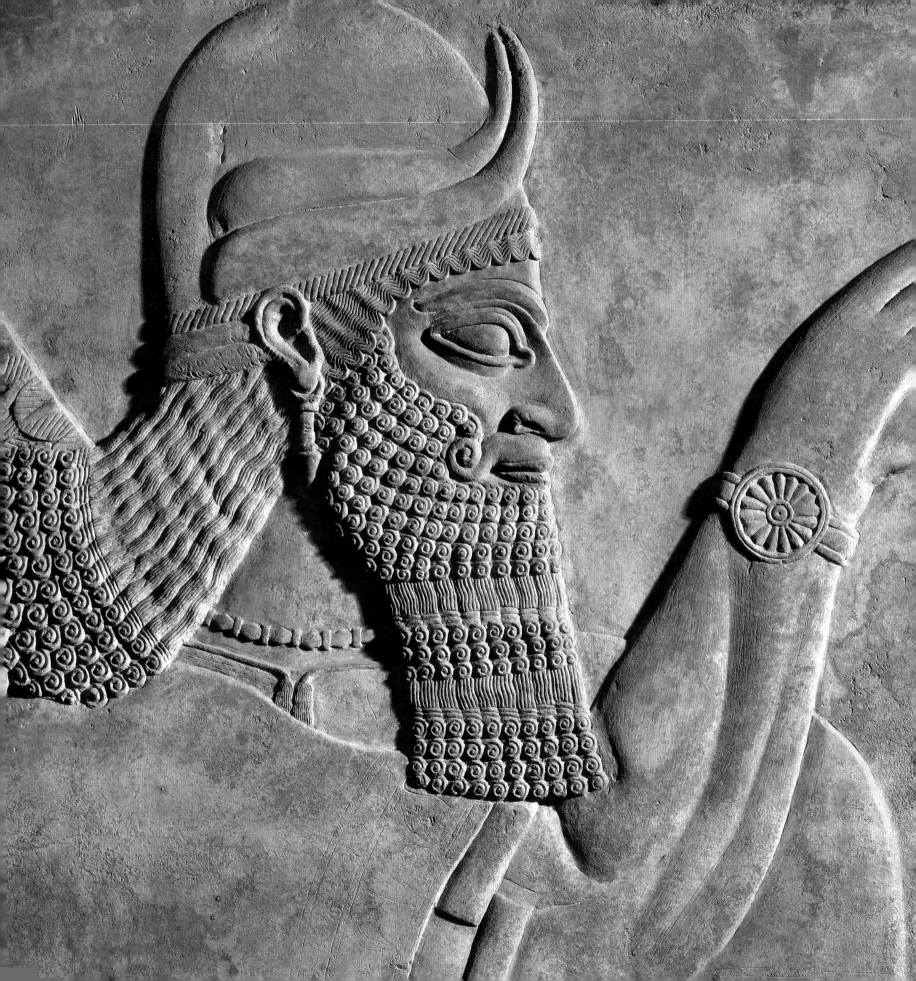

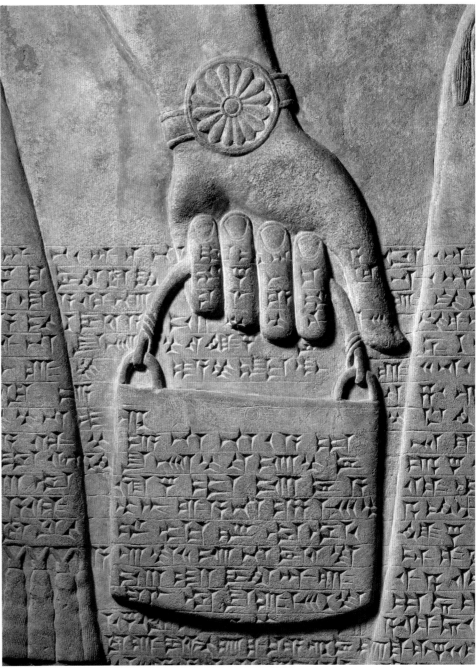

A PROTECTIVE SPIRIT purifies Ashurnasirpal with holy water sprinkled from a symbolic fir cone. The rosette, worn as a bracelet by both the king and the spirit, stands for the divine source of their power. *above*

INSCRIPTION AND IMAGE interplay in a detail of a ritual bucket containing purifying water. *above*

FINE INCISED DESIGNS representing
embroidery reinforce the religious
message of the reliefs with a winged
spirit grasping a sphinx in combat.

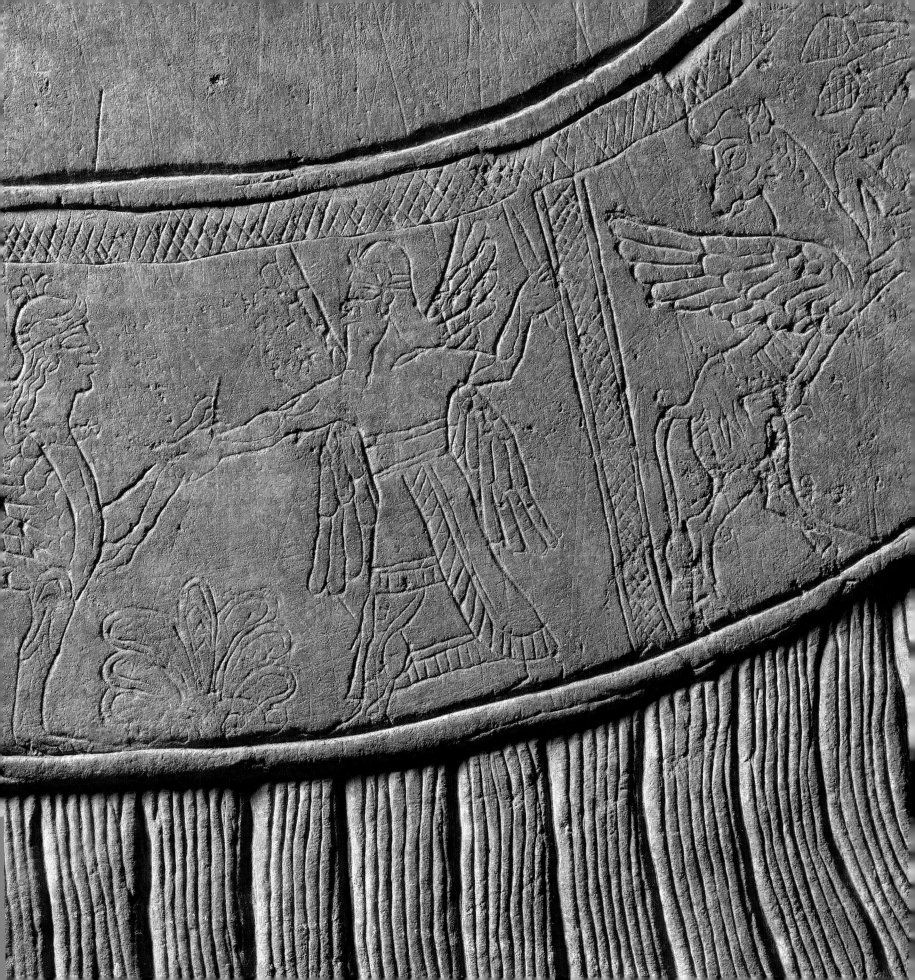

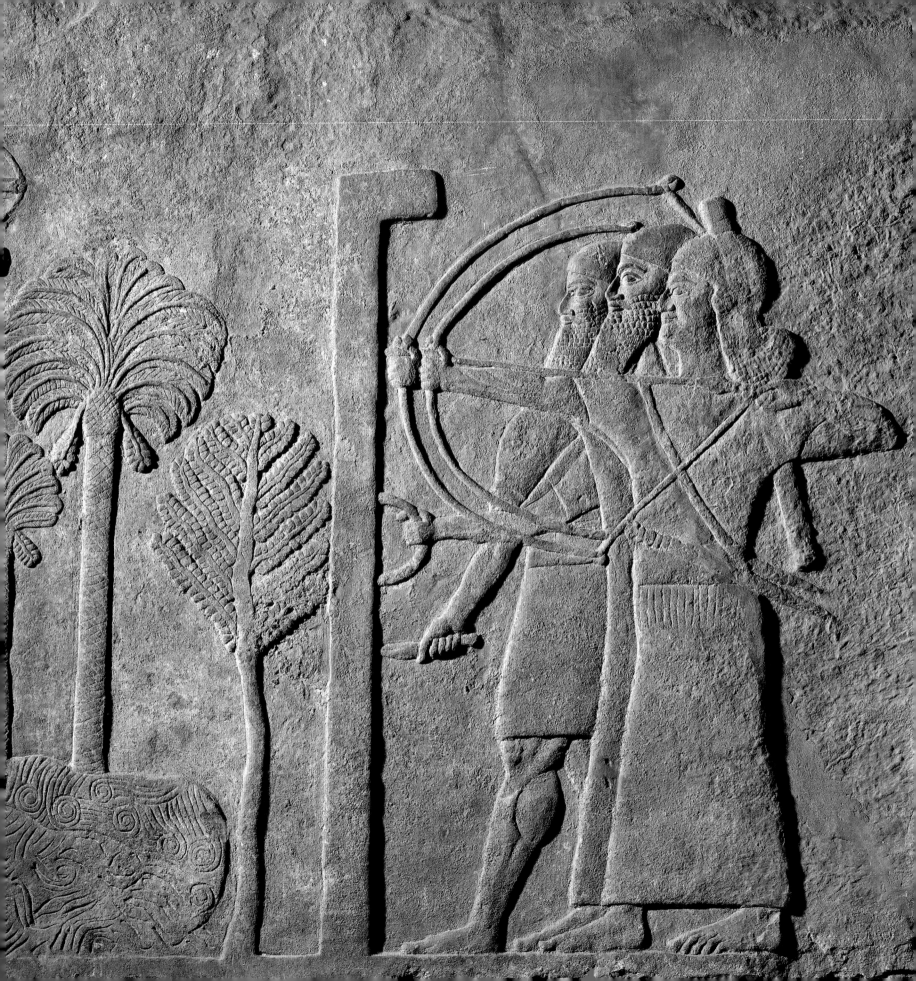

THE ART OF TIGLATH-PILESER III

BY THE MIDDLE OF THE EIGHTH CENTURY BC ASSYRIA HAD LOST CONSIDERABLE PRESTIGE AMONG the western states, and the northern frontiers were under pressure from the powerful kingdom of Urartu centered on Lake Van in eastern Anatolia. This weakened position was reflected in the absence of costly stone relief decoration after the reign of Ashurnasirpal II. The grim situation ultimately gave rise to rebellions within Assyria and the throne was seized by one of the royal princes, Tiglath-pileser III (744–727 BC). The new king lost no time in attacking the root cause of Assyria's dwindling authority. Urartu was effectively contained and Syria reorganized into a series of provinces placed under the control of Assyrian governors. Neighbouring rulers now rushed to pay tribute to Tiglath-pileser, including those of Israel, Tyre, Byblos, Damascus and Carchemish. Military campaigns were directed east into Iran, and to the west where, in 732 BC, Damascus was captured and established as the centre of a new Assyrian province. Finally, after several years of conflict, Tiglath-pileser was even able to claim the throne of Babylon.

These remarkable achievements once again gave Assyria access to resources of materials and labourers. However, years of expensive campaigns meant that it was only towards the end of his reign that Tiglath-pileser was able to have his own palace constructed. The so-called Central Palace was built on the citadel mound at Nimrud and, for the first time in some 130 years, carved stone panels formed part of the decorative programme of a royal building. It is difficult to judge the overall scheme of decoration since the palace was possibly never completed and many of the reliefs were later removed for reuse by King Esarhaddon (680–669 BC) in his so-called Southwest Palace. None the less, it is clear from the surviving sculptures that, although the inspiration for the decoration probably

ASSYRIAN ARCHERS are protected by a shield-bearer in a landscape of water and palm trees that stands for Babylonia.

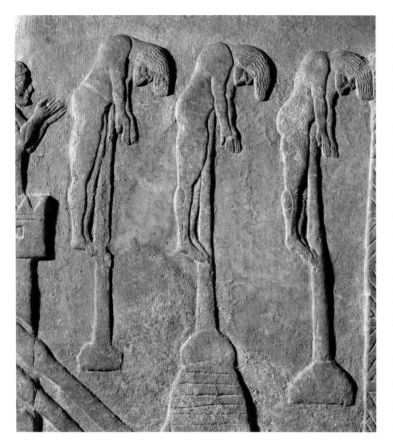

came from the Northwest Palace, the scale of the work was less impressive, perhaps reflecting a rushed job. The *lamassu* guardian figures, for example, were simply carved in relief rather than almost in the round.

Despite their often poor finish the clarity of design of the reliefs is very effective. Images are formed from strong outlines, often emphasized by deep cutting of the stone. Generally, figures are shown standing on a ground line and fill the whole space of a slab or a register. Sometimes, however, they are arranged in two or three rows without ground lines and, although their height on the panel represents depth of field, the resulting impression is that some figures are floating in space. Compared with Ashurnasirpal's sculptures, the compositions have a less formal organization in which symmetry of design is often absent; this may suggest that there was not as much consultation as previously between scholars and the sculptors. The result, however, is a more varied repertoire of imagery. Symbolic statements of conquest and triumph are largely replaced by representations of the defeat of actual enemy tribes, cities and individuals. Such historical narratives, in which events are depicted as set within defined landscapes and accompanied

THREE CORPSES HANG from stakes on which they have been impaled, the inevitable outcome for those who rebel against divine order. *above*

IN HILLY COUNTRY, a city is attacked by Assyrian soldiers using siege ladders. The enemy are overwhelmed and unable to fight, falling from the battlements and stripped naked in death. *right*

by written captions, are known earlier on smaller-scale objects such as the bronze gate decoration of Ashurnasirpal II and Shalmaneser III (858–824 BC) from the site of Balawat. This approach was adopted and adapted for Tigalth-pileser's palace sculptures and the longer compositions cross multiple slabs.

The interest in historical narratives is mirrored in the inscriptions which accompany the sculptures. As in the Northwest Palace, many of the carved panels in the Central Palace are divided into two registers of imagery separated by an inscription but here the text occupies a narrower band and records Tiglath-pileser's annals, which narrate his military campaigns. Scenes of battles and cities under siege as well as the aftermath with captives and animals under escort are thus favourite subjects; specific locations are identified by short captions or the depiction of landscapes and vegetation or even a seascape with islands and boats. The central role of the king is emphasized in novel scenes that show him crushing a rebel leader under foot or seated on a throne to receive his officials and captives. Tribute and booty are now carried to the king rather than being shown as a visual list placed separately in the field. Such realistic details extend to the inclusion of a standing figure who might be an artist; holding a scroll and a pen, this man may be sketching the scene before him so that it can be used as a guide by the palace sculptors.

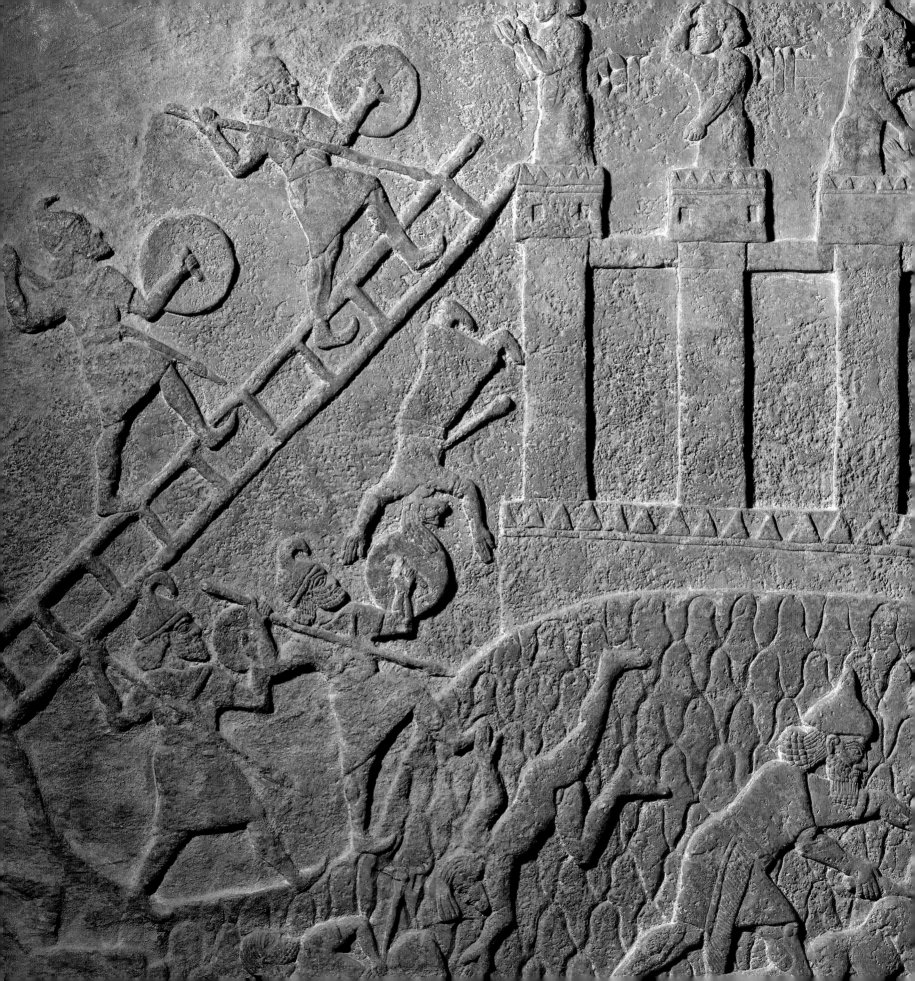

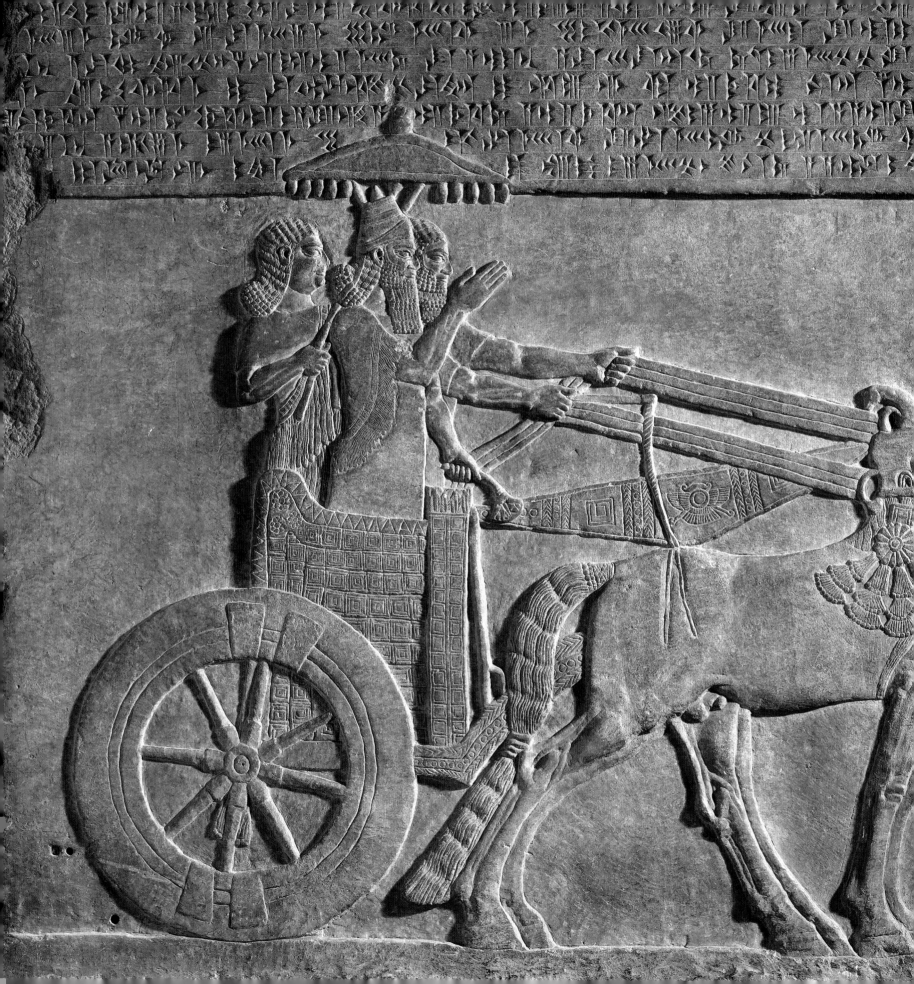

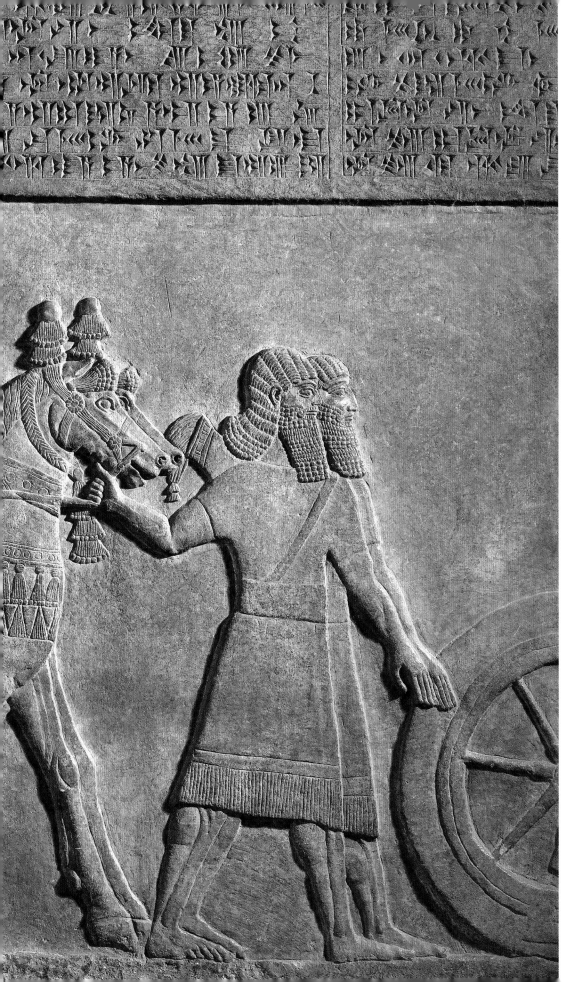

TIGLATH-PILESER III stands majestically in his chariot. A parasol, the king's prerogative which defines and protects his unique space, extends beyond the register to establish a link between the image and the text.

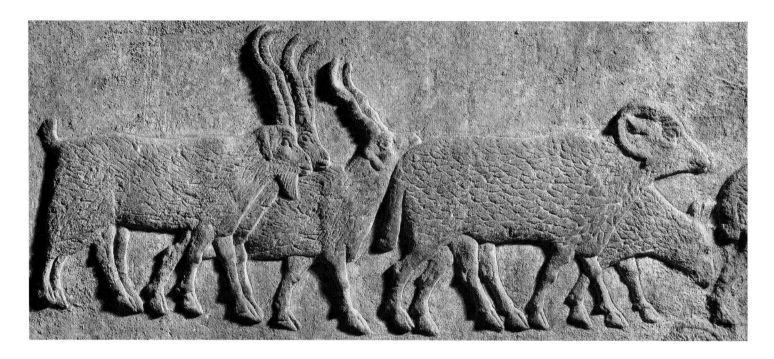

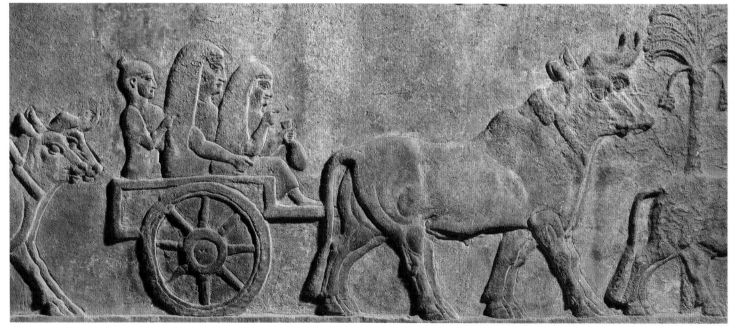

CAPTURED FLOCKS represent considerable wealth for the Assyrian king. *top*

PEOPLE LEAVE A conquered city to be counted and perhaps deported to another region of the empire. *above*

THE SPOILS OF victory are recorded by a scribe on a clay tablet. A second man is possibly sketching the scene before him on a scroll. *right*

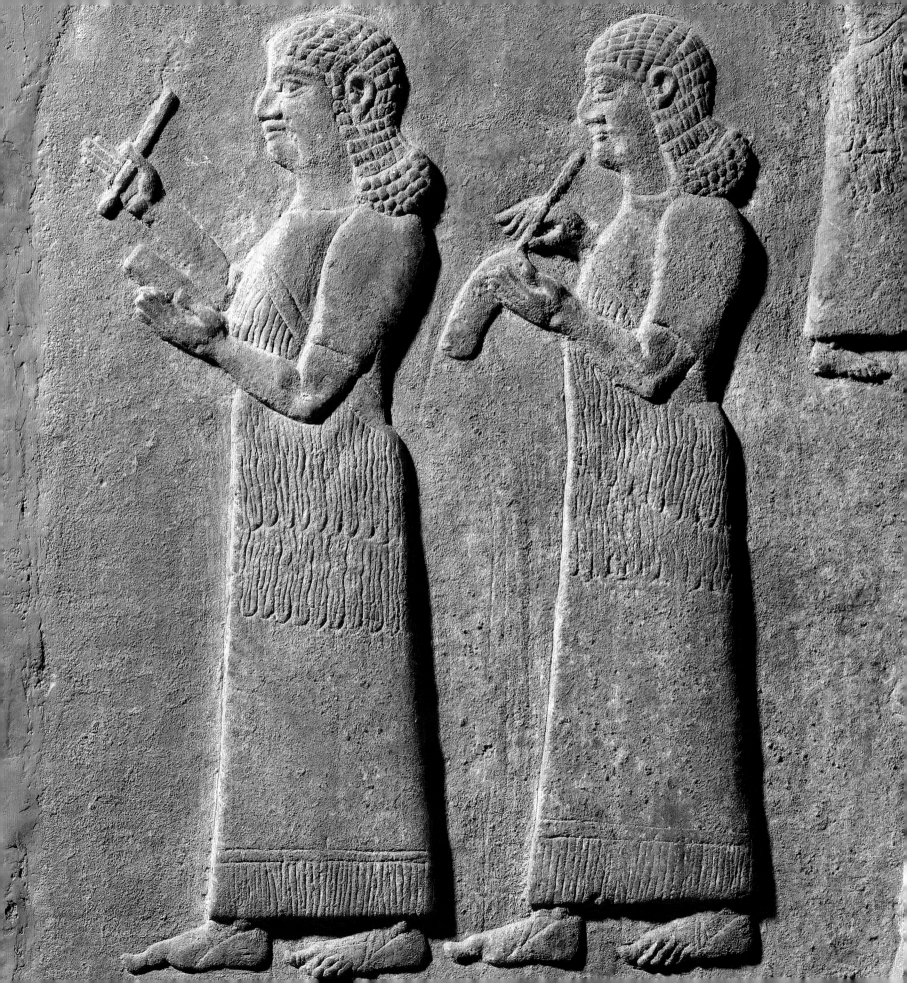

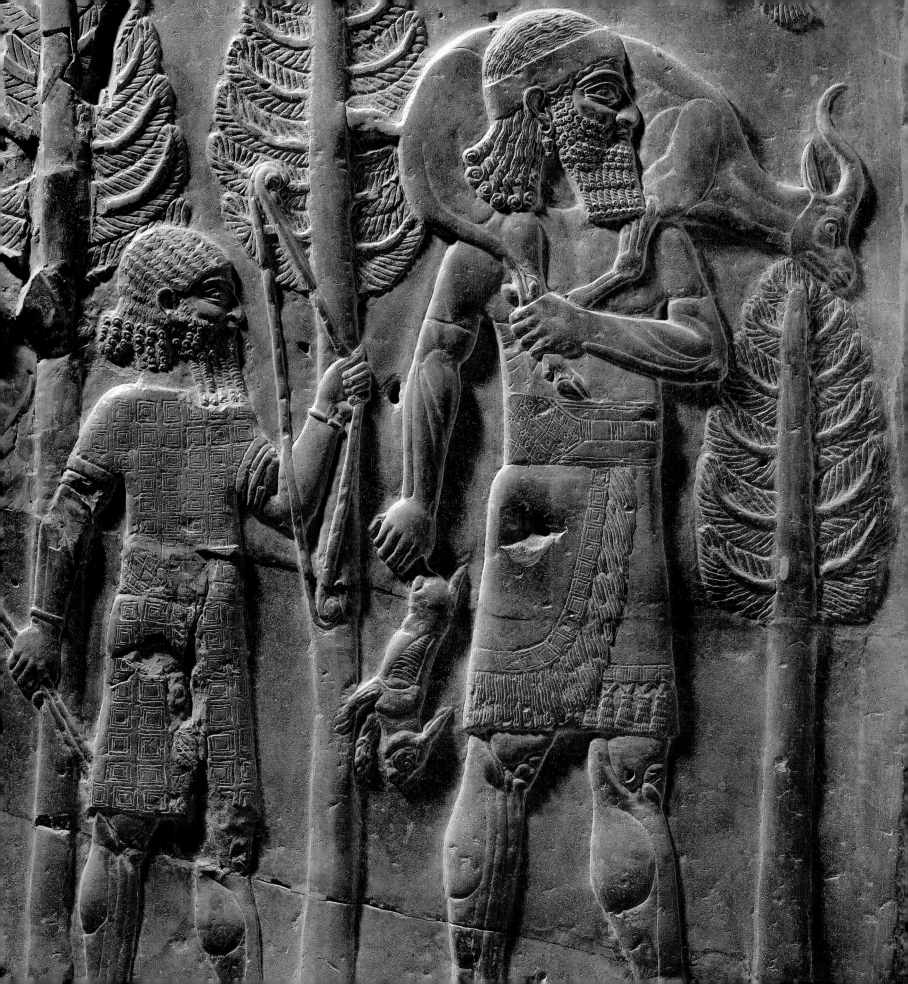

THE ART OF SARGON II

LIKE HIS FATHER TIGLATH-PILESER III, SARGON II (721–705 BC) SPENT MUCH OF HIS REIGN ON campaign. He had claimed the throne from his brother, Shalmaneser V (726–722 BC), probably in a violent coup, and completed the conquest of Samaria, capital of the kingdom of Israel, which was turned into an Assyrian province. However, Assyria continued to face pressure from neighbouring powers: Babylonia made an alliance with Elam in southwest Iran throwing off Assyrian authority and, at the same time, Urartu continued to threaten Assyria, establishing links with Phrygia which dominated central Anatolia under King Midas. In 717 BC a revolt in Carchemish instigated by Midas was crushed by Sargon and vast amounts of booty from the great trading city was carried to Nimrud and stored in the refurbished Northwest Palace. In 714 BC Sargon led his army into Urartian territory, plundering the wealthy frontier state of Musasir, and four years later he reclaimed the throne of Babylon.

Sargon's hard-won status was mirrored by an enormous royal centre he had constructed on land purchased from local communities some twenty kilometres northeast of Nineveh. The city was named Dur-Sharrukin ('Fortress of Sargon', modern Khorsabad) and was surrounded by a wall seven kilometres long. It was built on an artificial terrace and contained temples and a magnificent royal palace of over 240 rooms, many decorated with stone reliefs. The court moved to the new capital in 707–706, even though the construction was not completely finished.

As was the case with his father's palace, the inspiration for the layout and decoration of the new building at Khorsabad was probably the Northwest Palace at Nimrud. Huge five-legged, human-headed winged bull *lamassus* carved almost in the round guarded the

ATTENDANTS HOLD the weapons and kill of a successful hunting expedition within a forested landscape. The black limestone is unusual for Assyrian palace reliefs and recalls the dark stones used for sculptures in the west of the empire.

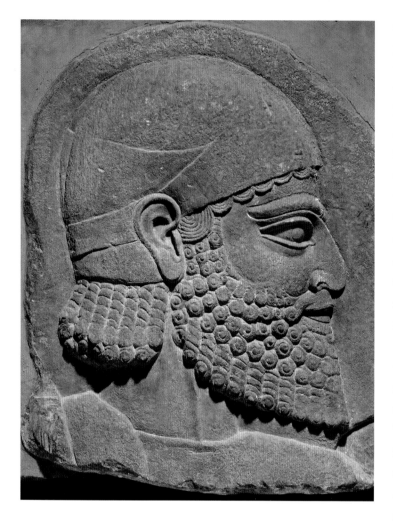

city and palace gateways. Reliefs of both winged and wingless protective spirits also stood at doorways but the large amount of wall-space devoted to magical and ritual imagery at Nimrud was replaced at Khorsabad with formal scenes of processions of larger-than-life courtiers and tribute-bearers that occupied the entire height of the slabs lining the walls of courtyards and many of the rooms in the palace. Such images represented an ordered world as established by Sargon in which tribute came to him from east and west; images of the king flank doorways to receive the bearers who progress towards him from both directions. The sculptures are all cut in exceptionally high relief and this may reflect the influence of workers from Syrian cities such as Carchemish with its long tradition of sculptors working in hard stone; according to Sargon's inscriptions, he deported such craftsmen to Assyria following his western conquests.

In other rooms of the palace, the design and composition of the carved slabs owe more to his father's reliefs but they are much better organized. Sargon's sculptures depict military narratives, sport and feasting as well as the punishment of rebels. The images are still arranged in two registers separated by an inscription (the king's narrative annals), but each register appears to have been devoted to a single theme. Thus, for example, scenes of banqueting in the upper register encircle a room whilst a campaign or a hunting expedition occupies the

THE DEEPLY CUT head of a tribute-bearer, whose turbaned head and style of hair suggests that he comes from the west. *above*

THE BEARDLESS FACE of this Assyrian courtier suggests that he is a eunuch. A foreign sculptor may have been responsible for mistakenly providing him with a headband which was then re-carved as hair. *right*

lower register. The interest in focussing on the defeat and punishment of individual enemies known from Tiglath-pileser's palace sculptures continues at Khorsabad and such scenes are often highlighted by captions. In addition, the prominent role of the king is maintained and he can appear at both the beginning and the end of narratives to start and complete a story. These carved episodes were made more specific by differentiating the ethnic physiognomies of enemies, a technique which may have developed under Egyptian influence.

The representation of different landscapes is expanded at Khorsabad to underscore the varied world being conquered and ordered by the king. The mountains of Musasir, for example, are represented by the traditional scale pattern, and in a series of remarkable sculptures, now in the Louvre Museum, multiple figures, shown moving planks of cedar wood along the coast of the eastern Mediterranean, are placed against a background of swirling water and scale patterns that cover the entire height of the panels so that objects and humans no longer appear to float in space.

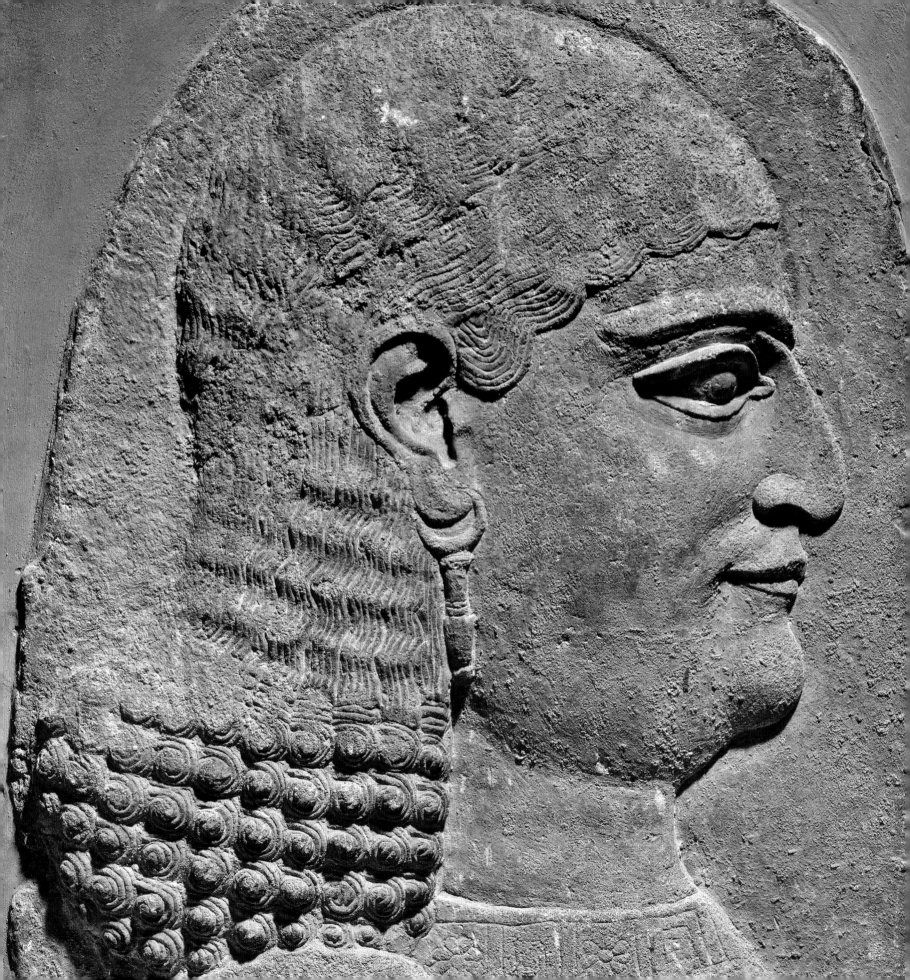

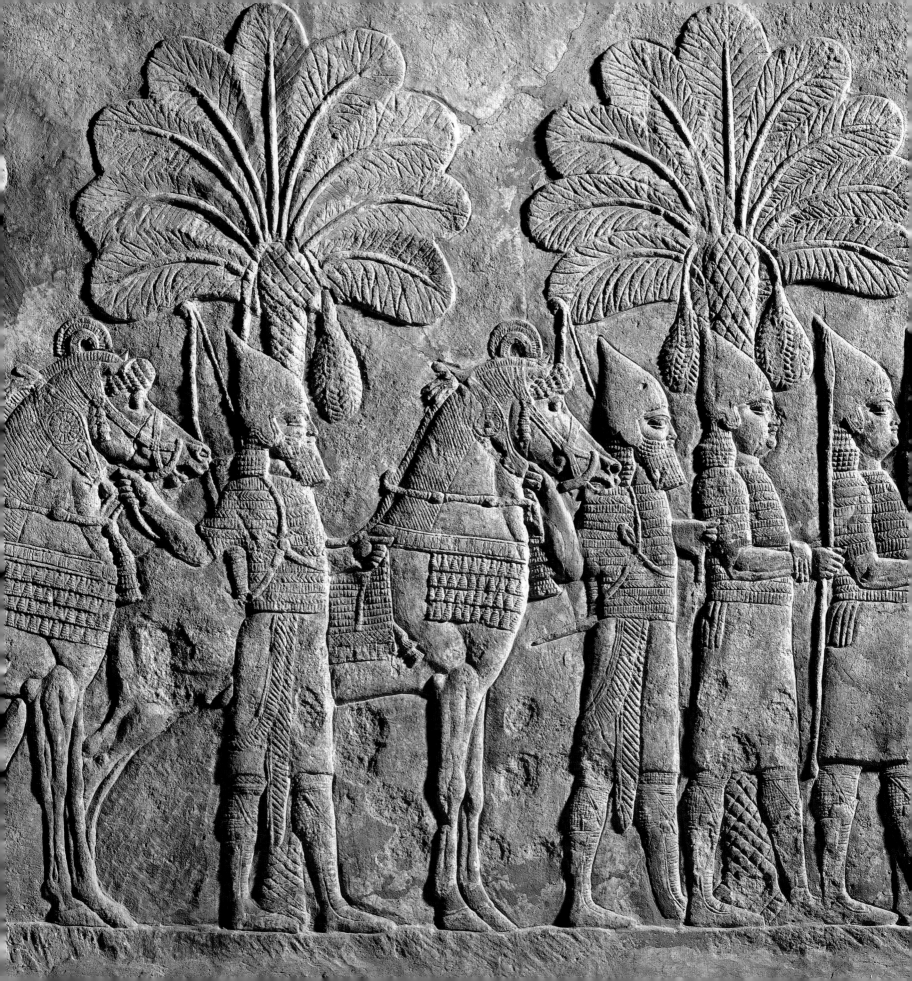

THE ART OF SENNACHERIB

THE WARS FOUGHT BY SARGON II RESULTED IN A RELATIVELY STABLE EMPIRE THAT ALLOWED HIS son and successor Sennacherib (704–681 BC) to initiate his own building programme within years of coming to the throne. However, his father's inauspicious death in battle, combined with the somewhat artificial creation of Khorsabad, led Sennacherib to establish his royal centre at the ancient and venerable city of Nineveh. Here the king set about creating a capital worthy of an empire that now dominated the Middle East. The new city occupied an area twice that of Khorsabad and was enclosed by a wall twelve kilometres long with eighteen gates. Canals were built to bring water up to seventy kilometres to feed extensive farm and park lands in and around the city. Sennacherib's palace, built over some fifteen years, was constructed on the old settlement mound (modern Kuyunjik). Known today as the Southwest Palace, the building was immense, much larger than any earlier Assyrian palace. It included a huge throne room with adjoining chambers, an inner court surrounded by reception rooms, and a second inner court – a feature not found before – surrounded by more rooms. The majority of chambers were panelled with reliefs; up to seventy such spaces and about three kilometres of sculpted slabs were uncovered in the nineteenth century (representing perhaps only half of the palace).

Sennacherib tells us in his inscriptions that he intended the palace to be without rival, an incomparable building which he had created for the 'astonishment of all nations'. The stress on nations rather than peoples reflects the scale of the empire the king now ruled, one that would require a palace to match its dimensions. The Assyrian world view had expanded with its territories and the decorative scheme of the palace was adapted

THE ROYAL BODYGUARD of spearmen and archers overlap each other, indicating that they are standing side by side.

accordingly. Large-scale processions of court officials and tribute-bearers disappear from the sculptures and new features were introduced to express the extent of the empire: columns from Syria, new forms of protective spirits from Babylonia and Syria, soldiers from Iran and the Levant appear within images of the Assyrian army. Traditional gateway bull-*lamassus* were now carved on a truly massive scale and were no longer conceived, as at Nimrud and Khorsabad, from the combination of two-dimensional images but rather as three-dimensional animals with four legs. They thus appear more believable.

The novel features of the palace decoration also extended to the relief panels, which are highly innovative in style and subject. The narrative scenes are no longer divided into two registers with a band of inscription between them, but fill the entire height of the panels (though features in a landscape, such as a river, are sometimes used to divide the imagery into two or more registers). Although there were a few experiments with this approach in Sargon's palace at Khorsabad, at Nineveh it became the norm. The increased size of the stone canvas gave Sennacherib's artists space to incorporate considerably more information within single compositions: many more figures could be included, often at different scales and arranged in horizontal, vertical or diagonal lines to direct the eye towards crucial moments in the narrative. The depiction of diverse landscapes is methodical, with entire backgrounds filled by details of vegetation and physical features representing the varied world controlled by Assyria. While vertical perspective continues to be used, where height on the slab represents depth of field, figures no longer appear to float in space but all exist in the same realistic environment as if seen from a high and distant viewpoint. There was simply no need for a perspective where the figures are shown smaller as they become more distant because the existing visual rules provided sufficient information for the meaning to be clear. The different backgrounds, such as the scale pattern to represent mountains, were also useful to distract the eye from the individual figures in the scenes because the quality of the carving is sometimes quite poor. This reflects the mass production of the reliefs which was necessary in order to fill the many rooms of the palace swiftly.

The Southwest Palace reliefs depict two main themes: battles to crush disorder at the distant borders of the empire and the creation of order at the centre. The latter subject was traditionally symbolized by the construction and refurbishment of temples but under Sennacherib it is represented by the extraordinary elaboration and transformation of the city of Nineveh and the surrounding landscape. Details of technological marvels, such as bronze casting, and the acquisition of exotic building materials that demonstrate the king's divinely granted ingenuity and power, are presented in royal inscriptions and images. This message is expressed in a wonderful series of relief panels from the Southwest Palace depicting the quarrying and transport of a bull-*lamassu*. The huge

stone sculpture is shown at various points on its journey to Nineveh against a single panorama in which hills give way to reed swamps and finally the river Tigris. The king also appears more than once within the landscape calmly overseeing the operation, which involves scurrying officials and workmen. The colossus is dragged by hundreds of captives who, hauling at ropes, are arranged in rows one above the other.

The most common theme of Sennacherib's reliefs is military campaigns and nearly every room in his palace was devoted to a battle or siege. The crushing of a western revolt among the cities of Phoenicia, Philistia and Judah in 701 BC included the siege and capture of Lachish. Although not mentioned in the royal inscriptions, the fall of Lachish is recorded in reliefs which lined the walls of a room located at the very heart of the palace and which was approached through three successive gateways each guarded by pairs of bull-*lamassus*; Sennacherib presumably considered the capture of this city worthy of special attention. The narrative of events consists of three sections, read from left to right across the panels. The first episode depicts the advance of the Assyrian army; parallel rows of soldiers, each doubled to indicate plurality, march across the mountainous lands of Judah. The central imagery changes scale to show the attack on Lachish itself where lots of incidental details are included as the Assyrian siege engines and troops advance up artificial ramps. As the attack takes place, the captive citizens emerge from the city gate. A return to a larger scale concludes the story with captives and Assyrian soldiers all moving towards a scene in which rebels are executed or prostrate themselves before the enthroned Assyrian king.

Sennacherib is never shown actively fighting but he oversees the final episodes of narratives where order has been achieved. The contrast between conflict and resolution can include the well-rehearsed use of change in direction within Assyrian art; action scenes move contrary to more peaceful scenes, sometimes in opposing registers. The central role of the gods remains paramount but now their presence in the visual narrative is reduced to divine standards attached to chariots or scenes of ritual activity within the Assyrian camp so as not to disturb the literalness of the images. The possibility that a viewer might overlook such details is recognized by the inclusion of descriptive captions, which help focus attention on crucial elements, especially the figure of the king.

THE THRESHOLDS OF major gateways were paved with stone imitation carpets. The harmonious pattern of symbolic rosettes, palmettes, lotuses and fir cones represents the ordered and abundant world of Assyria.

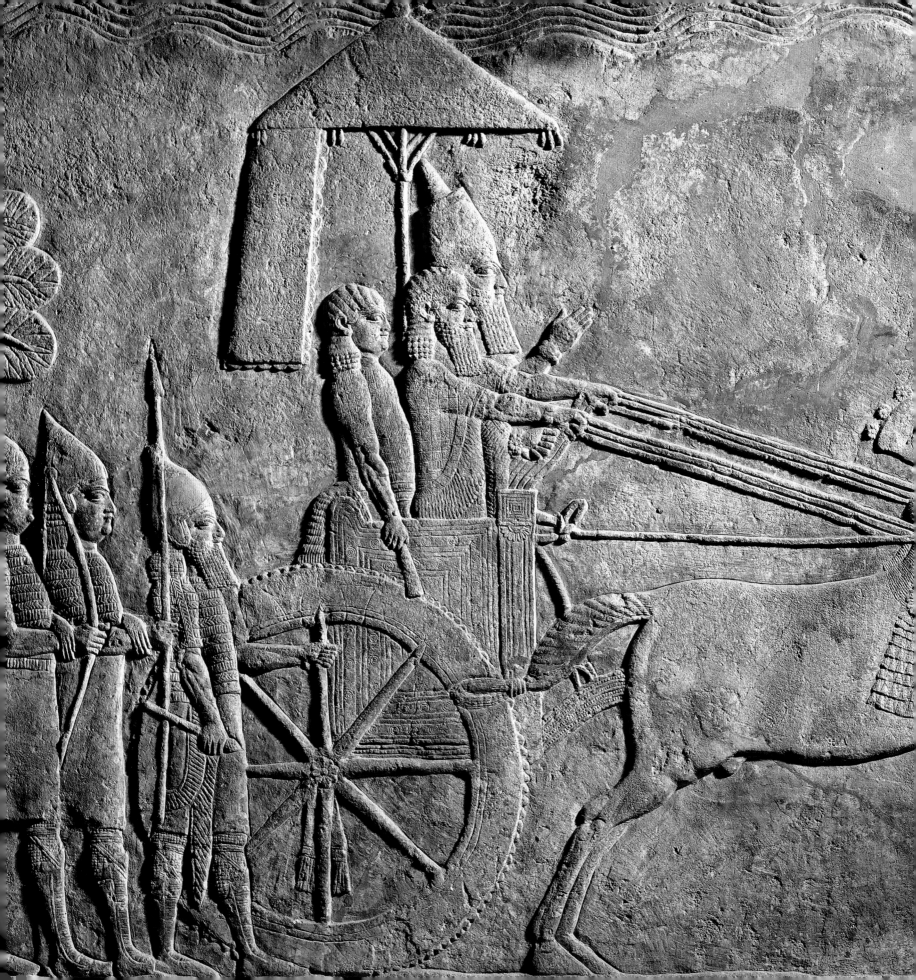

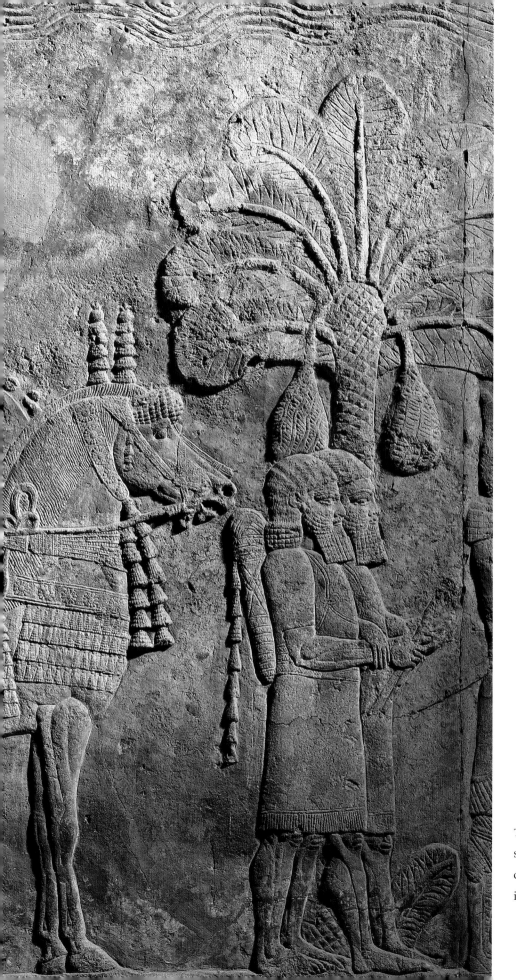

THE ASSYRIAN KING, shown
slightly magnified and wearing a tall
crown, oversees the restoration of peace
in Babylonia following a rebellion.

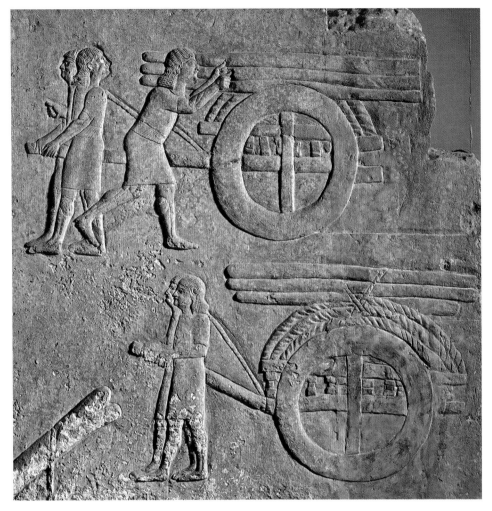

IN THE REIGN OF Sennacherib, eunuchs, once a powerful group at court, are reduced to fetching and carrying equipment. *above*

WITHIN THE HILLS, Assyrian soldiers stand guard as prisoners empty bags of rubble brought from the quarry floor where a stone bull-*lamassu* has been cut. *right*

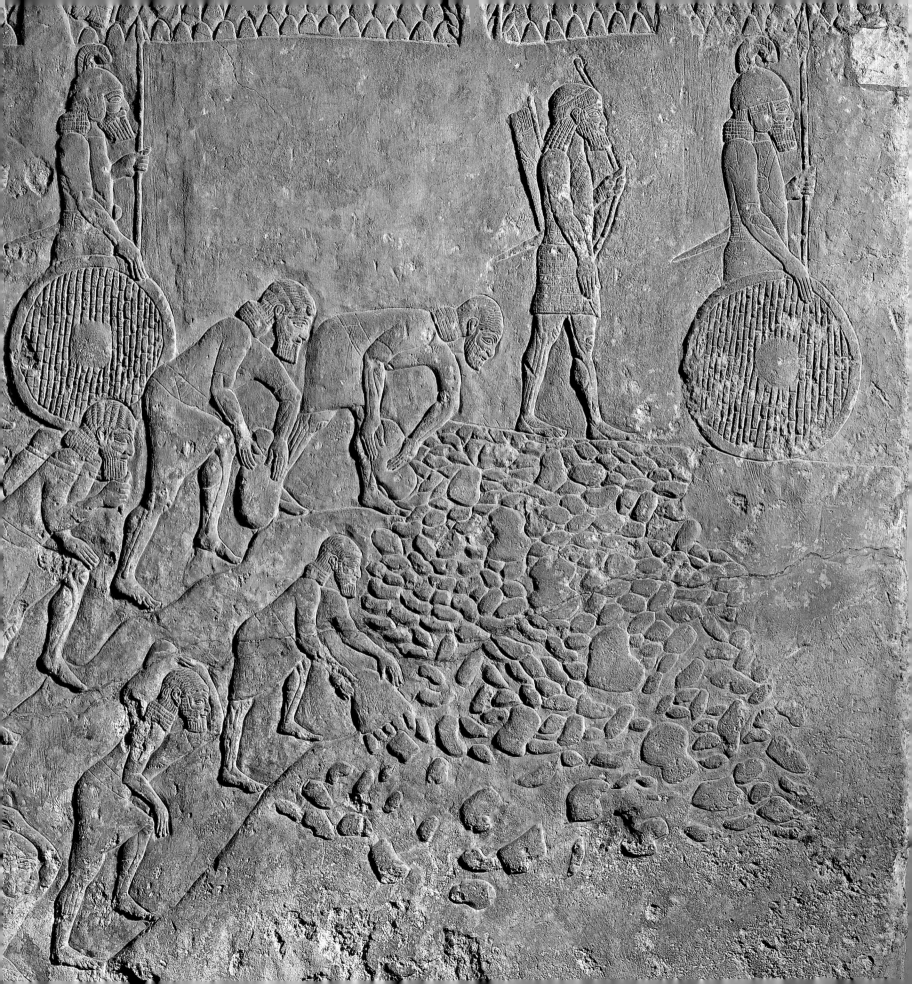

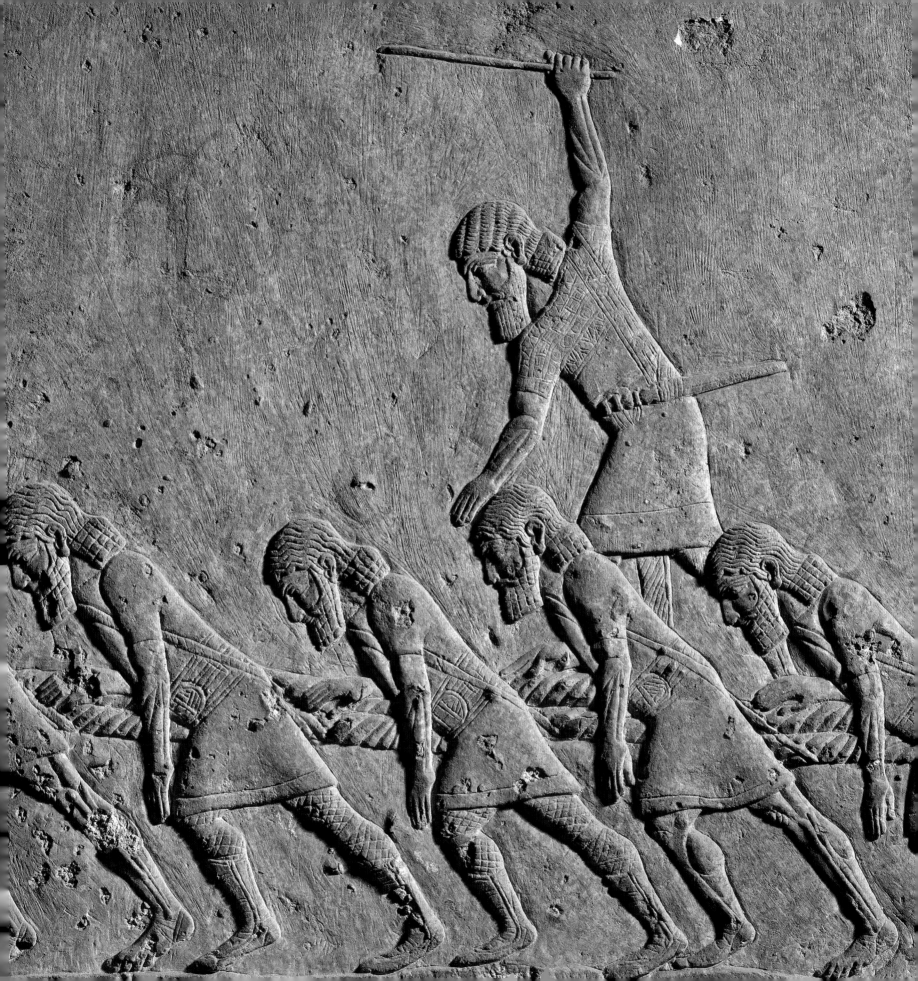

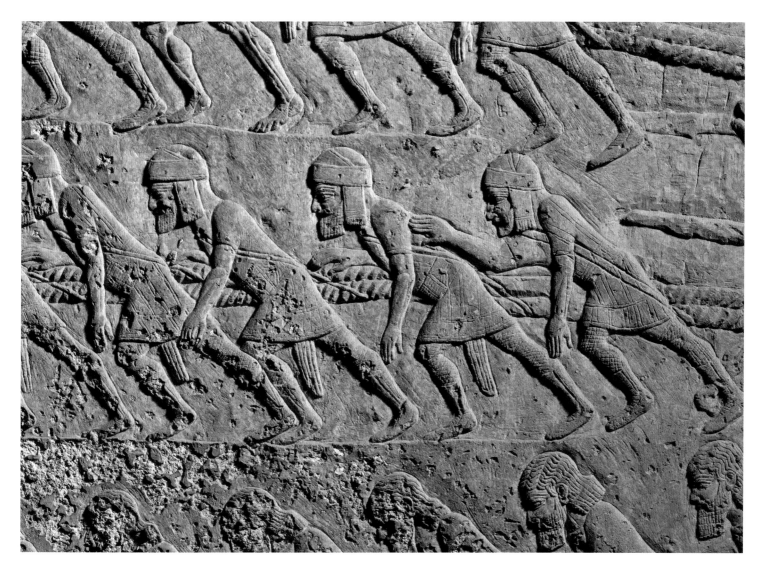

AN OFFICIAL RAISES a staff to persuade captives forcibly to pull a stone sculpture from the quarry. *left*

A MAN PLACES HIS right hand on the back of his fellow captive, perhaps to offer support, as he and hundreds of others haul on ropes to drag a stone colossus towards Nineveh. *above*

FIR TREES LINE the bank of the River Tigris close to Nineveh. *following pages*

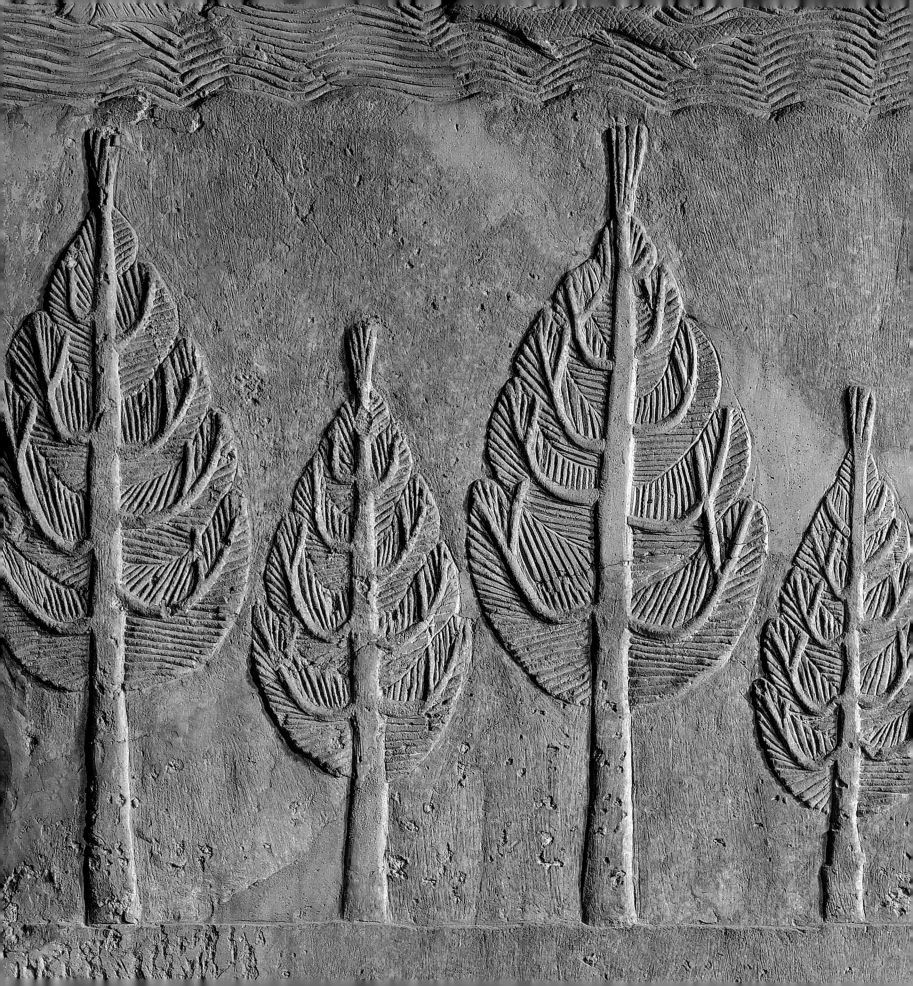

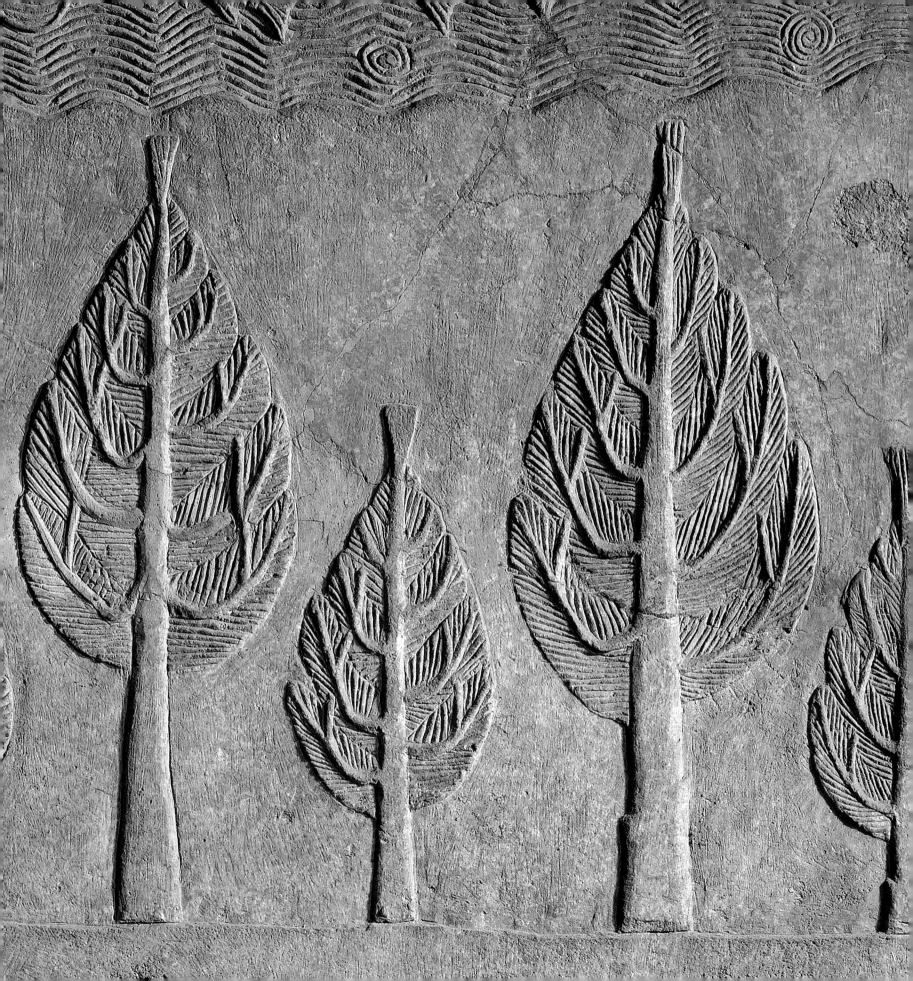

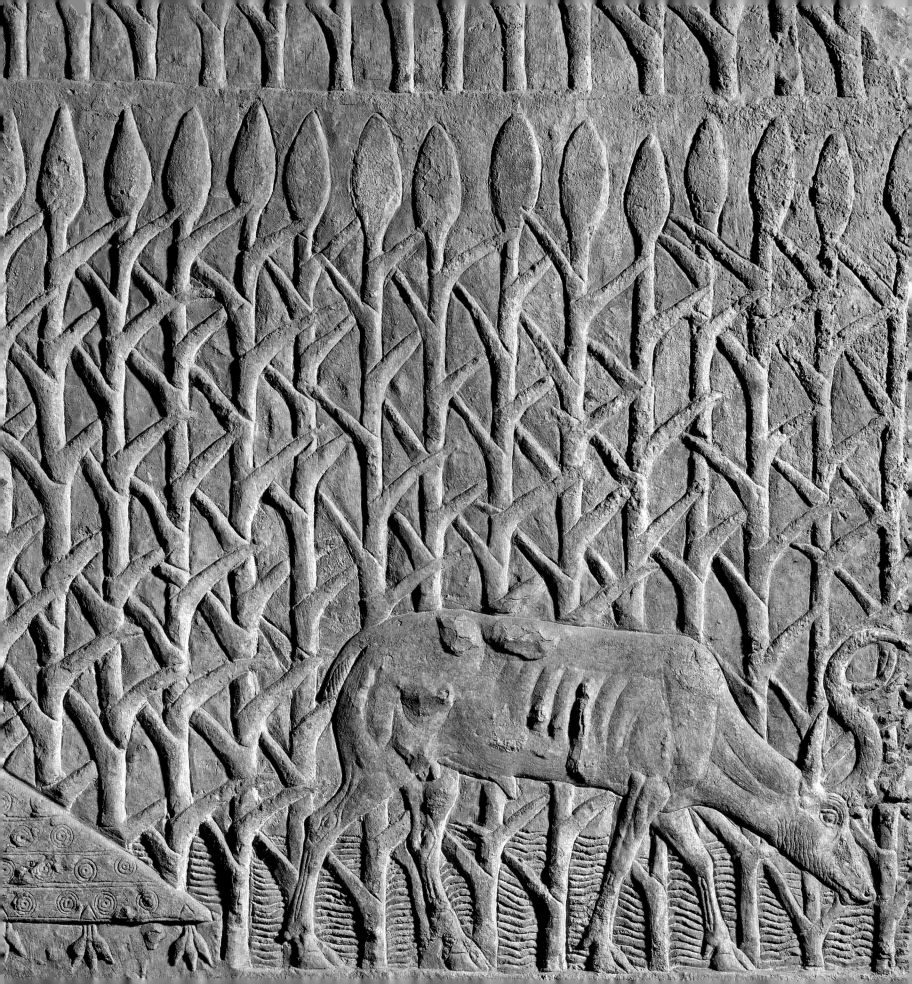

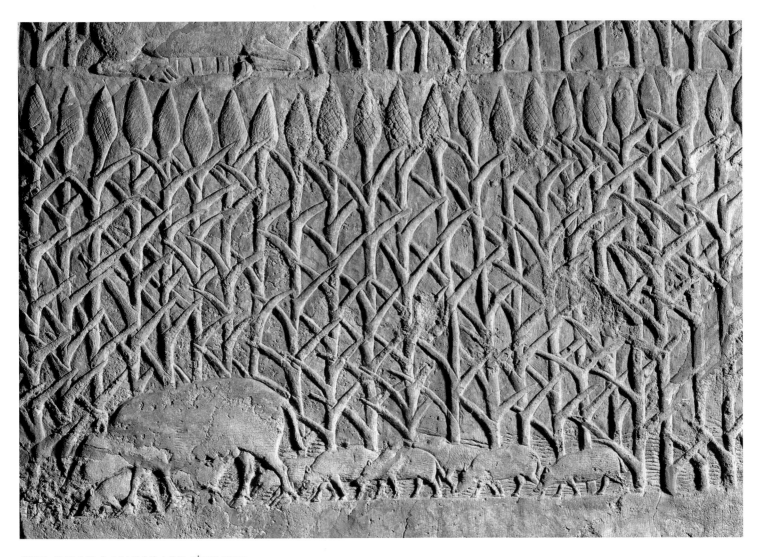

THE HILLY LANDSCAPE gives way
to reed marshes, which provide cover
for wild animals such as deer and pigs.

left and above

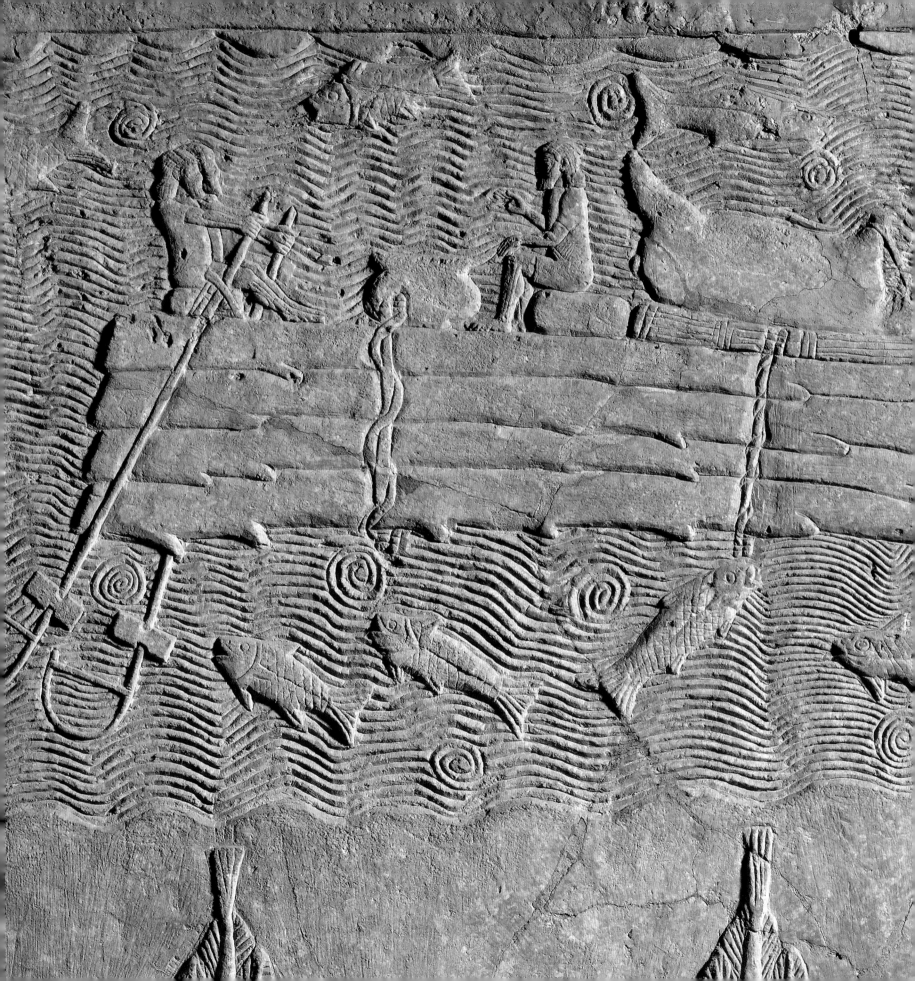

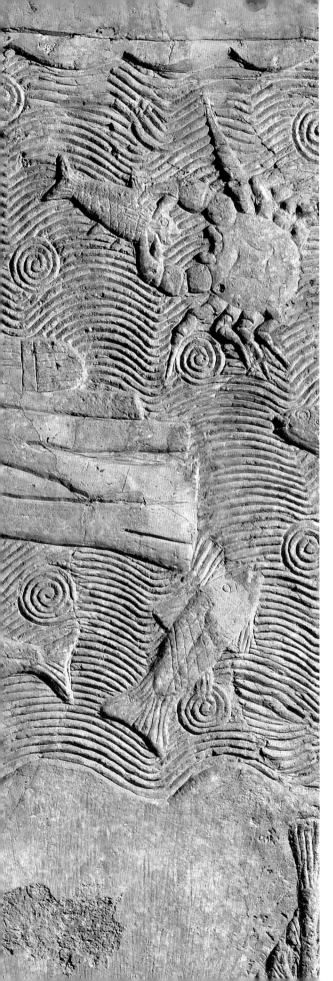

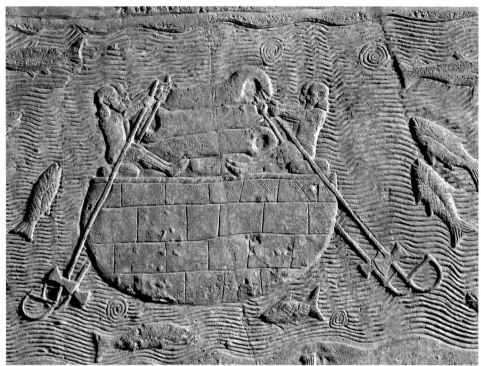

A LARGE RAFT transports a seated figure together with a cauldron and an animal haunch. A crab grabs a fish from among the shoals that fill the river. *left*

THE RIVER BUSTLES with coracles carrying equipment and supplies. *above*

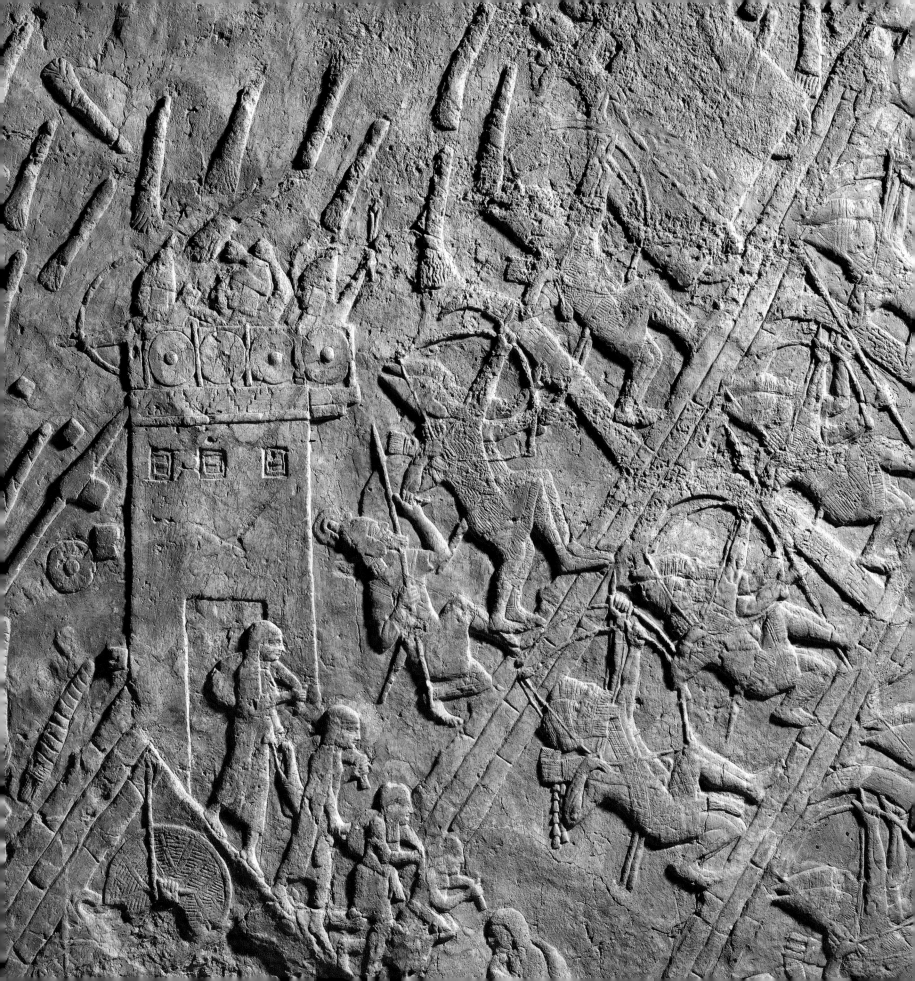

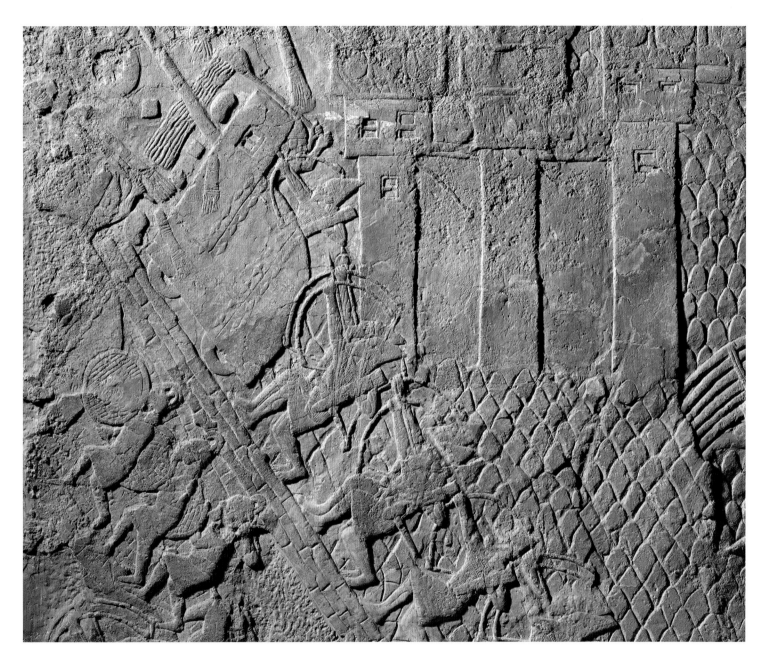

HEAVILY DAMAGED by the fires that raged through the Southwest Palace following the fall of Nineveh, these sculptures depict an Assyrian attack in 701 BC on the city of Lachish in Judah. Siege engines approach the city walls on artificial ramps, followed by heavily armed infantry. The unavoidable conclusion is played out at the bottom of the scene on the left, with the survivors of Lachish leaving the captured city through a gateway.

left and above

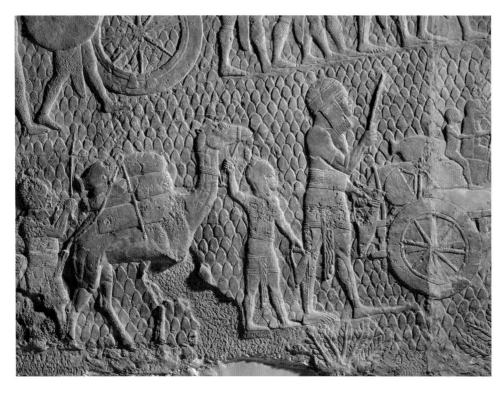

SOME OF THE PEOPLE of Lachish leave the ruined city with their possessions loaded onto a camel and a cart. *above*

BOOTY IS CARRIED through the hills towards the Assyrian king. *right*

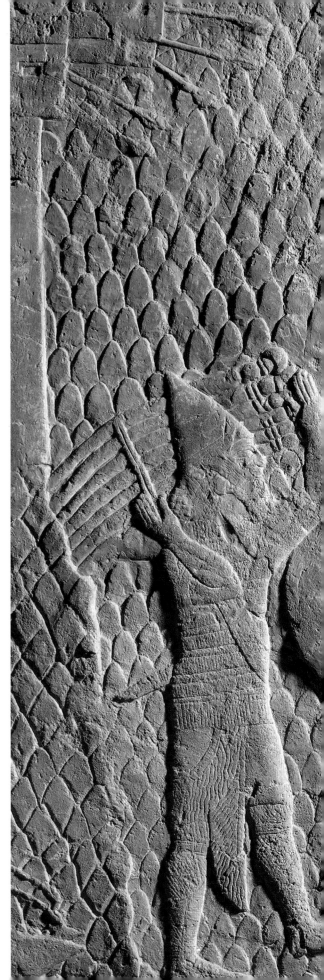

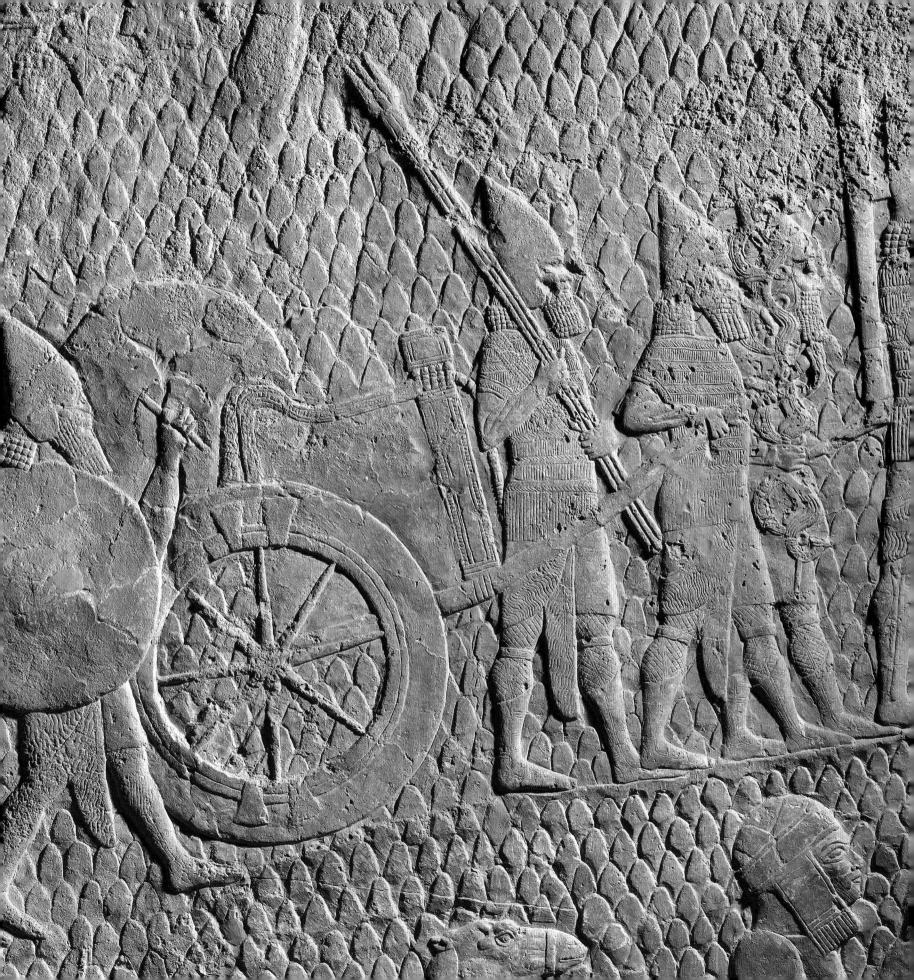

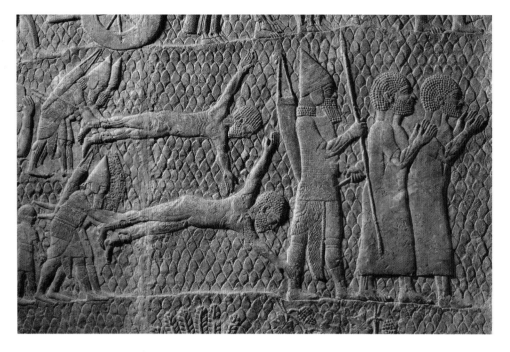

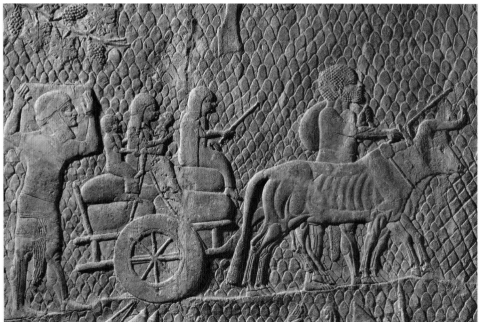

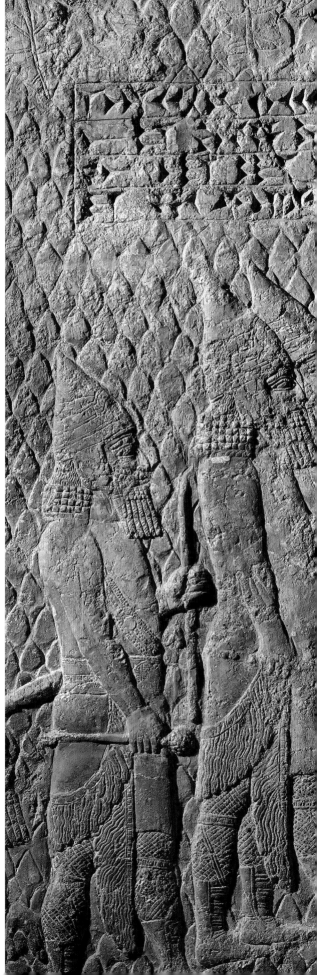

PUNISHMENT AND execution are reserved for the leaders of the revolt. Two men, naked and spread-eagled, are probably being flayed. *top*

FAMILIES SET OUT on a forced journey to be settled elsewhere. *above*

SENNACHERIB SITS on a magnificent throne with arm rests supported by three rows of divine beings. He oversees the capture of Lachish from a distant hill, holding the bow and arrows of a conqueror. *right*

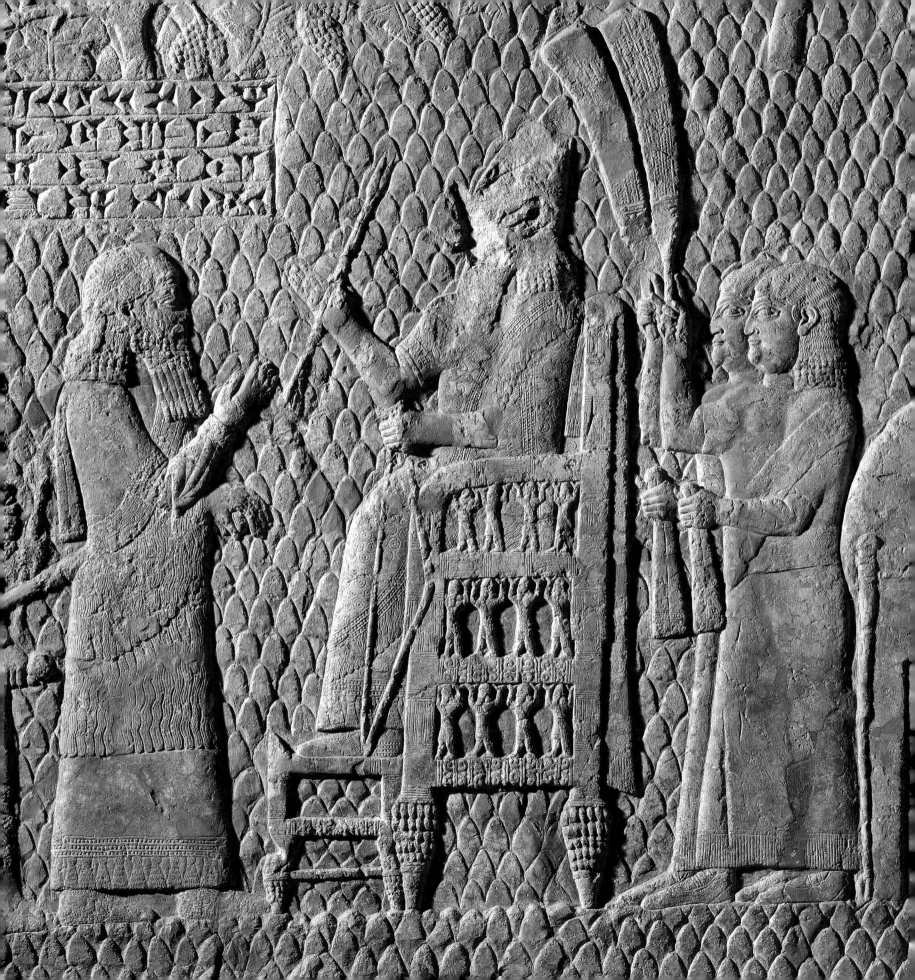

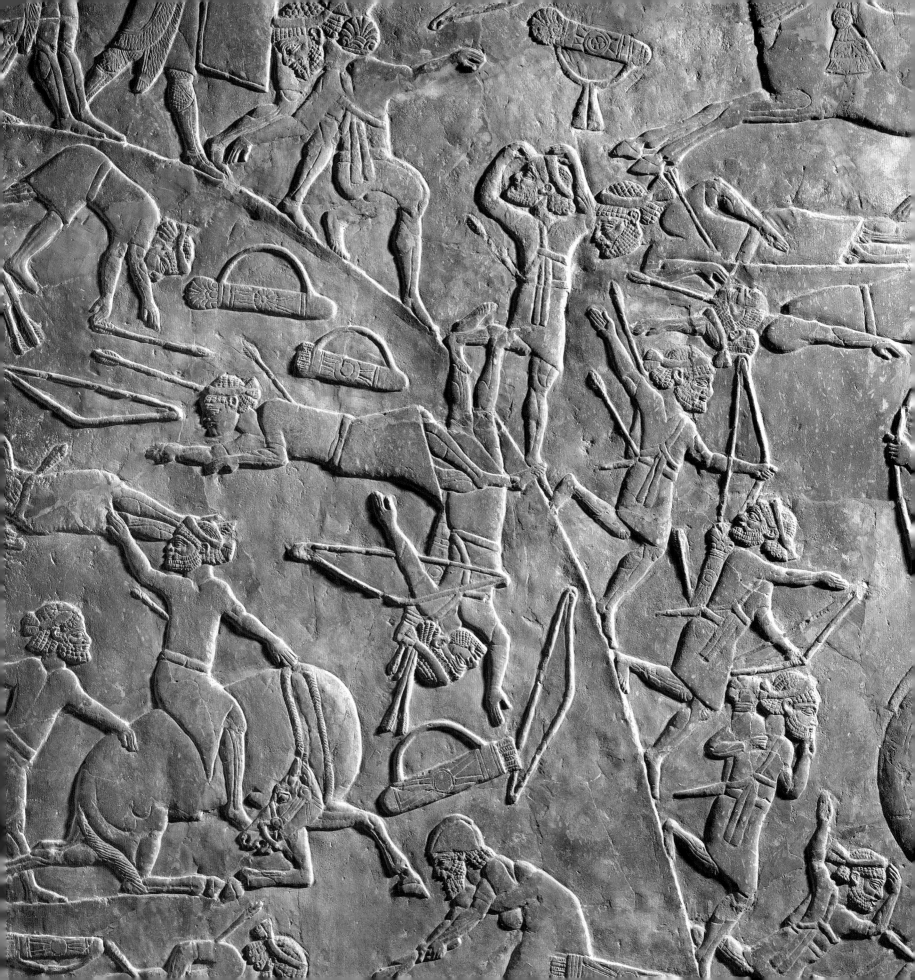

THE ART OF ASHURBANIPAL

ASHURBANIPAL (668–C.631 BC) RESIDED FOR MOST OF HIS REIGN IN THE SOUTHWEST PALACE AT Nineveh. With his brother Shamash-shum-ukîn established as the king of Babylonia, Ashurbanipal was able effectively to confront the two main powers opposing Assyria at its western and eastern borders: the 25th Dynasty rulers of Egypt were forced out of that country in 664 BC and replaced with a more amenable king; and the Elamite king Teumman was killed in battle around 653 BC. Assyria was at the height of its power and this was reflected in the creation of a series of remarkable reliefs in the Southwest Palace depicting the defeat and death of Teumman at Til-Tuba in southwest Iran. The reliefs are carved on slabs of beautiful limestone which Sennacherib had obtained from sources some 200 kilometres to the north of Nineveh. These sculptures are among the greatest achievements of Assyrian art. Every part of the composition is packed with details of soldiers, animals and chariots to produce what appears at first sight to be a meaningless explosion of figures which, nevertheless, wonderfully expresses the chaos of war. Closer inspection, however, reveals a tightly controlled vision, with Assyrian soldiers forcing the enemy Elamites down a hill in an unstoppable movement across the panels to the right. In the centre of the scene several narratives are played out along a series of parallel ground lines: Teumman tumbles from his chariot and, fleeing to the right into a seemingly claustrophobic woodland, he is caught and decapitated. In triumph, an Assyrian soldier carries the severed head left across the field. These chilling images are carefully captioned with incidental details and even speeches by the enemy. The registers of narrative dissolve on the far right and the Elamites tumble into a river which, along with the hill, acts to frame the entire composition. The Til-Tuba reliefs decorated a wall on one side of a doorway, on the opposite side of

THE UNSTOPPABLE momentum of the Assyrian advance is apparent in the disordered and desperate manner in which Elamite soldiers flee down a hill at Til-Tuba.

which were reliefs depicting the aftermath of the battle with the Assyrians installing their appointee in Elam and the torture and humiliation of surviving rebel leaders. The arrangement of these scenes into strict registers with neat rows of Assyrian soldiers and prostrating Elamites represents the ordered world as restored by Ashurbanipal and contrasts with the perceived chaos of Teumman's rule.

Following the crushing of a rebellion by the Babylonians and the defeat of their Elamite and Arab allies between 652 and 646 BC, Ashurbanipal ordered the construction of a new palace on the citadel at Nineveh (the so-called North Palace). As in the Southwest Palace many of the rooms were lined with reliefs depicting warfare, generally arranged in two or three clearly defined registers. Although many were mass-produced, the quality of the carving is superior to that done under Sennacherib. The throne room was decorated with scenes of Ashurbanipal's triumphs in Elam placed opposite scenes of victories in Egypt and which thus stood for the extent of the empire from East to West. As in his grandfather's reliefs, the king is never shown engaged in fighting, and indeed Ashurbanipal is entirely absent from the battle scenes. This probably reflects the real situation but, although literalness has become an important element of the reliefs, the imagery continues to be heavily selected. There is an increasing interest in the suffering and humiliation of the enemy rather than a focus on the activities of the king, whose main role is to receive defeated people and booty. The king dominates such scenes, standing in his chariot, slightly magnified in scale and wearing his tall crown. Sometimes the image of the king occupies the entire height of a register with rows of smaller figures standing in lines before him, one above the other. Direction of movement across the reliefs remains significant. For example, deportees in upper registers can be led from a city siege to the right but they move left in the lower registers towards the king who is thus positioned below the city, making a visual statement about who was ultimately responsible for the conquest. On the opposing walls of the same room the arrangement is reversed so that the king is placed in the upper register, above the city under siege, to receive deportees moving right.

The finest sculptures from the North Palace are, without doubt, the scenes of Ashurbanipal hunting and killing lions, the most powerful and dangerous animals in Assyria. The theme of the royal hunt was closely associated with the notion of Assyrian kingship and had been a popular motif in royal inscriptions and imagery from the second millennium BC onwards; indeed the king grasping and stabbing a rampant lion was carved on seals that had been used for centuries by the palace administration. However, Ashurbanipal exploited the image as never before in both literary texts and magnificent images. Reliefs depicting the king hunting lions decorated some of the more private areas of the palace and reinforced the notion of the powerful king at the very heart of the empire. The carved slabs in one room had scenes of the king hunting lions from a chariot within an arena. Unlike the Til-Tuba reliefs with their densely packed imagery, the sporting scenes play with large areas of empty space

to evoke the arena itself as well as the drama of the spectacle. We know from Ashurbanipal's inscriptions that the hunting field was actually in Nineveh and was dedicated to the warrior goddess Ishtar. This is, therefore, a ritual act in which the killing of the eighteen lions may, as Elnathan Weissert has suggested, be a magical way of protecting the eighteen gates of the capital city. The wild animals were brought to the arena in cages from the neighbouring plains. In reliefs elsewhere in the palace, lions and other animals are hunted in the wilderness: wild donkeys and gazelle, which spoil pasture and farmland, flee before the royal hunter. The use of a continuous narrative in which a lion is shown in multiple images rushing from his cage towards the king is a truly masterful use of a single space to explore the excitement of the confrontation. Perhaps more striking than any

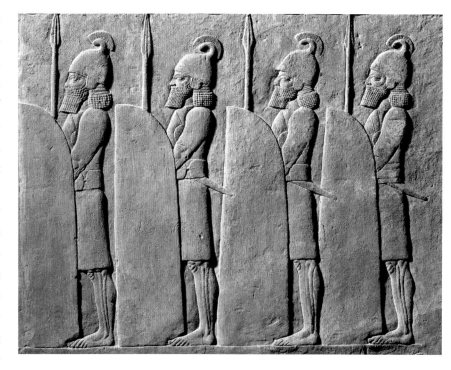

SPEAR-BEARERS GUARD an area where preparations are made for a ritual royal hunt.

other quality of these superb reliefs is the remarkable way in which the sculptors have captured the naturalism of the animals as well as their terrible suffering. The aim of the artists was not to generate pity for the dying creatures but rather to highlight their raw, dangerous presence and to show how they, like the evil Teumman, collapse in agony at the hands of the Assyrian king who, through the support of the gods and his skill with weapons, brings civilization to the chaotic and disordered world that the animals represent.

The ultimate triumph of the king over the forces of chaos is depicted in a sculptural masterpiece that decorated a private room in the North Palace. It is a scene of Ashurbanipal apparently relaxing with his queen in a landscape of trees and vines. The presence of the queen and female attendants is a highly unusual image and reflects how far traditional compositions had been expanded and transformed by the mid seventh century BC. The royal couple are engaged in a banquet, celebrating the triumphs of Assyria over Elam as represented by the severed head of Teumman hanging from the branches of a fir tree on the left of the panel. On the right of the scene, a long staff, held by a figure carved on the adjoining slab, scatters troublesome birds from a fir tree and a fruiting palm, the latter tree associated with Babylonia and Elam whose people had similarly been scattered by the Assyrian army. The atmosphere is charged with symbolism, perhaps even ritual import. Indeed, the perceived significance of such images of kingship was so great that, when Nineveh fell in 612 BC to invading Babylonians and Medes, it was somebody's job to seek them out and have them mutilated. By gouging out the king's face, as well as that of other important Assyrians and their allies, the presence of Assyria itself was thought to be obliterated.

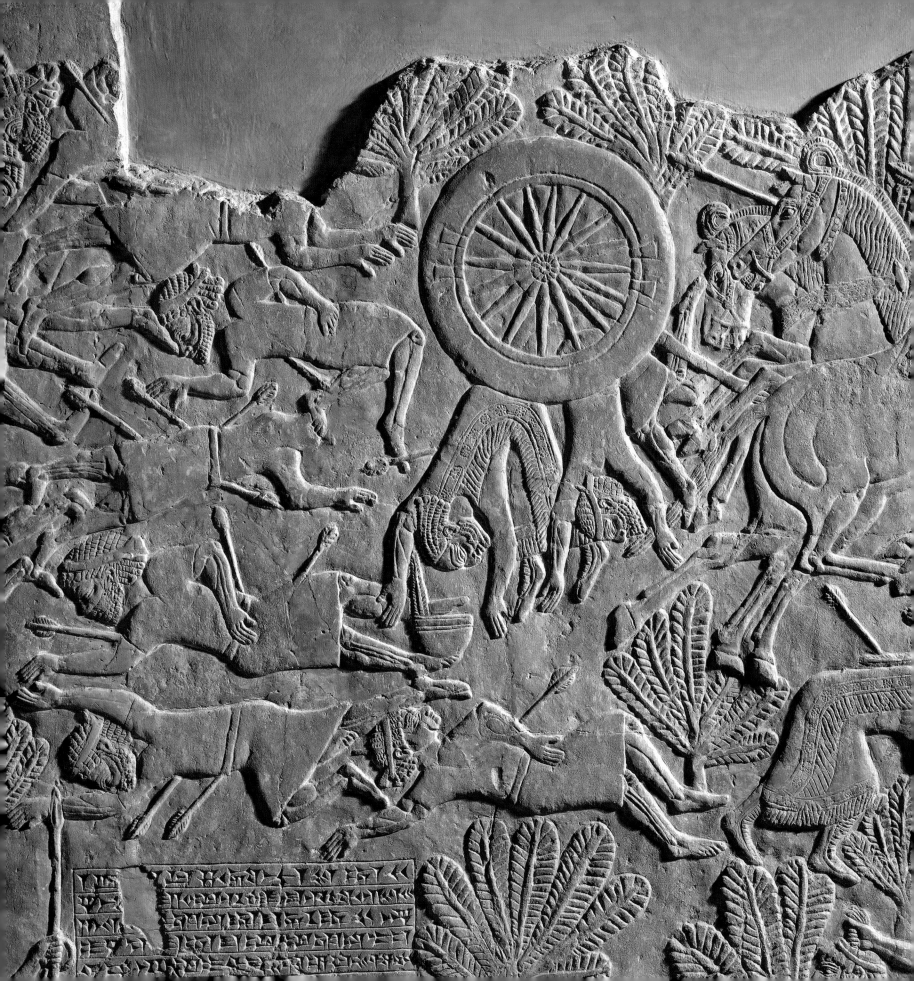

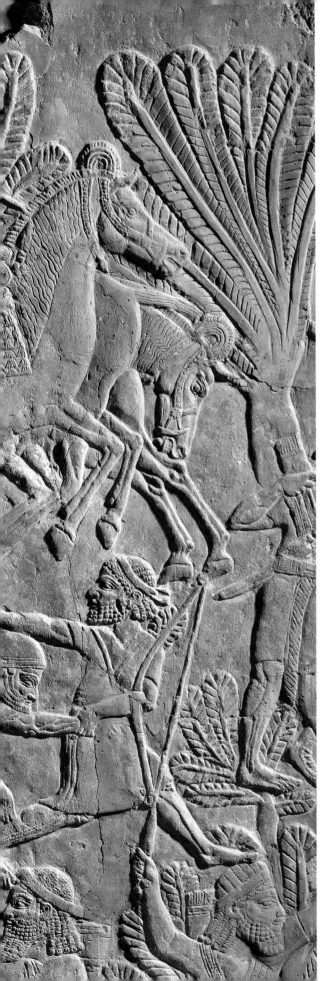

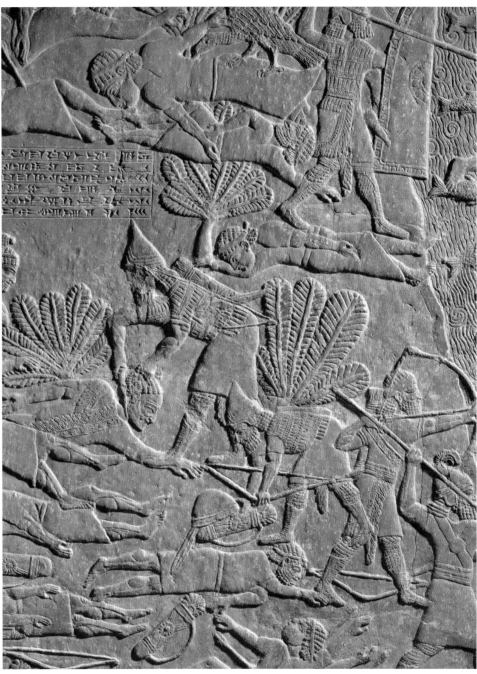

THE EVIL KING Teumman and his son fall from their upturned chariot; the horses twist and rear in fright and confusion. The king, with an arrow in his back, does not stand his ground but is led by his son into the woods. *left*

TEUMMAN IS CAUGHT and decapitated by an Assyrian soldier whose colleague collects the ruler's distinctive hat. The battle is over and a vulture pecks at the body of a dead Elamite. *above*

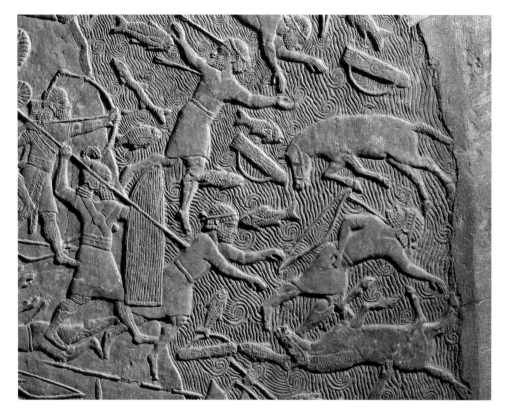

THE REMAINING ELAMITE soldiers
are driven into the River Ulai and, together
with their horses and equipment, are
swept away like refuse. *above*

DEAD BODIES FLOAT among the fish
as the river flows past Elamite musicians
who have emerged from their city to
welcome the Assyrian conquerors. *right*

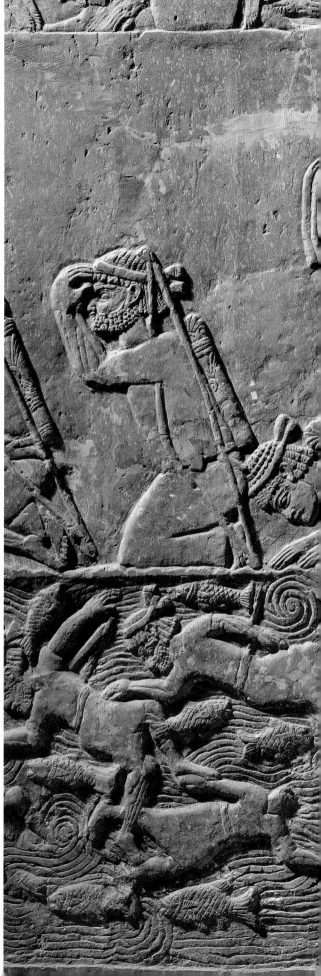

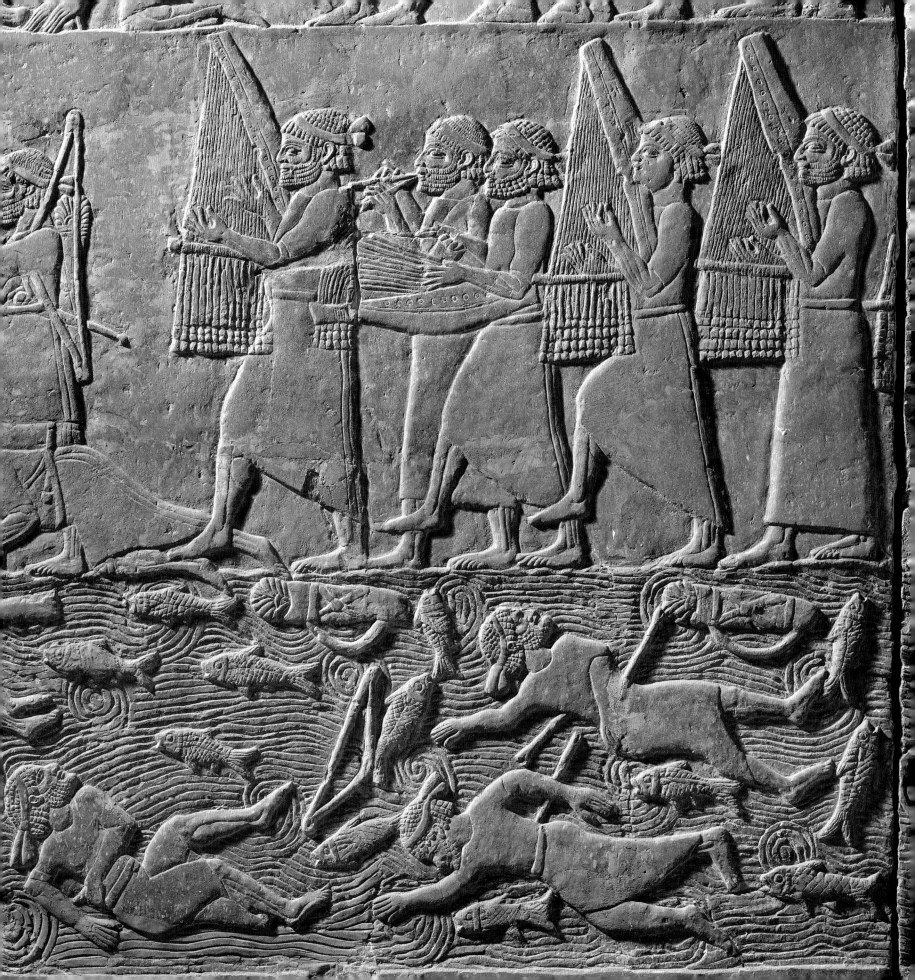

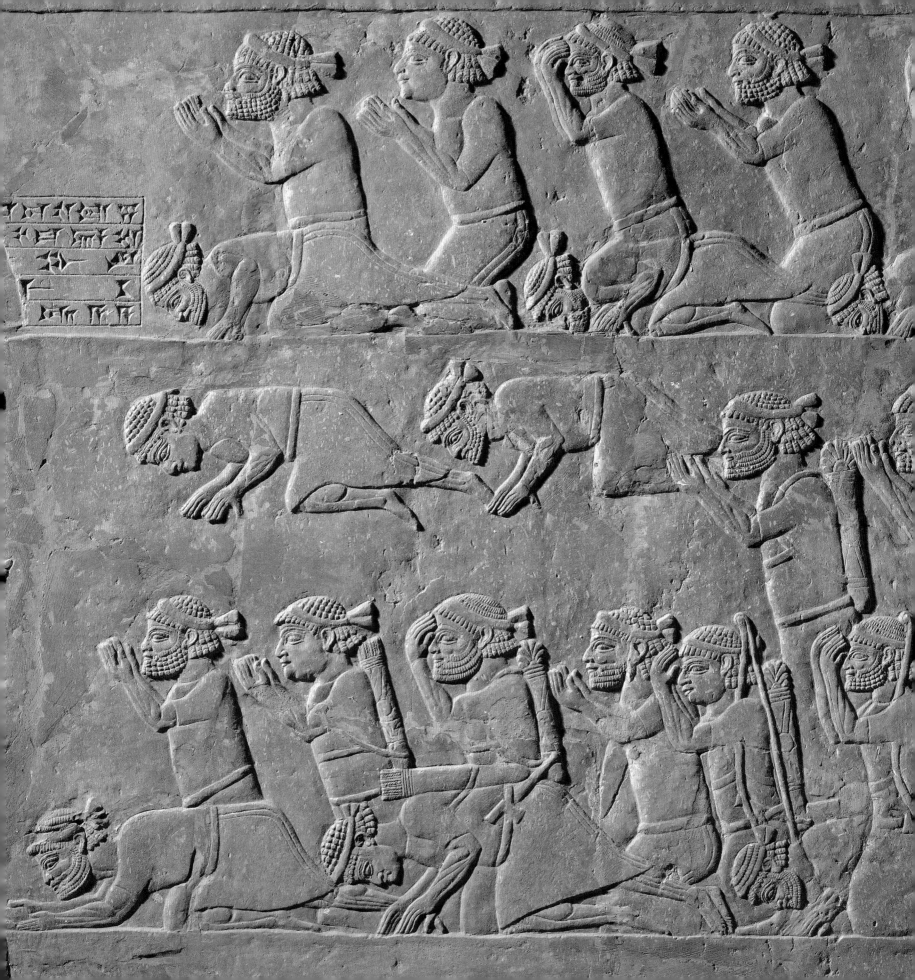

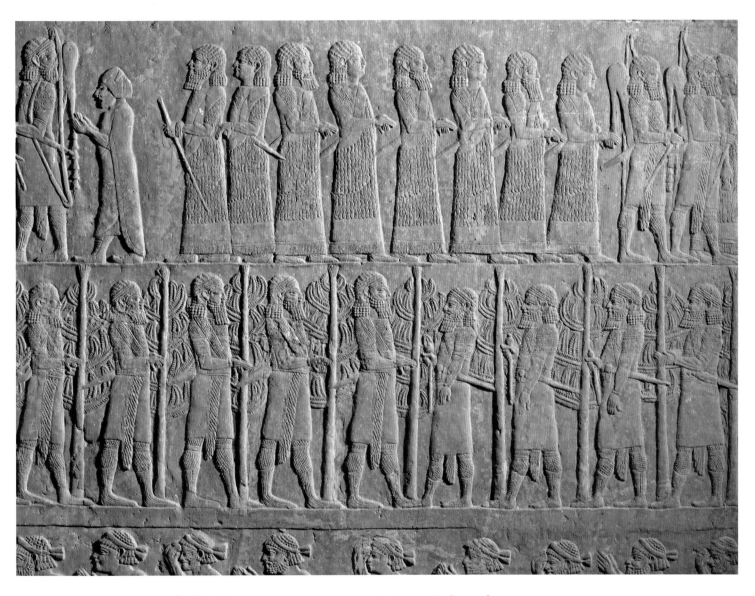

ORDER IS IMPOSED on the Elamite forces and they kneel and bow in organized lines to acknowledge their new ruler appointed by the Assyrians. *left*

IN ASSYRIA, REGIMENTED lines of disciplined officials reflect the harmonious world of Ashurbanipal. *above*

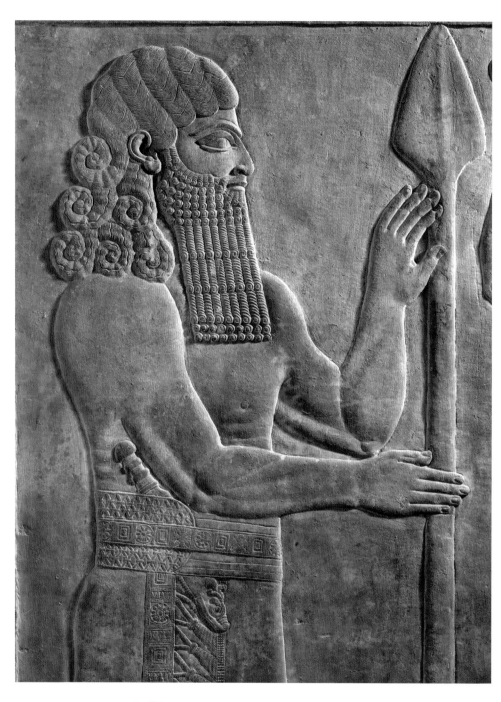

THERE WERE NO bull-*lamassus* in the North Palace but gateways were still guarded by supernatural beings, such as this *lahmu* spirit. *above*

RED PAINT SURVIVES on the head of a 'Great Lion' spirit. *right*

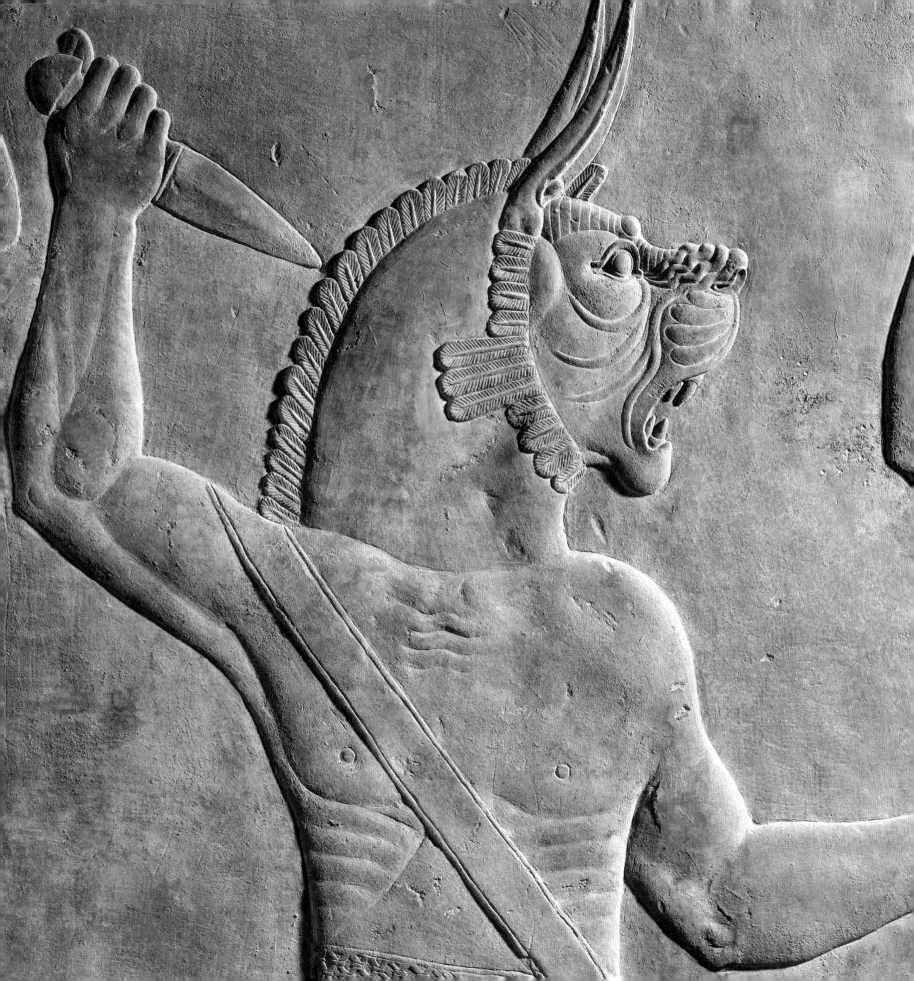

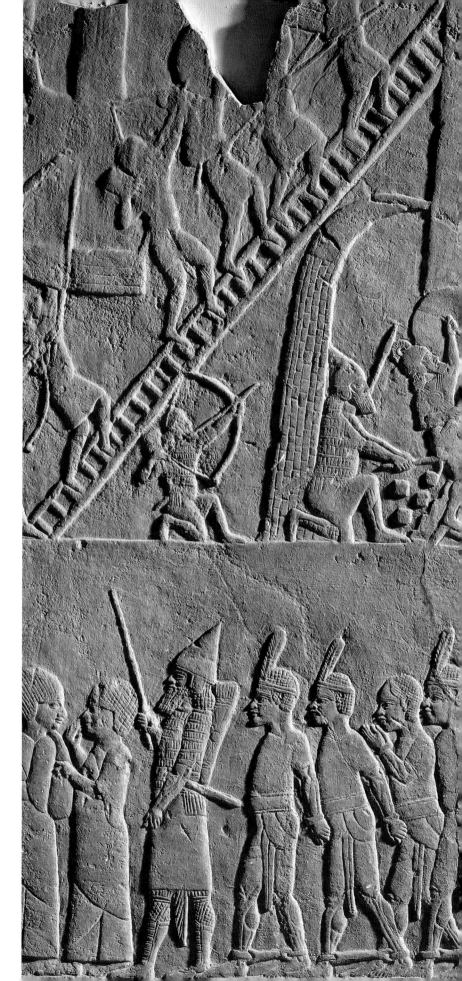

THE DISTINCTIVE PYLON gateway
of an Egyptian city is set alight by an
Assyrian soldier during a siege. Other
soldiers march bound captives with
African facial features away from the city.

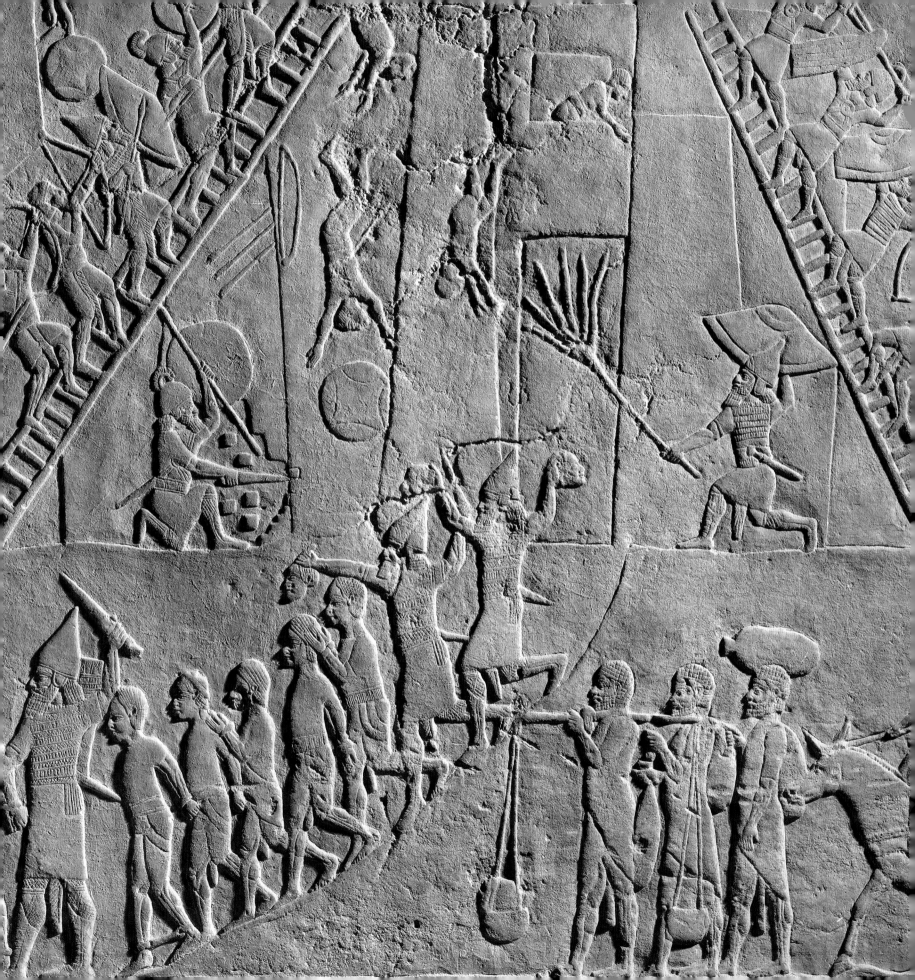

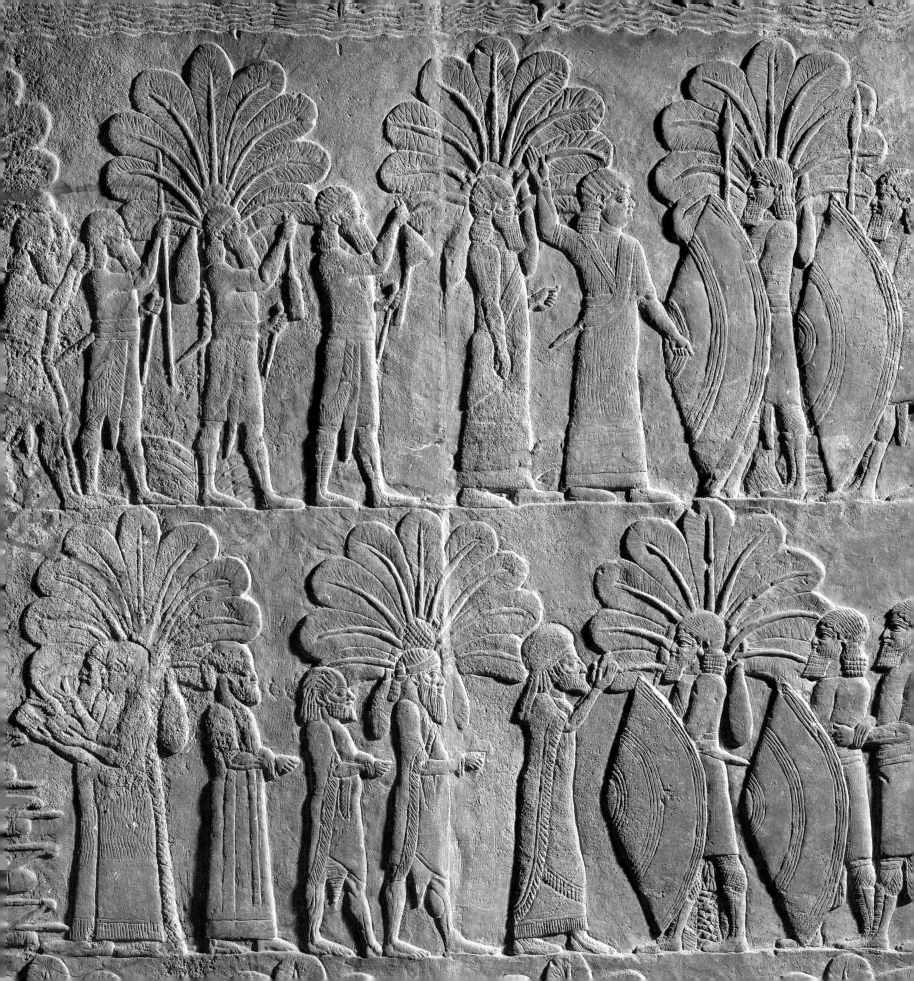

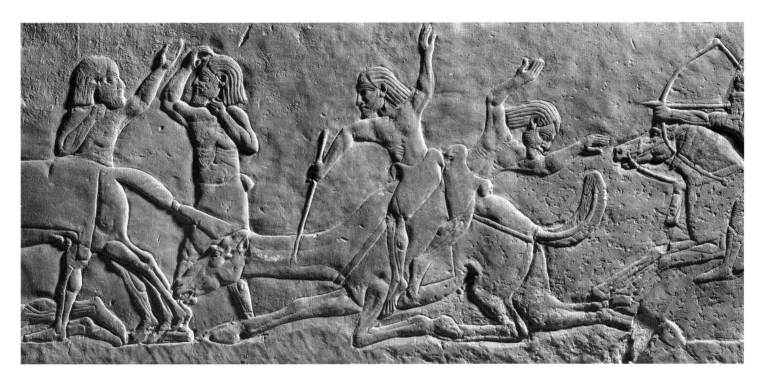

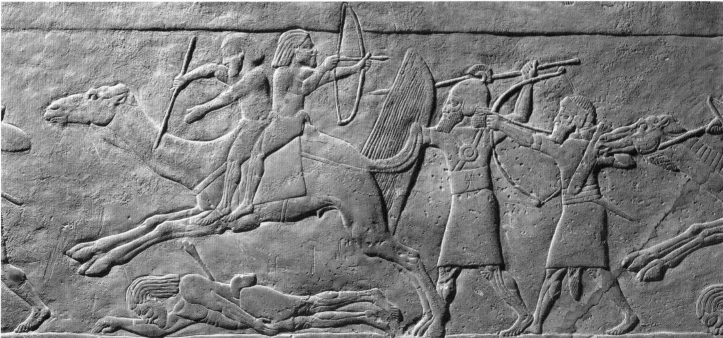

THE ROYAL REGALIA of Babylonia and representatives of conquered people are paraded towards the Assyrian king. *left*

A CAMEL STUMBLES and collapses, and its Arab riders are about to be unseated, as an Assyrian cavalryman descends upon them. *top*

ARABS ON A CAMEL attempt to flee from an Assyrian archer and spearman. *above*

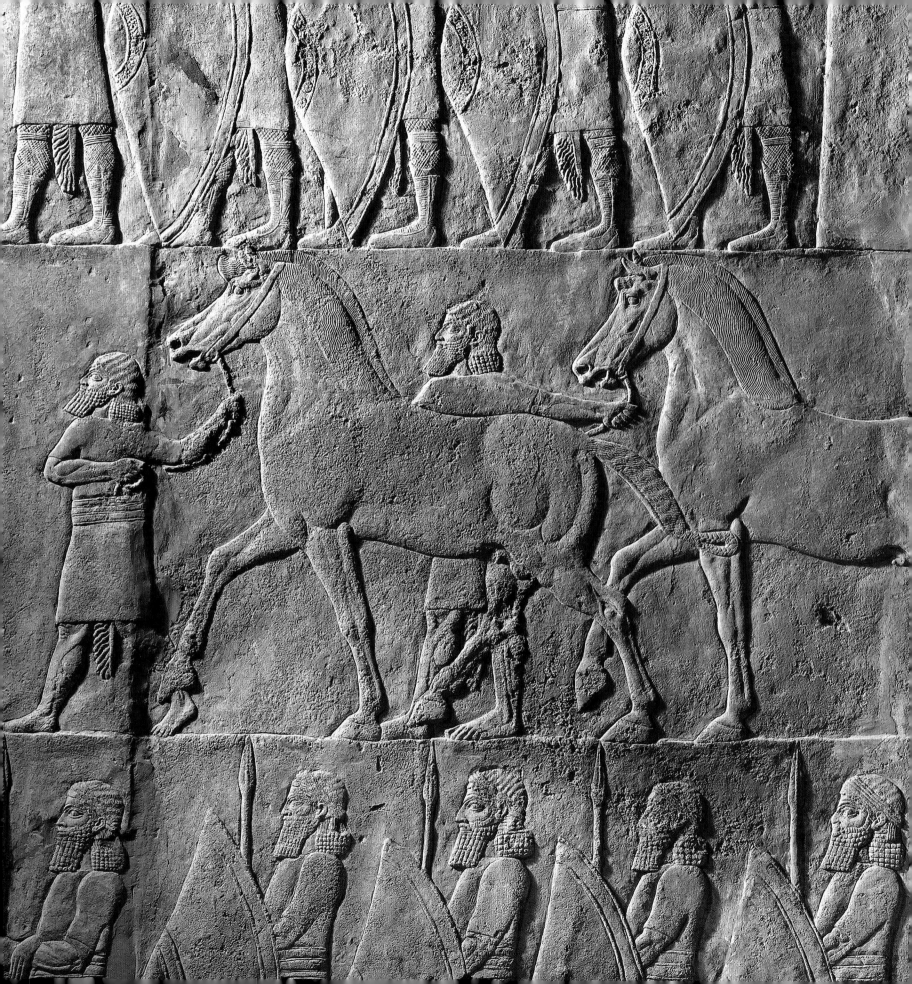

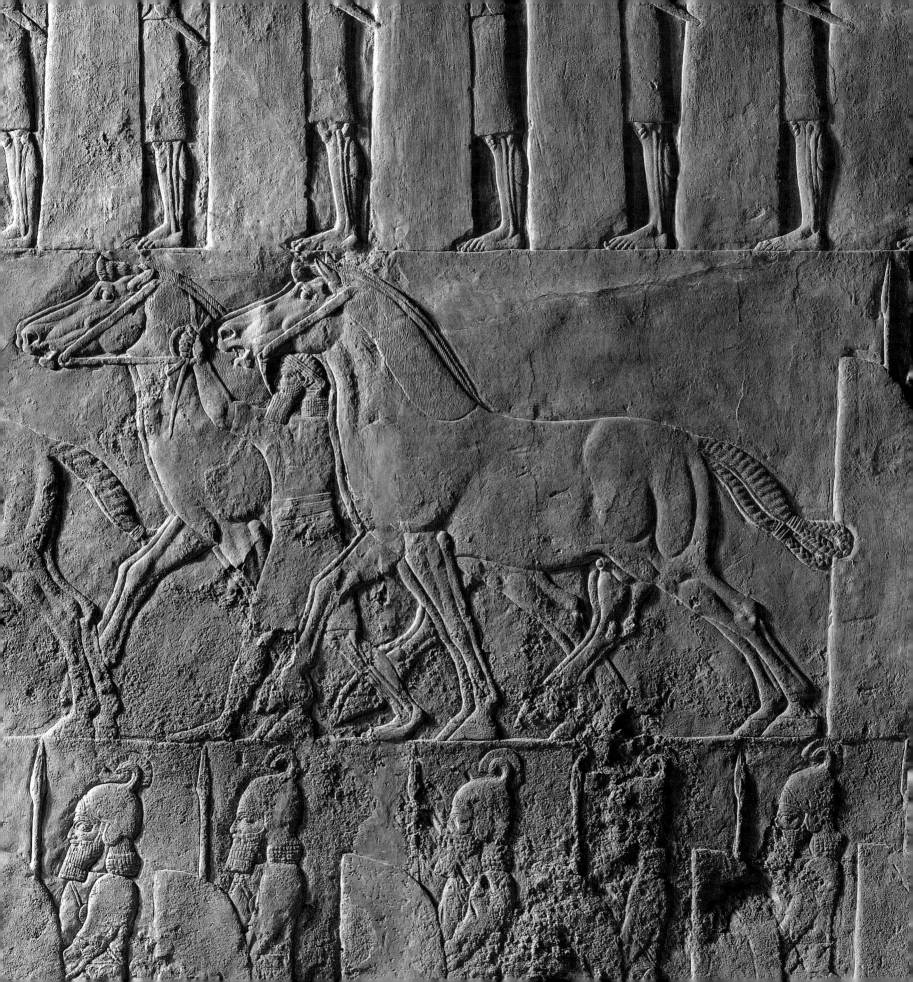

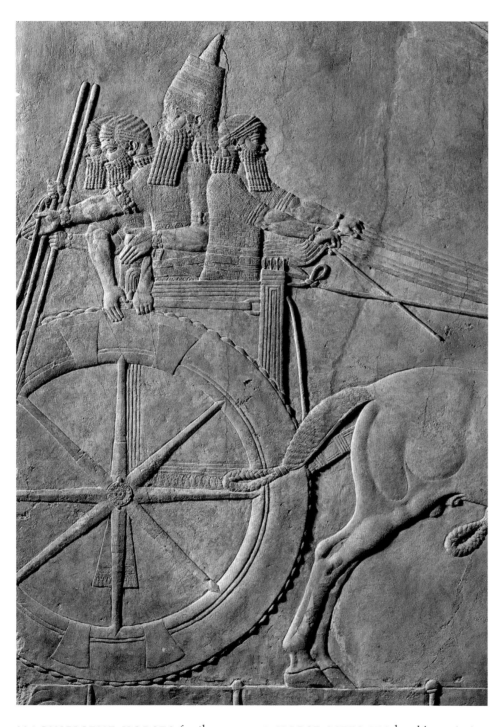

MAGNIFICENT HORSES for the king's chariot are led along a road lined by spear-bearers. *previous pages*
THE KING IS handed his bow. *above*

A HORSE LIFTS ITS head in protest as two officials attempt to reverse the animal towards the king's chariot; another horse, already harnessed, is alert to the struggle beside it. *right*

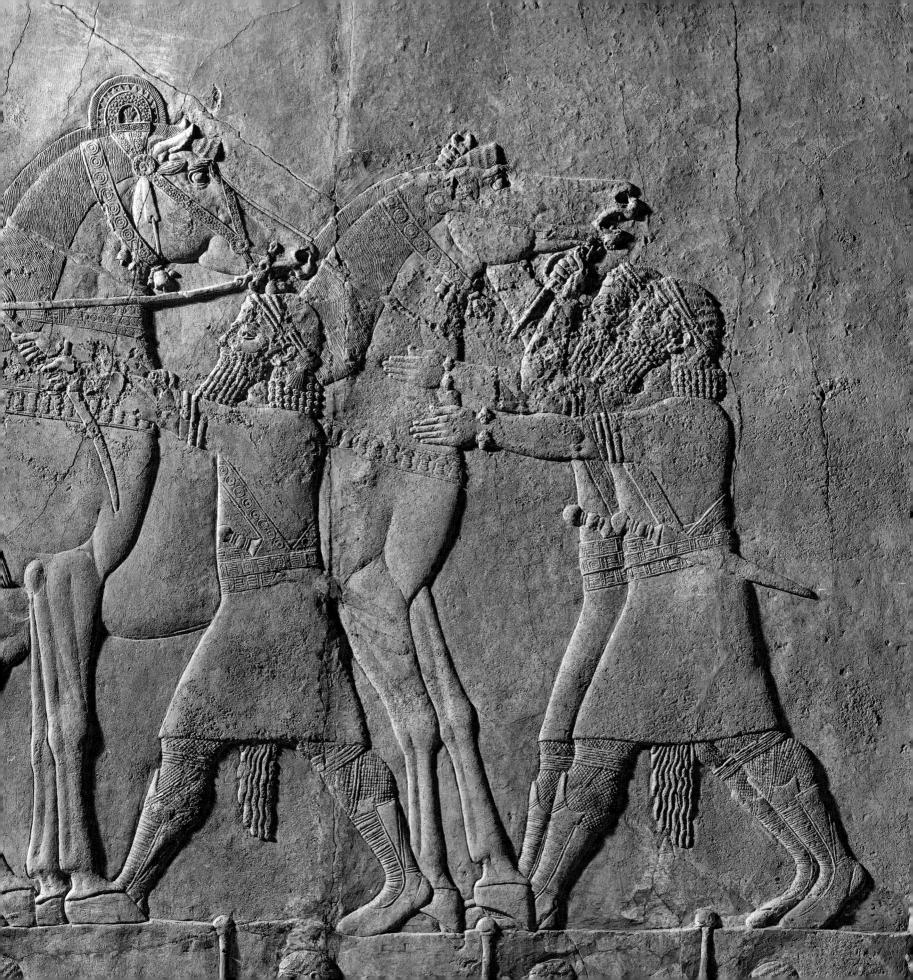

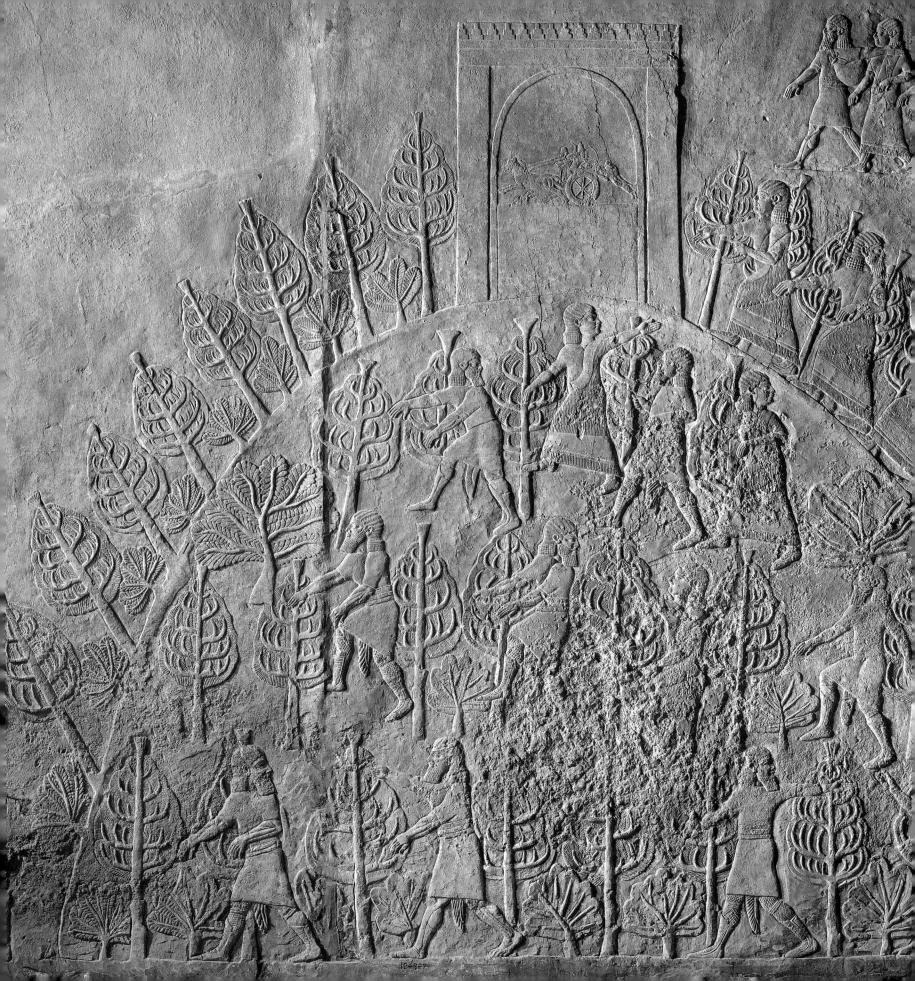

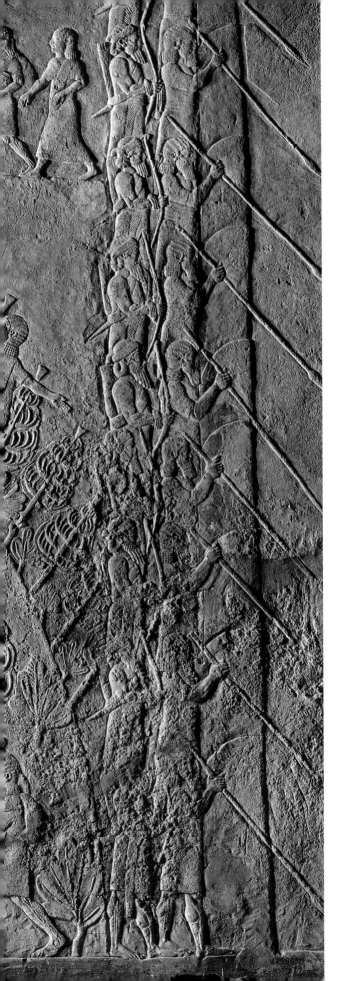

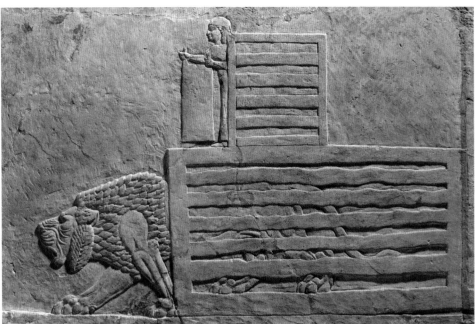

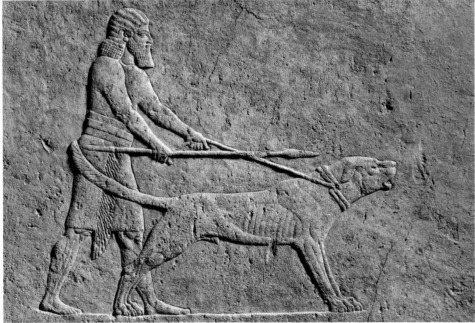

ASSYRIANS, OVERWHELMED by the majesty of their king in action, flee from the hunting grounds across a wooded hill surmounted by a monument depicting the royal triumph. *left*

A WILD LION EMERGES cautiously into the arena, having been released by a boy with his own protective cage. *top*

A MASTIFF STANDS ready to turn back wounded lions into the heart of the hunting grounds. *above*

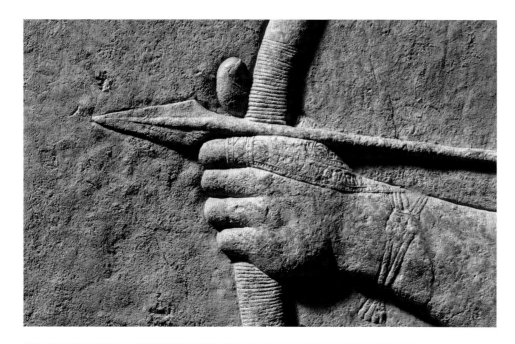

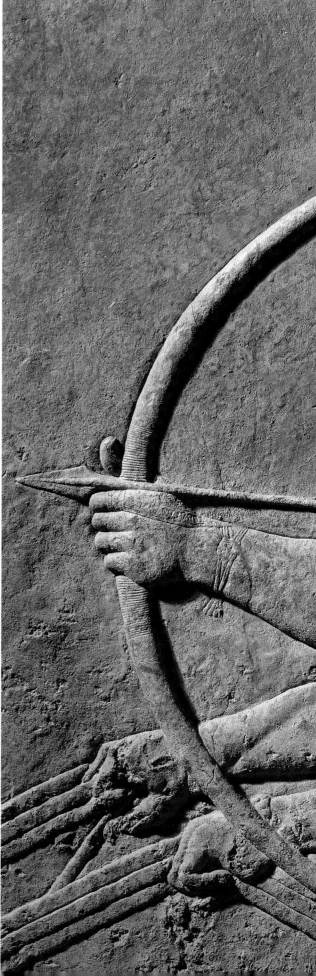

A COMPLEX INTERSECTION of faces, limbs and weapons creates a sense of drama and intensity as arrows are released at lions from the king's bow, itself decorated with a lion's head.

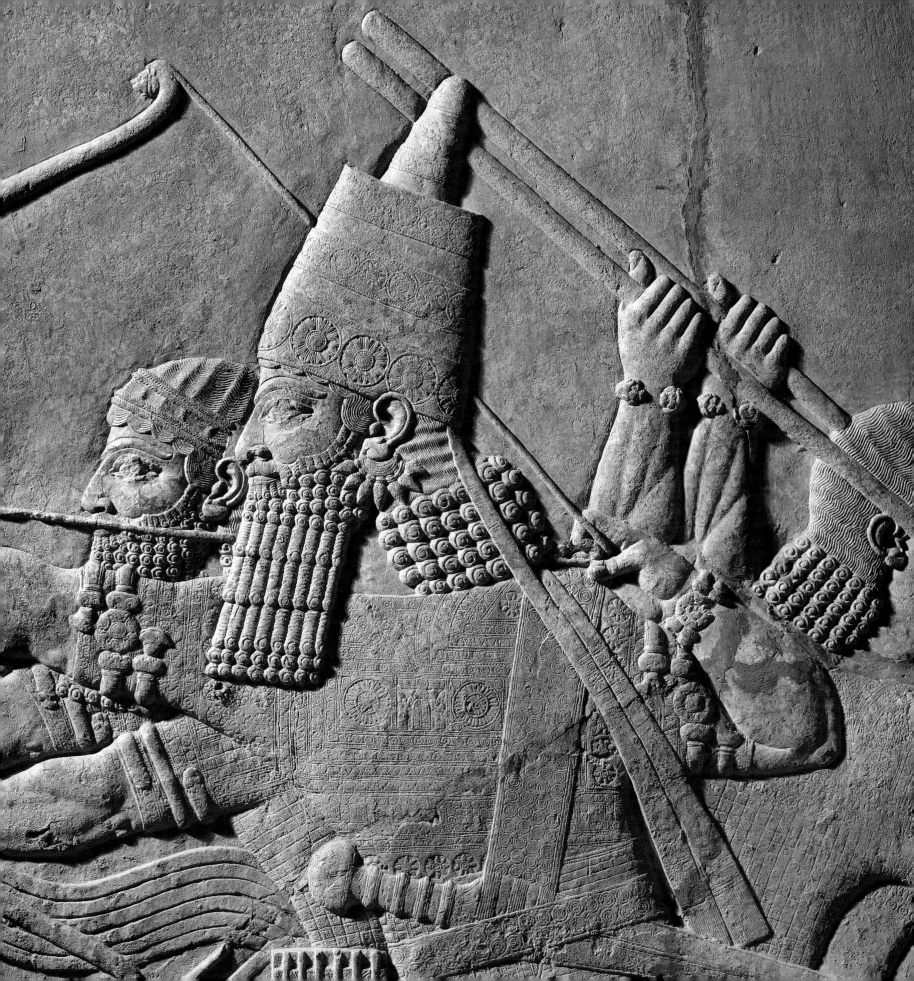

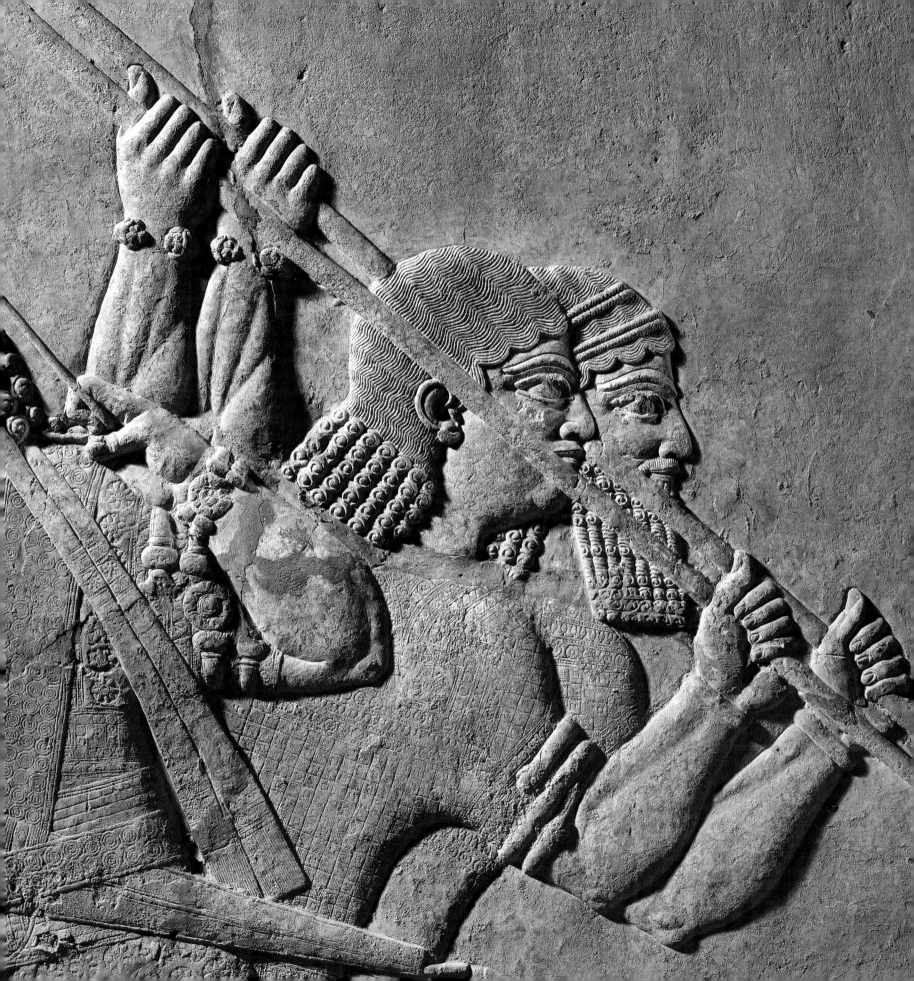

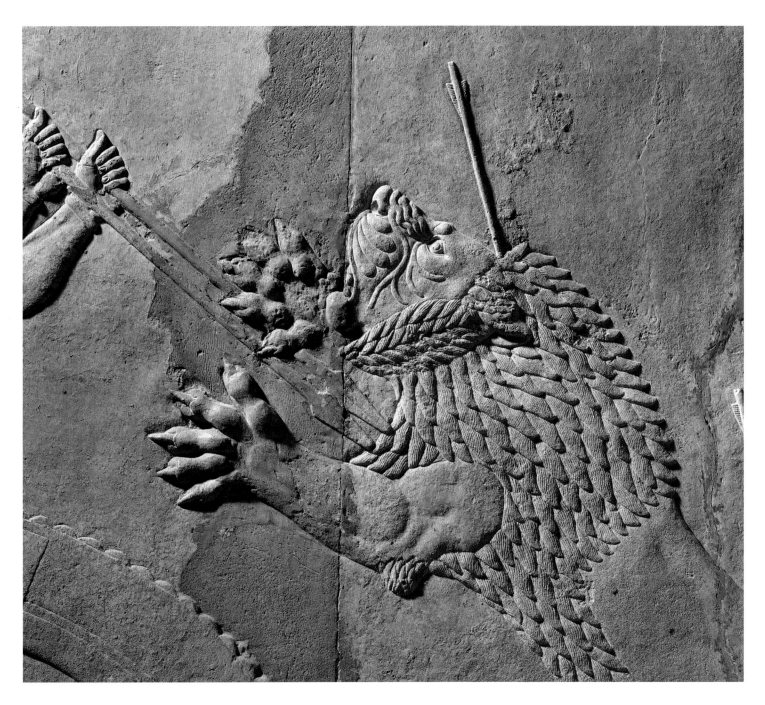

ROYAL ATTENDANTS ward off a
wounded lion with spears. *left and above*

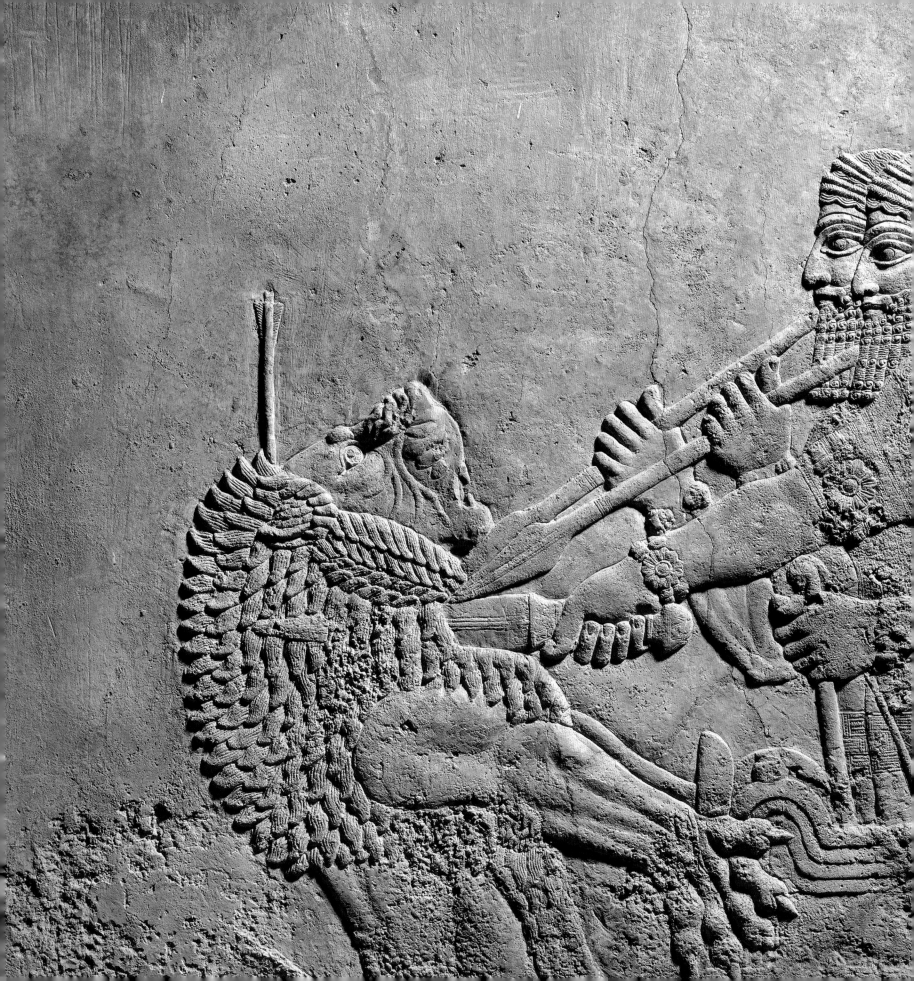

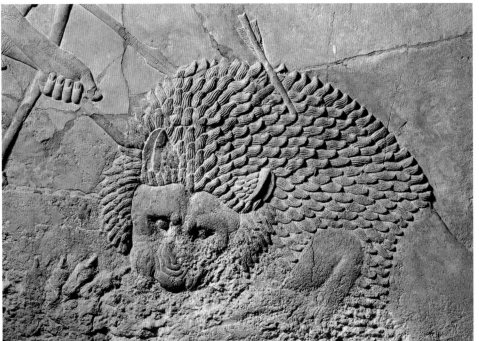

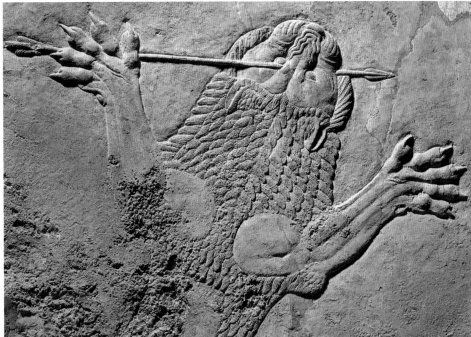

THE VIOLENT, PAINFUL and degrading death of dangerous lions is depicted with skill and even beauty in order to convey what Assyrian kings describe as the 'radiance' and 'awe' of their weapons. These were granted to rulers by the gods and brought terror and defeat to their enemies. *left, above and following pages*

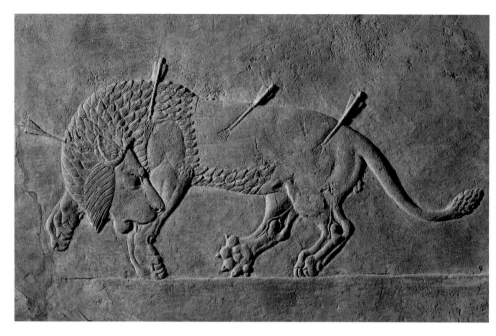

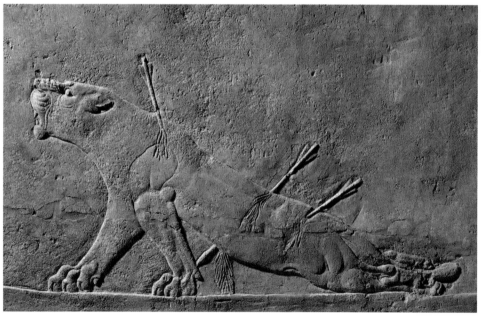

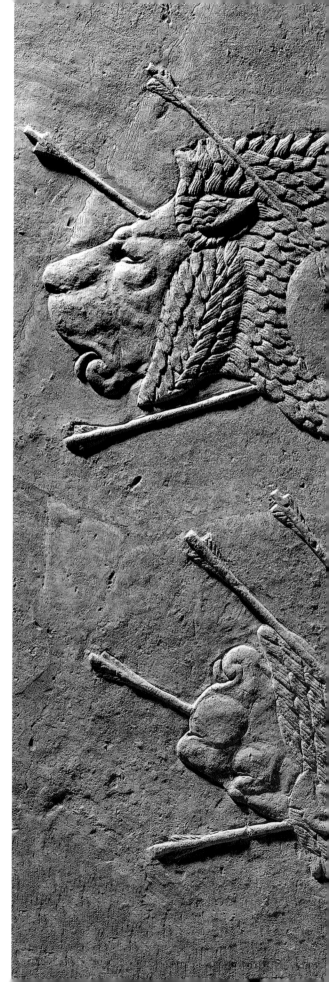

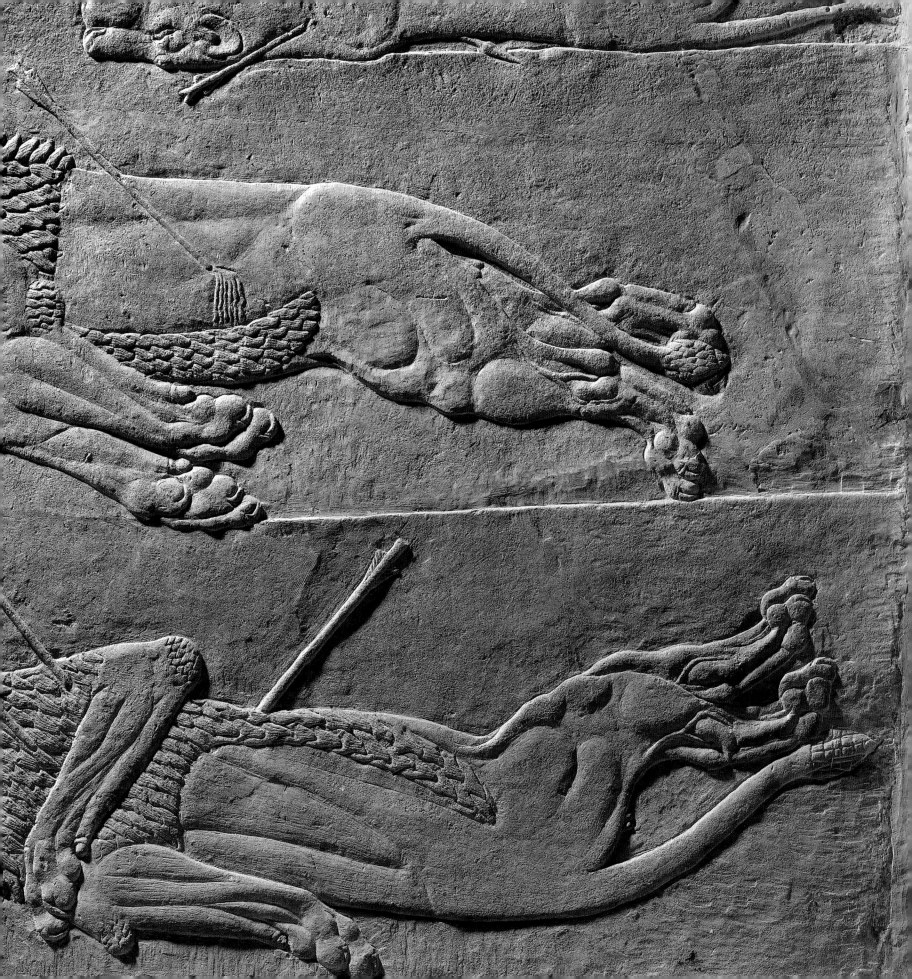

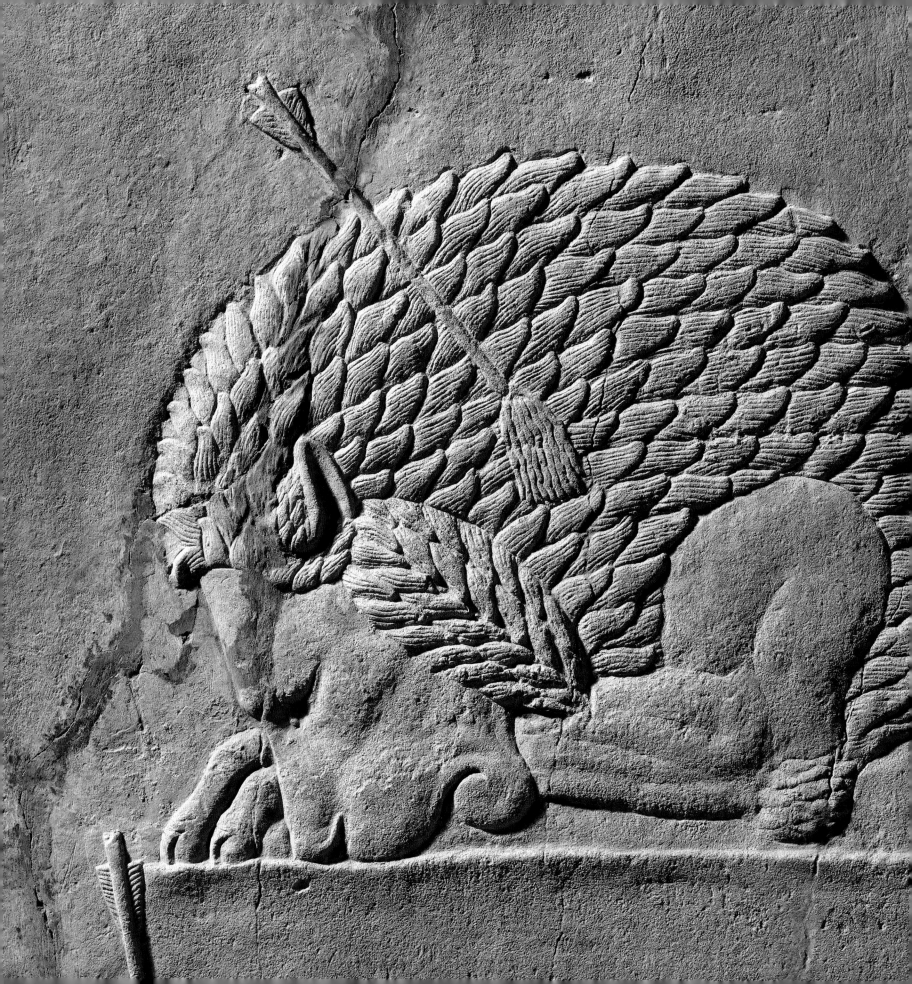

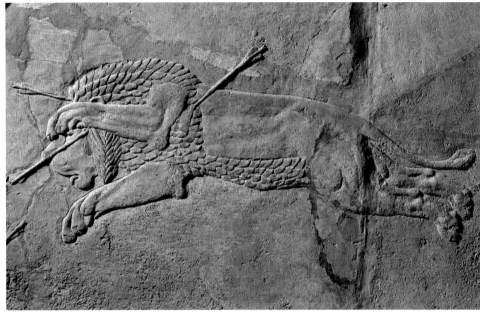

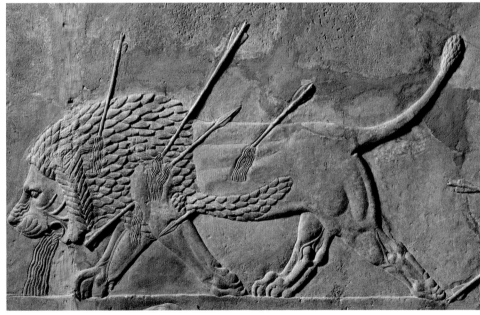

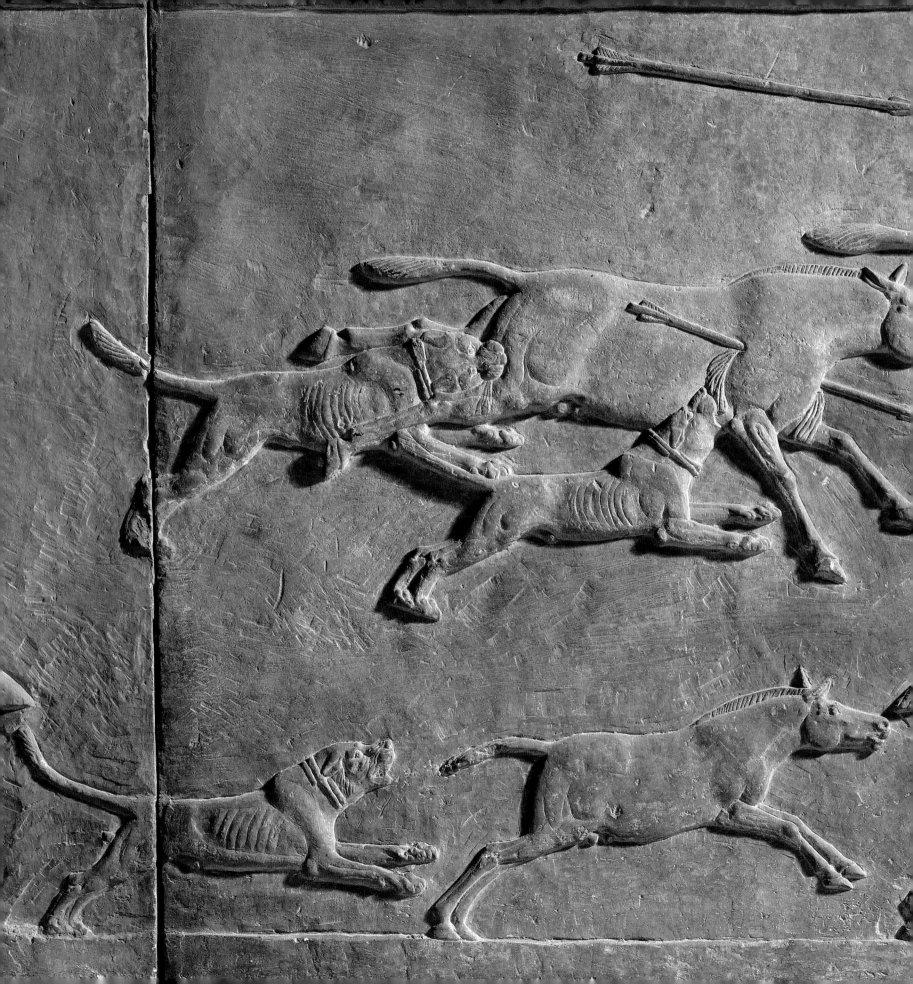

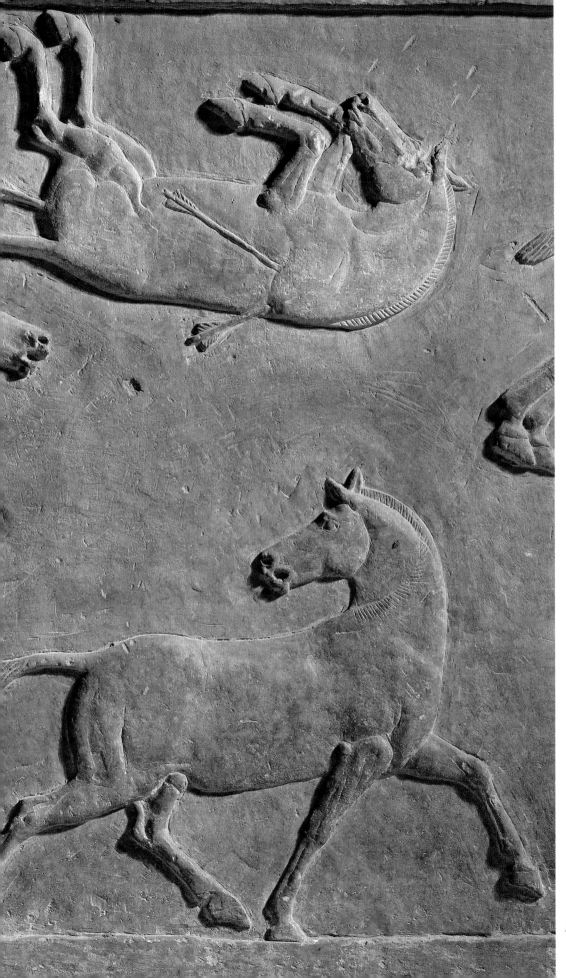

THE IMMINENT DANGER to a wild donkey foal from a pursuing mastiff causes its mother to pause and turn her head back in concern. It is already too late for others in the herd and they are brought to earth by the king's hunting dogs and arrows. *left*

THE DRAMATIC USE of space, across which a gazelle and her young wander, evokes the rolling plains beyond Nineveh. *following pages*

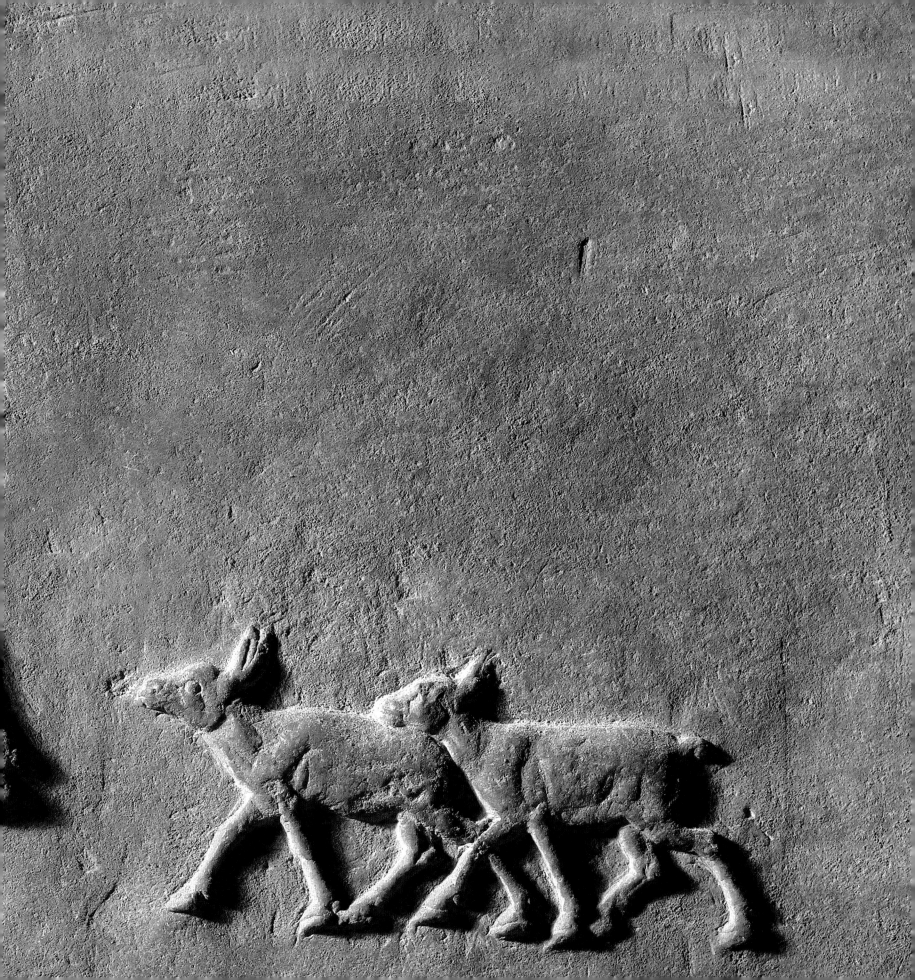

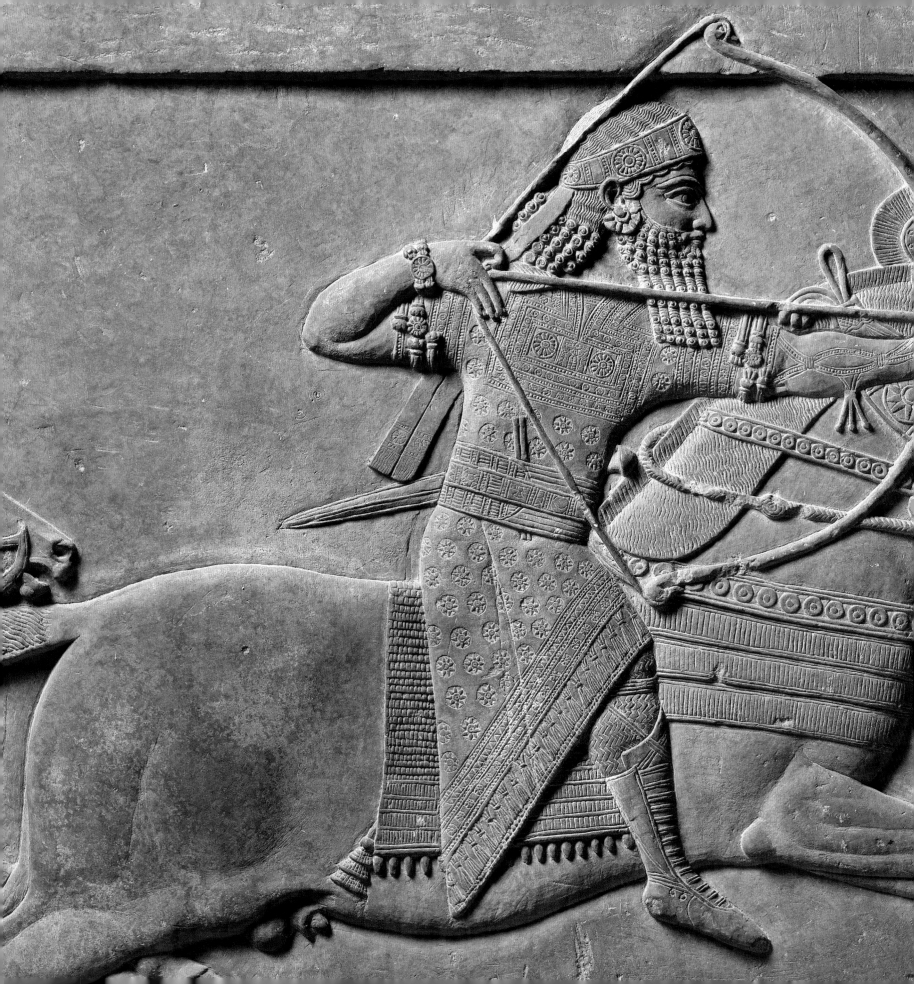

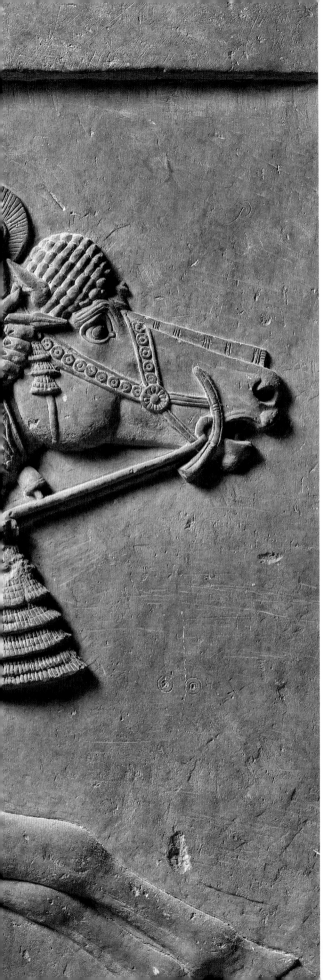

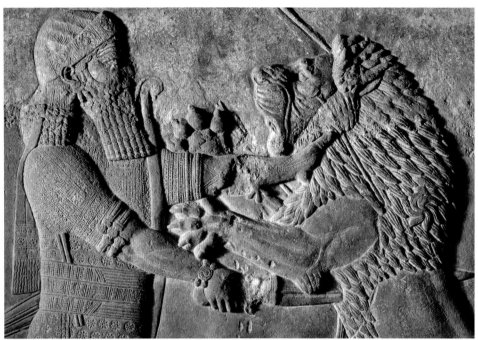

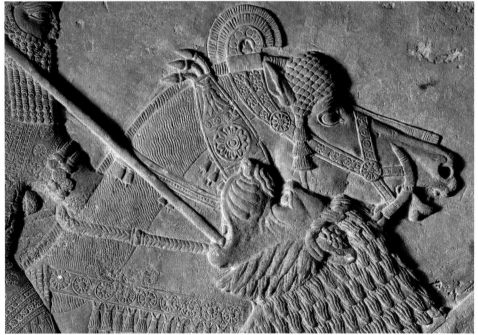

ASHURBANIPAL IS MASTER of all weapons: the bow, the sword and the spear. *left and above*

BOTH THE INSCRIBED caption and image describe Ashurbanipal dedicating his hunting bow to the goddess Ishtar while he libates wine over dead lions, just as we are told elsewhere that he poured wine over the severed head of the rebel king Teumman. *following pages*

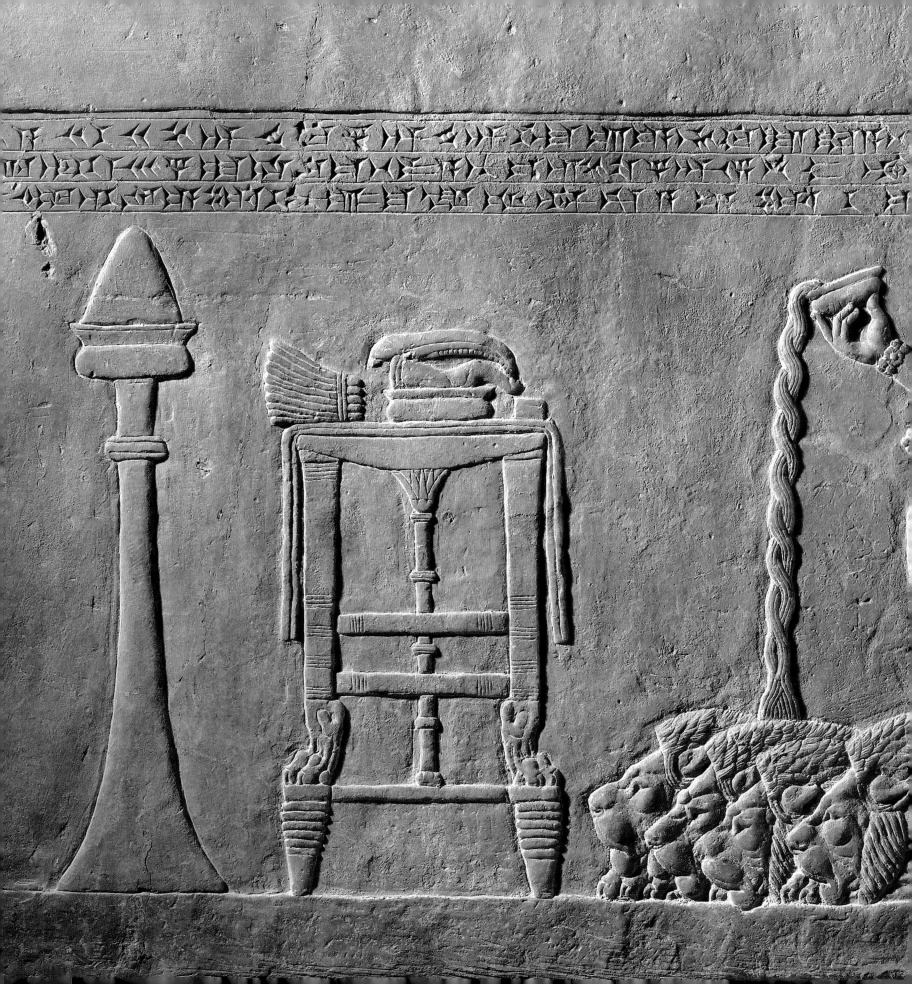

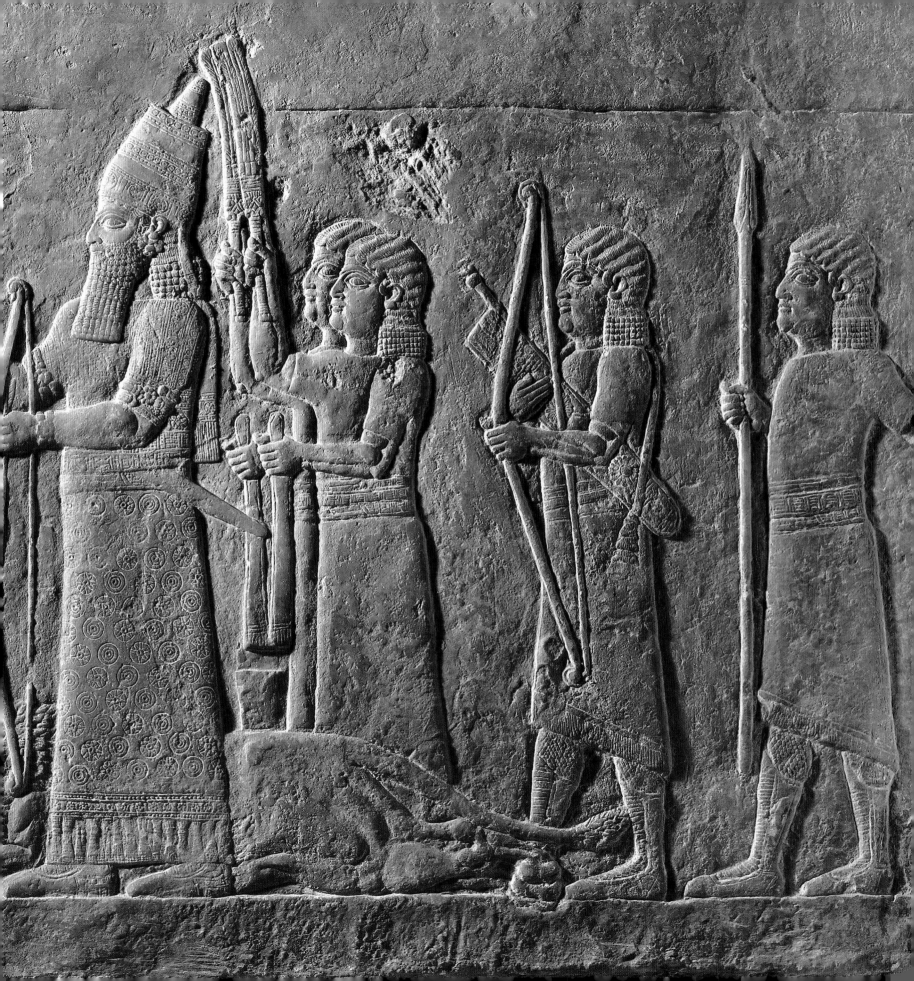

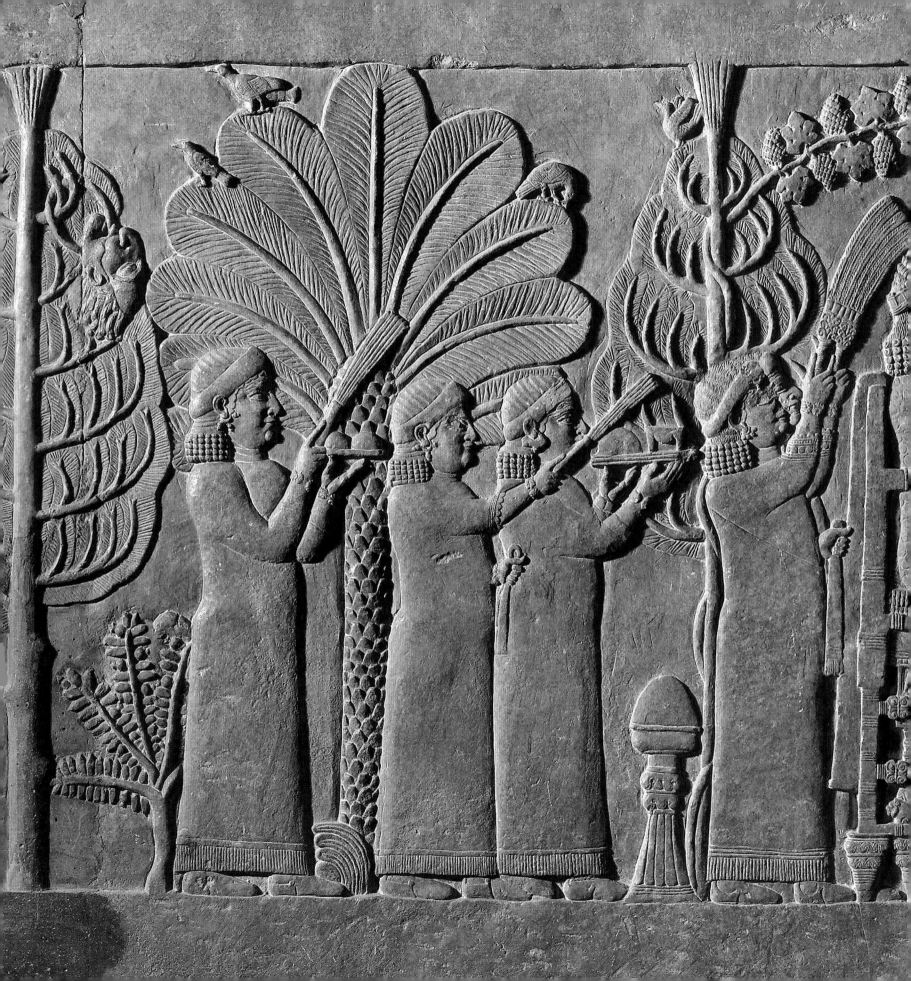

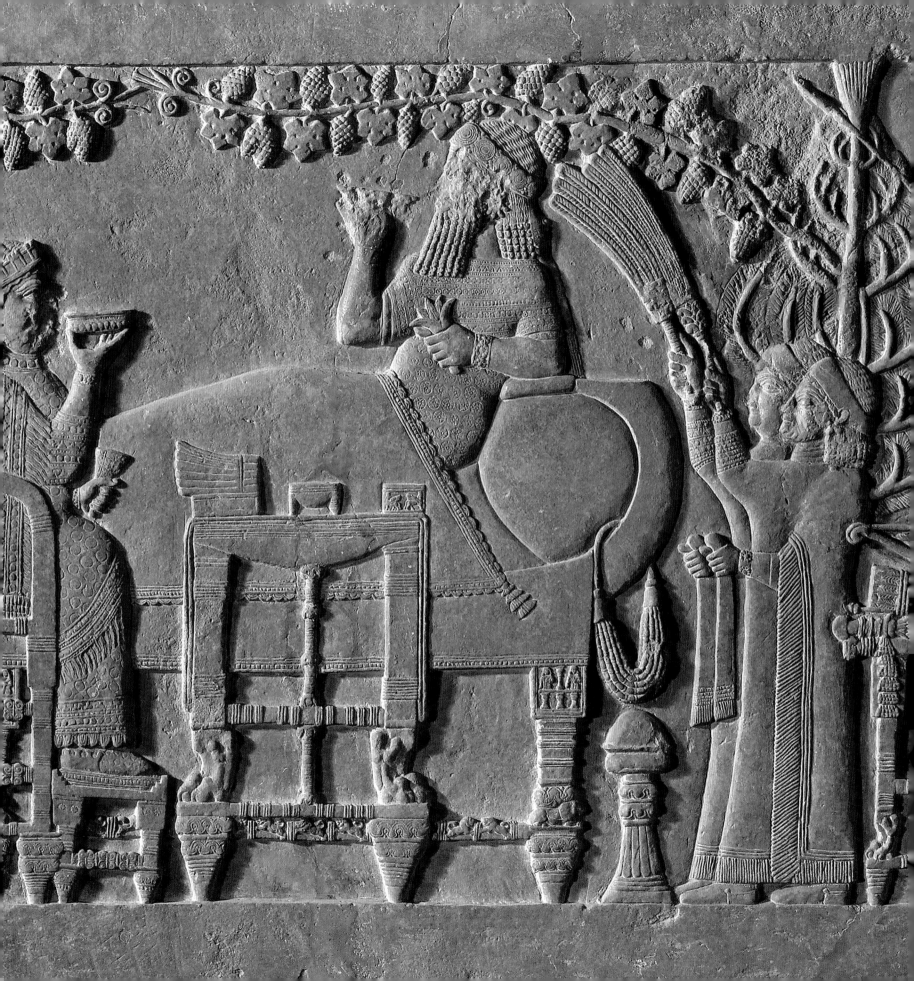

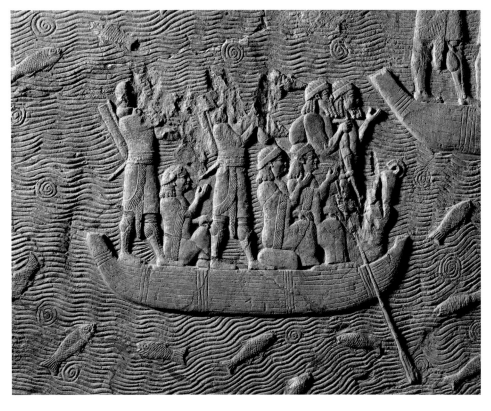

ASHURBANIPAL ENGAGES in a celebratory banquet with distinct ritual overtones. Accompanied by his queen and female attendants, he is the only male in the scene, although the head of his arch-enemy Teumman hangs from an Assyrian fir tree. *previous pages*

AMONG THE LAST palace sculptures to be carved are a series from the Southwest Palace at Nineveh showing a campaign in Babylonia. Captives are ferried across a lagoon. *above*

FUGITIVES HIDE within the dense reed marshes of southern Iraq. *right*

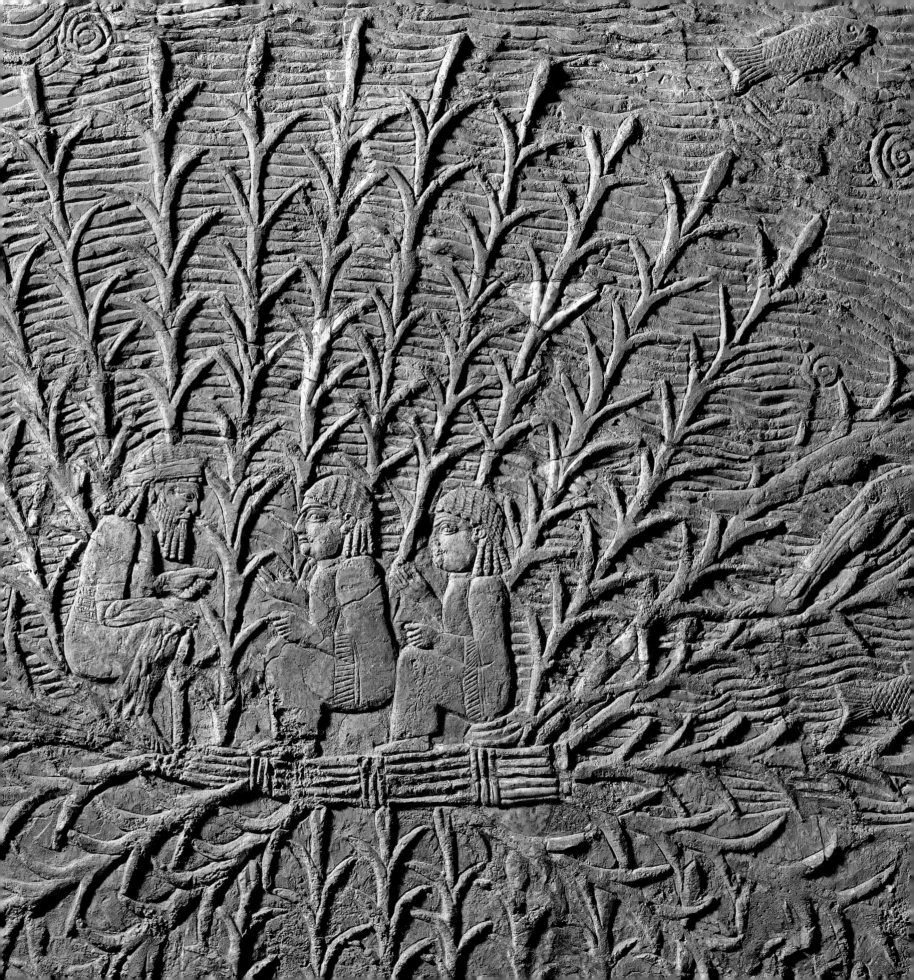

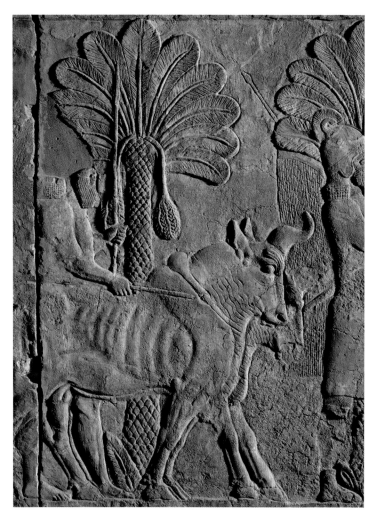

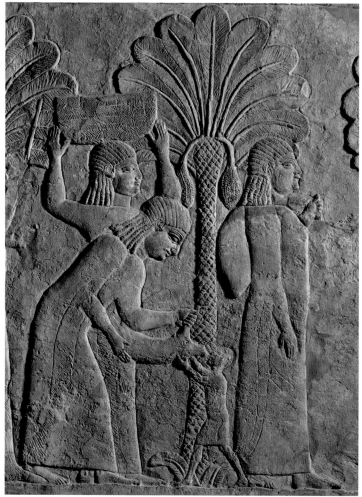

CAPTIVES AND THEIR animals are brought out of the marshes and approach Assyrian scribes, who are placed at the centre of the decorative scheme as the representatives of royal order, methodically recording enemy heads. *above and right*

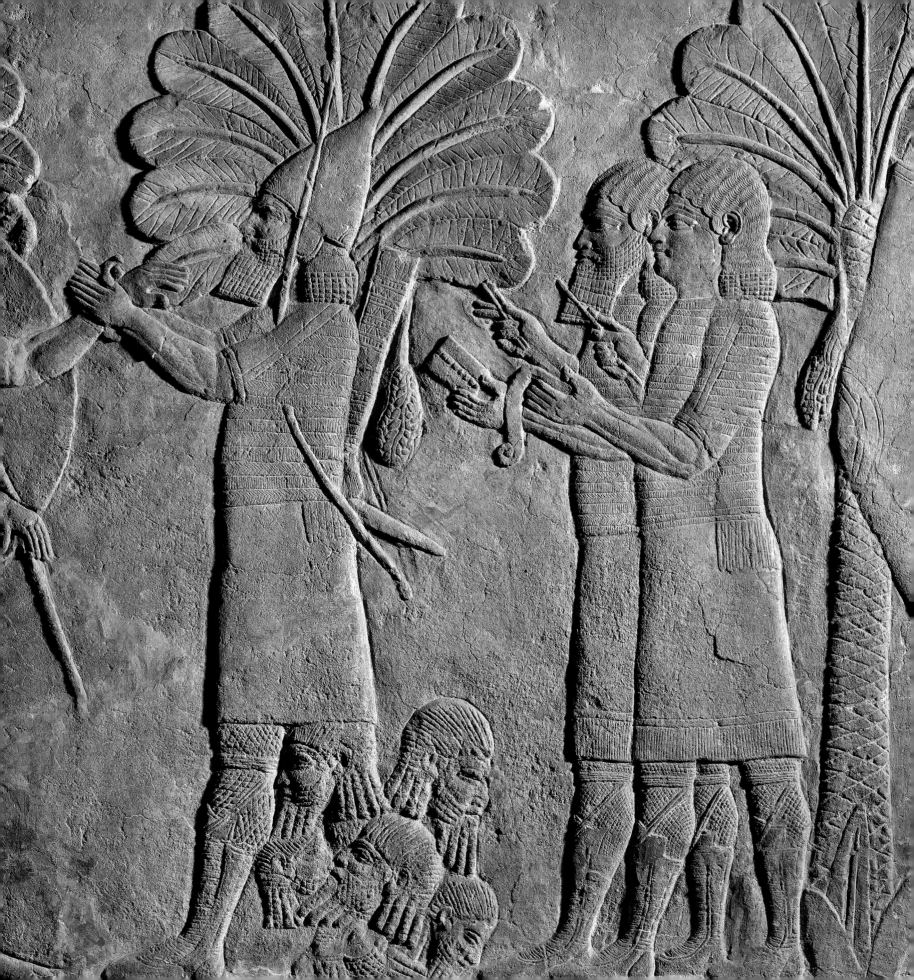

For introductions to Assyrian history and art, see:

J.E. Curtis and J.E. Reade (eds), *Art and Empire: Treasures from Assyria in the British Museum*, London 1995.

J.E. Reade, *Assyrian Sculpture*, London 1998.

P. Collins, *From Egypt to Babylon: The International Age 1550–500 BC*, London 2008.

For the rediscovery of the Assyrian sculptures, see:

A.H. Layard, *Nineveh and its Remains*, London, 1849.

M.T. Larsen, *The Conquest of Assyria: Excavations in an Antique Land*, London 1996.

For the nineteenth-century reception of the Assyrian sculptures, see:

J. Rudoe, 'Lady Layard's Jewellery and the "Assyrian Style" in Nineteenth-Century Jewellery Design', in F.M. Fales and B.J. Hickey (eds), *Austen Henry Layard tra L'Oriente e Venezia*, Rome 1987, pp. 213-25.

I. Jenkins, *Archaeologists and Aesthetes in the Sculpture Galleries of the British Museum 1800–1939*, London 1992.

F.N. Bohrer, *Orientalism and Visual Culture: Imagining Mesopotamia in Nineteenth-Century Europe*, Cambridge 2003.

For detailed studies of the Assyrian palaces and their decoration, see:

NIMRUD

R.D. Barnett and M. Falkner, *The Sculptures of Assur-nasir-apli (883–859 B.C.) Tiglath-pileser III (745–727 B.C.) Esarhaddon (681–669 B.C.) from the Central and South-West Palaces at Nimrud*, London 1962.

S.M. Paley, *King of the World: Ashur-nasir-pal II of Assyria 883–859 B.C.*, New York 1976.

I.J. Winter, 'Royal Rhetoric and the Development of Historical Narrative in Neo-Assyrian Reliefs', *Studies in Visual Communications* 7/2 (1981), pp. 2-38.

J.M. Russell, 'The Program of the Palace of Assurnasirpal II: Issues in the Research and Presentation of Assyrian Art', *American Journal of Archaeology* 102 (1998), pp. 689-96.

KHORSABAD

P. Albenda, *The Palace of Sargon, King of Assyria*, Paris 1986.

NINEVEH

R.D. Barnett, *Sculptures from the North Palace of Ashurbanipal at Nineveh (668–627 B.C.)*, London 1976.

J.M. Russell, *Sennacherib's Palace Without Rival at Nineveh*, Chicago 1991.

E. Weissert, 'Royal Hunt and Royal Triumph in a Prism Fragment of Ashurbanipal', in S. Parpola and R. M. Whiting (eds), *ASSYRIA 1995. Proceedings of the 10th Anniversary Symposium of the Neo-Assyrian Text Corpus Project, Helsinki, September 7-11*, Helsinki 1995, pp. 339-58.

H. Pittman, 'The White Obelisk and the Problem of Historical Narrative in the Art of Assyria', *The Art Bulletin* 78/2 (1996), pp. 334-55.

R.D. Barnett, E. Bleibtreu and G. Turner, *Sculptures from the Southwest Palace of Sennacherib at Nineveh*, London 1998.

All the photographs of Assyrian reliefs from the British Museum collections were taken by Lisa Baylis and Sandra Marshall and are copyright the Trustees of the British Museum.

BRITISH MUSEUM NUMBERS OF THE ASSYRIAN SCULPTURES